PHOTOGRAPHY FOR
Advertising

PHOTOGRAPHY

FOR

Advertising

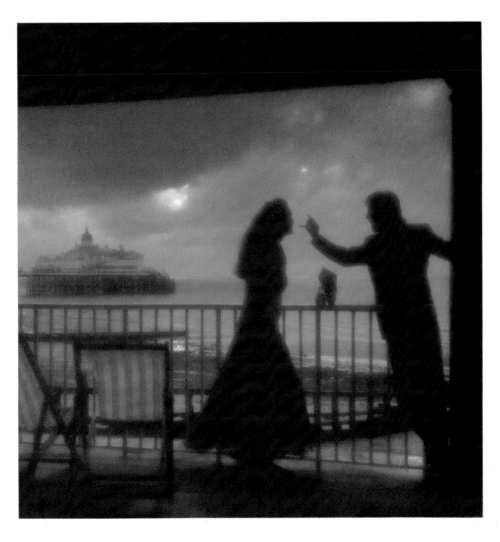

DICK WARD

Macdonald Illustrated

For Zoé and Henry

A. **Macdonald Illustrated** BOOK

© Macdonald & Co (Publishers) Ltd 1990
© Text Dick Ward Associates Limited 1990

First published in Great Britain in 1990
by Macdonald & Co (Publishers) Ltd, London and Sydney
A member of Maxwell Pergamon Publishing Corporation

British Library Cataloguing in Publication Data

Ward, Dick
 Photography for advertising
 1. Photography
 1. Title
 770

 ISBN 0–356–17580–4

Typeset by Bookworm Typesetting, Manchester
Printed and bound in Italy by O.F.S.A.

Editors: Cathy Rubenstein
 Gillian Prince
 Sandy Shepherd
 Sarah Chapman
Art Editor: Muffy Dodson
Designer: Dave Goodman
Production Controller: Caroline Bennett
Photography: Derek Aslett
Project Manager: John Wainwright

Macdonald & Co (Publishers) Ltd, Orbit House
1 New Fetter Lane, London EC4A 1AR

Opposite: Final shot for the Knorr
Chicken Soup ad by photographer
Christine Hanscomb

CONTENTS

INTRODUCTION

Photography is basically a simple process, merely being the effect of light on a chemically-treated surface. The full impact of this simple discovery was not realized for many years, and the early pioneers little dreamt of the multi-billion pound industry their innocent discovery would lead to.

The role of the contemporary commercial photographer is a complex one. Not only does he have to photograph a subject with technical perfection, he also has to create an image with impact from his mind's eye and the view finder of the camera and produce that special image the art director is after.

The essence of advertising generally, and advertising photography in particular, is to turn something which is ostensibly mundane into an exciting and arresting image. The advertising photographer is selling dreams and aspirations – sometimes his own. Commercial photography of this nature means painstakingly creating an elaborate yet intimate image that invites the viewer to almost imagine a story rather than just see the objects in the shot. To have this ability to create an imaginary world, is the mark of a good creative photographer.

In fashion photography, for instance, the photographer must capture spontaneous movement from the models, and at the same time show the clothes to the best advantage. He is often creating more of a mood or a feeling of the clothes than just a straightforward representation of them, and he needs a good rapport with the models to achieve this. Fashion advertising would be extremely boring if the clothes were portrayed on a line of tailor's dummies. In this book, Chris Craymer has created a relaxed yet sophisticated atmosphere which fits the product and the target market perfectly.

Apart from a good rapport with models, a photographer shooting any live-action scene also needs to be skilled in logistics and personnel management, as the campaign for Bergasol describes. It was shot in Barbados by John Bishop, and meant organizing four girls, plus make-up, wardrobe and ancillary crew, to travel to the Caribbean. The images make it look like a holiday, but in fact live scenes like this involve extremely hard work.

One of the most difficult subjects to photograph is children. When this is done for a commercial brief, the difficulties are compounded because the photographer has to achieve a successful image within a deadline, and if the baby or child won't co-operate life can be very difficult indeed! Many people say that successful photographs of children are the result of countless exposures. That may be true, but if the photographer doesn't know his job and does not relate to babies, no matter how many frames are shot, there will not be an acceptable one among them. In the case illustrated in this book, Steve Cavalier has succeeded beyond expectations. The result has been nominated deservedly for two Silver Awards, for Campaign Press, and two Silver D and AD awards.

It is said that photographing animals or children poses similar problems, as neither can be directed! However, for the Sony campaign, Mike Parsons produced a delightful image of an extremely ugly customer!

Landscape photography is another extremely specialized field, and here Duncan Sim demonstrates that it is possible to create a superb photograph from a scene that many wouldn't look twice at for their holiday album. The secret lies in using a large-plate camera, keeping it low and using a set of special filters. Duncan Sim has distinguished himself taking action shots and landscapes in remoter parts of the world, but the excellent example here of an English seaside resort compares favourably with any of them.

Cars have become the most important and highly-prized consumer icon of the 20th century, and the Porsche photography by Jon Cox shows how much trouble has to be taken to create a seemingly impossible image. As a car is a multi-faceted object, the many lights in the studio are positioned to pick up the best features, but the problem is to make sure there are no ugly reflections on even the tiniest piece

A shot by photographer Steve Cavalier
for Abbot Mead Vickers on behalf of the
Leeds Building Society.

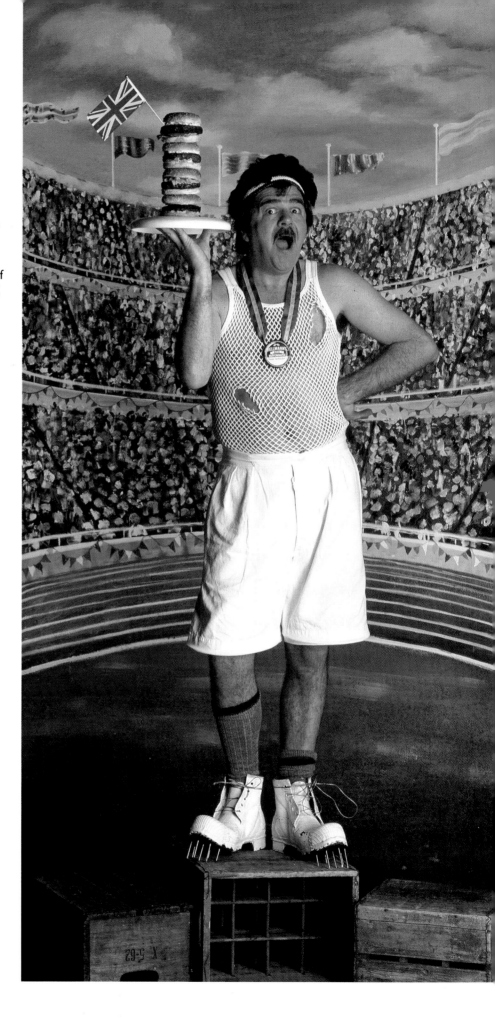

A shot by photographer Steve Cavalier for BMP Davidson Pearce on behalf of Hellmann's Mayonnaise. Hellmann's Mayonnaise is a registered trademark of CPC Int. Inc. USA. Produced in the UK by CPC (UK) Ltd. Registered User.

INTRODUCTION

of chrome trim, and that demands considerable skill.

Interior photography can involve having to build a set specially for the shot. Smallbone did this to show off their latest range of fitted bathrooms. With the interior specialist James Mortimer solving the technical problems with characteristic panache, the result is a controlled and accomplished shot that shows off the product to perfection.

Apart from set-building, model-making is also used extensively in contemporary advertising photography. One of the best examples is the highly-successful, long-running campaign for Benson & Hedges, in which abstract imagery has been employed to cleverly suggest the cigarette packet. Cigarettes used to be advertised in a way that would be totally unacceptable today, with links to sport and social and sexual success. This campaign is one of the most successful of the 'new breed' of cigarette advertising that makes no direct reference to the product, but rather, projects a series of surreal images that hints at the pack.

Matthew Wurr Associates are the modelmakers that have been involved in many of these ads. The featured ad, a shot by John Parker, involved creating an anonymous wood plane. As no recognized manufacturer of woodworking tools would want to be associated with cigarettes, it was essential that the plane couldn't be identified as a brand name. This involved designing a plane that looked like no other, and as every part had to be invented virtually from scratch, the problems were enormous.

The same modelmaking team was called in to make the plate for Christine Hanscomb for the Knorr Soup ad. In this case it was easier to make a plate than try and find one off the shelf that fitted the art director's specifications. Food photography is a highly-specialized field with its own associated problems, and Christine Hanscomb is one of the leading exponents of the art. The shot featured involved a bowl of soup, which doesn't appear too difficult at first sight. But, as with all food photography, the product must be

perfect, so the services of an expert home economist are called for to make the product look as appetising as possible. All adjustments or additions to the product must be within the bounds of the guidelines laid down by the Advertising Standards Authority. So the final image must be a true representation of the product; this isn't necessarily easy, because something that may taste appetising doesn't always look it on film.

Advertising alcohol also presents many problems. Because the subject is a sensitive one, advertisers tend to show an evocative image that suggests the drink, rather than what it might do to the drinker. The idea is to evoke a scene the consumer would like to be associated with, and allow the consumer to make the link with the product and a desirable lifestyle. It is debatable, given the current 'anti-everything-that-might-be-enjoyable' climate prevalent in the western world, how long this style of advertising alcohol can continue before it goes the way of cigarette advertising and simply suggests the pack in an abstract manner.

In the shots for the Seiko ad there was no problem in showing the product, a superbly-crafted sports chronograph, associated with a healthy lifestyle. The photographer's task here was to duplicate the lighting conditions on a location shot with a second shot in the studio. This far from easy task was accomplished with consummate skill by Nadav Kander.

Finally, the last chapter pays tribute to the unsung heroes of the photographic world, the retouchers. There is scarcely an advertising photograph that hasn't been retouched to a lesser or greater degree. In some cases the photographer consults the retoucher before the shoot to find out what is possible and what isn't. It is an art form with new methods being discovered almost daily. As advertising photography is about selling, and more and more unusual imagery is created in an effort to attract the consumer (with the aid of graphic computers and other hi-tech equipment) the retoucher could well become the star of tomorrow.

STILL-LIFE

"The representation of inanimate objects in painting or photography" says the dictionary – but we should always remember Paul Klee's famous observation that "a still life is never still".

In still-life photography, strong visual concepts and meticulous care when presenting the subject are both essential, and the aim is to produce an image of something which may be superficially still but which at the same time has energy and dynamism.

Photographing still-life requires special equipment and techniques. Ideally a large-format view camera holding sheet film should be used, allowing the film and lens to be moved vertically or laterally relative to each other, or to be tilted. Careful use of these adjustments offers complete control over image, perspective and composition, and depth of field and focus, especially at distances below about 2 metres. Lenses tend to be of longer focal length than for many other types of photography because, in close-up, they minimize distortion produced by perspective. Lighting is, of course, critical and a 'suite' of different light sources is generally used, together with both reflected and incident light meters for exposure measurement. A tripod to support the camera, and a still subject, permit the use of very slow films (and therefore longer exposures), providing improved tonal scale, resolution and sharpness.

A self-promotional shot by photographer Barney Edwards demonstrates his ability to create a subtle and sophisticated still-life.

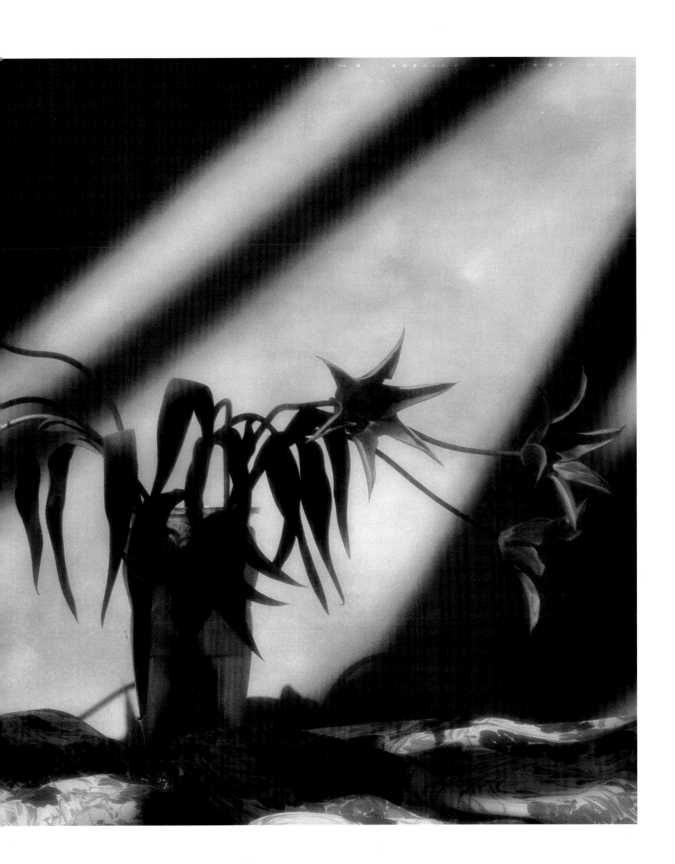

WATERFORD CRYSTAL

THE CLIENT	WATERFORD CRYSTAL
THE BRIEF	TO PRODUCE A HIGH-QUALITY CHRISTMAS AD FOR A TRADITIONAL BUT POPULAR PIECE OF CRYSTAL
THE AGENCY	AMMIRATI & PURIS
ART DIRECTOR	CLEM McCARTHY
PHOTOGRAPHER	BARNEY EDWARDS
AGENT	YOGI
ASSISTANTS	TOM AND ANDY
STYLIST	KIM CROSSMAN

The most important aspect of these ads for Waterford Crystal is that they present an image of quality. Therefore they chose a photographer known for his painstaking and meticulous approach. Barney Edwards is mainly a live-action film director, and he treated this job as if he were shooting a film, spending more than a day lighting and testing the set before shooting in earnest.

For this shot, a stylist/props buyer selected props weeks in advance and the set was built and dressed under the photographer's critical eye. The number and variety of lights was staggering, but the aim was to light as many facets of the crystal as possible, to bring it to life.

The use of an English photographer by a New York agency is symptomatic of the growing internationalism in advertising today. Nevertheless, for an English photographer to bridge the Atlantic is no mean achievement considering the standard of American photographers. Barney Edwards is a perfectionist, spending hours setting up, testing and finally producing a superb finished image that turns an ostensibly mundane object into something that is visually both exciting and attractive.

From the agency's viewpoint the results speak for themselves. Since this campaign was launched, three years ago, sales of Waterford Crystal in the States have increased, and continue to do so.

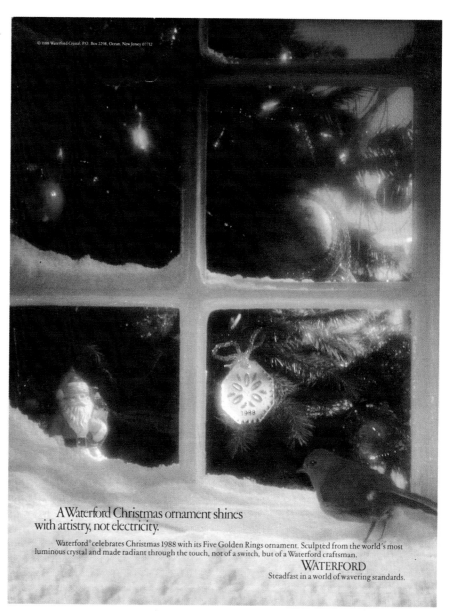

© 1988 Waterford Crystal. P.O. Box 2298, Ocean, New Jersey 07712

A Waterford Christmas ornament shines with artistry, not electricity.

Waterford® celebrates Christmas 1988 with its Five Golden Rings ornament. Sculpted from the world's most luminous crystal and made radiant through the touch, not of a switch, but of a Waterford craftsman.

WATERFORD
Steadfast in a world of wavering standards.

Interview with the Art Director

DICK WARD What was your brief?
CLEM McCARTHY After meeting with the client and discussing what had been done over the past three years we decided what the approach should be this time. Each year a Waterford Christmas ornament had been shot in a different setting: on a mantle hung from holly; next

Above and right: Creative lighting techniques are used to distinguish interior and exterior light and define every facet of the crystal.

to festively-wrapped packages, and interspersed with tinsel on a tree. This year we decided to make the mood more overtly whimsical, with traditional tree decorations and even a 'Father

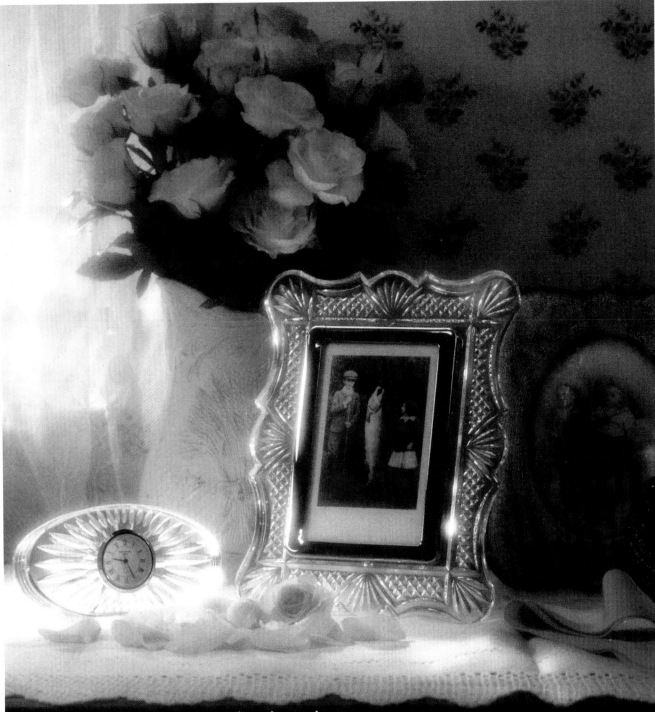

Waterford crystal puts time in settings acknowledged as "timeless."

All Waterford® crystal shares, to quote one connoisseur, "an affinity for timeless beauty."

For the crystal itself has unmatched warmth and luminosity. While Waterford's artistry is such that designs created two centuries ago are still in demand today.

Thus, you can be assured that nothing keeps memories alive quite like a Waterford picture frame.

And that our table clocks not only tell time, but transcend it.

WATERFORD
Steadfast in a world of wavering standards.

A Waterford Christmas ornament shines with artistry, not electricity.

1988

WATERFORD

Christmas' surrounding the Waterford piece. Waterford has introduced a different Christmas-themed ornament every year since 1978. The current '12 days of Christmas' motif began with the 1982 ornament, and the latest ornament featured a 'five golden rings' design. This particular piece was photographed to stand out as the most brilliant and focussed point in the picture.

DW Did you supply Barney with a layout?

CM Yes, but before that the client and I discussed exactly what we intended to show. We decided to feature a Christmas clock and a picture frame. Both the clock and the frame are relatively new additions to Waterford's product collection; therefore the intent with this advertisement was primarily to let people

know these items exist. This intent, however, was tempered by the need to introduce both items in a way that fits in with the perceived, rich heritage of Waterford. I then started work with the writer on headlines, and did a rough layout, liaising with Barney. We had a lot of contact before the actual shoot and I asked him how he thought we should approach it, and then between us we arrived at the rough.

DW So would you describe this as a traditional campaign?

CM Traditional in as much as we are showing the product in a natural environment. Not traditional in that Barney Edwards is shooting them and bringing his own special magic to it. The objects will be shown in a very rich and

Above and right: Clem McCarthy's visual roughs show that highly-finished marker drawings aren't necessary to convey the art director's concept of the ad.

warm setting, like a Victorian Christmas card, that will help to show them off.

DW What is your target market?

CM Both of these ads will be in magazines around Christmas time, so we are aiming for the Christmas gift market.

DW Who are Waterford's rivals?

CM There is a wide variety of machine-made crystal, which could be considered a rival to Waterford, because some consumers aren't aware of the difference between handcut and mass-produced crystal. There is also some good-quality crystal from Yugoslavia and there are

some Swedish brands, but Waterford has always been by far and away the leader. It's sales are the highest in volume compared to those of its competitors.
DW Is your media spread nationwide?
CM Yes, quality magazines in the U.S.
DW Is there any particular reason for choosing an English photographer?
CM It really doesn't make any difference what nationality the photographer happens to be, as long as he can do the job. We looked at a lot of photographers, both American and European, and Barney was one we particularly liked. He brings magic to ordinary objects, and his technique lends itself to producing something very rich.
DW What's your timing after having the rough approved by the client?

CM We had the roughs approved by the client about six weeks ago, and Barney's schedule fitted in nicely with us, so we should have plenty of time.
DW What is the basic target market? Do you have the same breakdown of your market groups in the States as in Britain, in terms of A's B's C's etc?
CM I'm not familiar with the letters. Our target market is mainly women, 18 to 45.
DW What's the strategy?
CM We are following the thesis that Waterford is the finest crystal money can buy. So we have to reach the traditional consumer, who also tends to be the older woman, who is aware of Waterford's timeless qualities. But we realize that there is a new kind of crystal-consumer who doesn't necessarily understand

Waterford's attributes. So we had these two profiles – the traditional consumer who understands the product and the new consumer who we have to educate to its finer qualities. In these particular ads, we are showing that even though Waterford keeps bringing out new designs to keep up with the times, all their designs have qualities that will endure.
DW How do you maintain its market position?
CM Waterford has a classic design tradition dating back for centuries. As long as we keep consumer awareness of the quality of the product, we feel confident about maintaining the brand as market leader.
DW Is there a high client involvement?
CM The client support has been

Handcut Waterford crystal puts time in settings acknowledged as "timeless."

WATERFORD

absolutely terrific. They've given us visits to the factory and good back-up in terms of information and facts, at the same time as allowing us to be the advertising experts. They let us decide what to say about a particular piece, which piece to photograph and which headline to choose. Thus, we decided that the setting for the clock and picture frame advertisement would be traditional, but not old-fashioned – in other words, timeless – and would tie in with the headline: 'Waterford crystal puts time in settings acknowledged as timeless'.

DW How long has Barney Edwards been doing this?

CM About three years.

DW Have the ads been successful?

CM Yes, extremely successful. Sales this year were up 40% – not that we can claim credit for all of that, but when we received this business Waterford's leadership status was threatened. Now it is by far and away the leader in all crystal sales. Retailers keep stocking Waterford and constantly asking for reprints of the ads or trannies to use for publicity.

DW What about point-of-sale?

CM Some of Barney's photography has been used for point-of-sale material because of the enthusiastic response from the retailers.

DW Do you measure the sales in different parts of the States?

CM Yes. New York is the most important market in terms of sales, with Bloomingdales' up by over a million dollars. Other important areas are the West Coast, Dallas/Fort Worth and Chicago.

Interview with the Photographer

DICK WARD What was your brief on Waterford?

BARNEY EDWARDS To make the objects look as attractive and appealing as possible. The way to do it was by

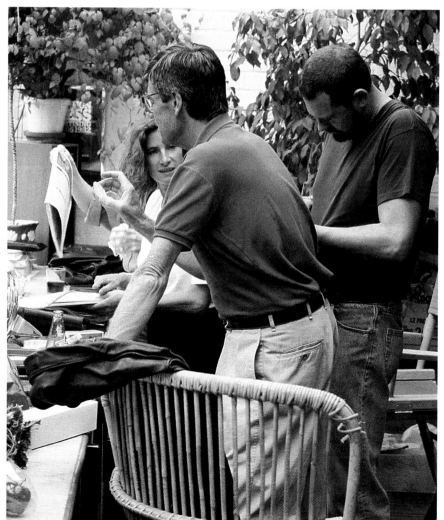

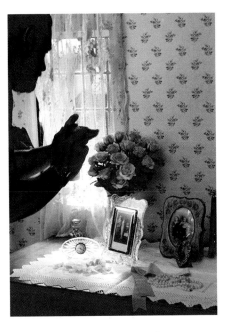

Opposite above: A variety of props assembled for the shoot. *Opposite below:* Clem McCarthy selects props for the first test. *Above left:* The backdrop for the table set. *Above centre:* The window receives a final lick of paint. *Above right:* Barney Edwards sprays moisture on the flowers to help create highlights.

association with other objects. Although the articles are popular as gifts, when they're shot in isolation they don't necessarily look very attractive. So I created a scene around the objects to give ambience and suggest a story. The lightness and freshness of the propping balances the unusual old photograph, to create a setting that is traditional and feminine without being too sentimental.

DW How did you start with this client?
BE I was experimenting some years ago, and produced some flower pictures, really just for myself, and it happened to coincide with the publication of a book called *European Photography* that went out every year. I sent in my flower pictures, and instead of choosing one, as I thought they might, they chose quite a

few. At the time I was doing some work for Ammirati & Puris in New York and I happened to meet the Waterford Crystal clients, who weren't happy with the work they had been getting. One of the art directors saw the *European Photography* book with my flower pictures, and asked me if I could take pictures of Waterford Crystal in that style.

DW What was the first Waterford piece you were asked to photograph?
BE If I remember rightly, it involved a shaving brush. We worked with the clients and created a little scenario to look as if it was early in the morning, in a luxurious bathroom with a marble surface. It is really a matter of doing work in my own personal style and putting Waterford into it.

DW Does the client leave it to you?
BE Yes. I think the most successful stuff has been when they just let me develop my own sense of direction with the object. In fact, when I'm working as a commercials director I am surrounded by dozens of people, but when I'm working as a photographer I'm doing my own lighting, focus pulling, and everything

else. Even though I have an assistant to work with, it's much more of a personal statement. It's enjoyable to work on something where only I have the responsibility for what the thing looks like. Because they allow me to do it my own way, I'm perfectly happy to come back. I do experiment and change things a bit every time, which continues to make it interesting and enjoyable.

DW What about this particular shoot?
BE I find the Christmas ones the most difficult, because every year we are all aware that a Christmas object is such a precise thing that it stops you from looking at it more obliquely. It's always got to be related to Father Christmas. It's the only time in the year I feel inhibited. Although we have Christmas imagery, I've tried to put that aside and think objectively about it. I've always said that, in many ways, it's easier to do a complicated period piece for Christmas, with everyone dressed up in costume, than it is to do this, because when everyone's dressed up it looks good anyway.

DW What's your timing on it?

WATERFORD CRYSTAL

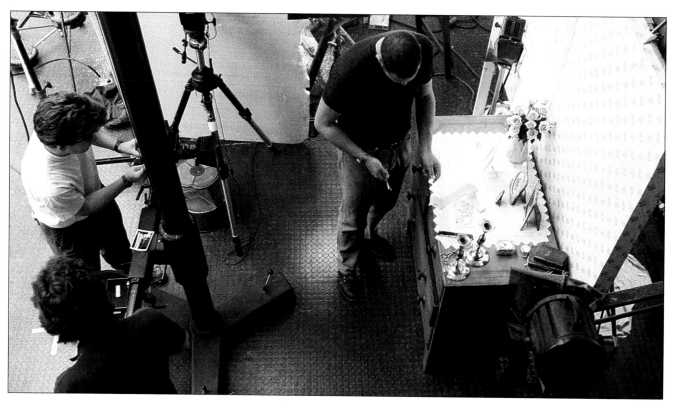

Top: Minute adjustments are made to the set until Barney is satisfied. **Above left:** Barney checks the composition to ensure there are no errors. **Above centre:** Barney discusses a polaroid test with an assistant. **Above right:** Clem and Barney discuss the respective merits of one of the full-size test shots.

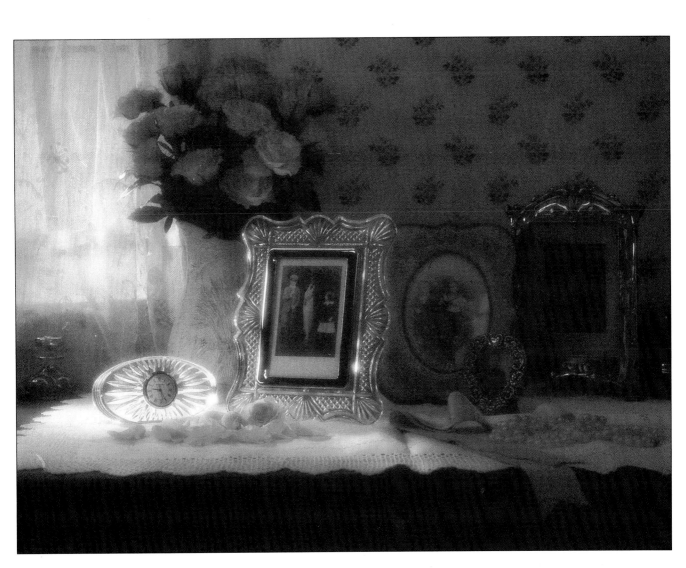

BE They send me the stuff two or three months before we're meant to shoot it, and I slot it in among the commercials. We find a date that works on my schedule – when I've got free time.
DW How long does the shoot take?
BE It usually takes me about a day to get in here and feel like a photographer again! I'll look at the props and do some lighting tests, look at the crystal properly and then the next day I'll do a series of proper tests. The day after that I'll actually shoot the final refined piece. Because I use a mixture of daylight, tungsten and strobe, it takes time for me to test the balance of light and colour. The colour temperature of the daylight is different to the tungsten, and the temperature of the tungsten is different to the strobe.
DW How far in advance do you buy the props, and do you give any directions?
BE They're bought weeks before. But generally what I do is take a wine glass, for example, and ask 'what do we do with a wine glass?' Maybe we should have an association with cheese, or maybe an after-dinner scene or an image during dinner. We make up our own story, then photograph that story. The stylist is very important in getting the story across.

The final shot of the table set – a high quality image obtained after hours of painstaking work.

DW Do you think there are any limitations on a studio shot, or can you create any atmosphere?
BE Any atmosphere can be created and that's what's exciting about this business. You can start with an empty space and create your own world. The problem is knowing that at the end of the day the false world stops and the real world begins again!
DW Do you use your assistant on tests?

19

BE Yes, he's been working with me for years, so he knows roughly what I'm going to do. I tell him what light sources I want to work with, and he sets them up and colour-balances them with me. Then I look at it and say 'change that or change this' as the case may be. We might pull one light out and replace it with another. Usually we overbook the lights – in other words, we order more than we are probably going to need because we can always reduce. We have point source lights, flat–reflected light sources, daylight, and strobe spots on ring flashes.

DW What camera do you use?

BE Mamiya.

DW Lens?

BE 120mm.

DW Any extension rings?

BE No.

DW Film?

BE Two types. Fuji 50 ASA and Kodak 200 ASA.

DW Filters?

BE 1a and a 5 magenta.

DW Why this particular combination of camera, lens and filtration?

BE In order to achieve warm colours and fine grain – a rich, painterly feel to the photograph was what I was aiming for.

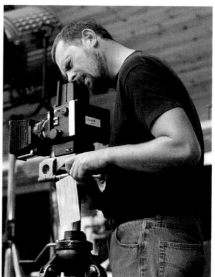

DW The lights and light source?

BE On the image where you're looking through the window, I wanted to get the feeling that the exterior had some light falling on it, while making the interior warmer. So the light was emanating from the window, with all the lighting on one side of the wall for the exterior, and all on the other side for the interior.

DW All tungsten?

BE There is a strobe spot for the robin.

DW Was it going to be a night-time shot

Top left and right, and above right: The tree is dressed with constant reference back to the viewfinder. ***Above left:*** A sieve is used to create textures in the snow (salt). ***Opposite top:*** An assessment is made of reflections off the crystal. ***Opposite top right*** One of the final tests.

outside the window?

BE I started off thinking it should be moonlight. The stylized film look, with the blue on the outside and the warm light on

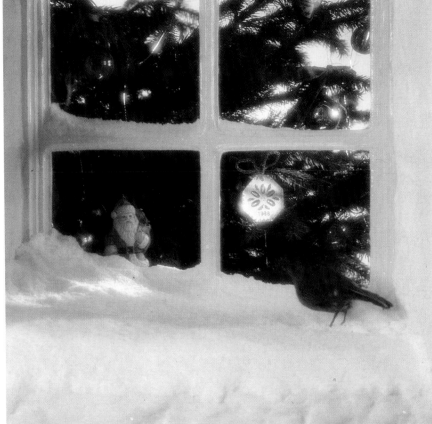

Left: To illuminate the sets, Barney used daylight, tungsten point source and flat-reflected light and a strobe spot (for the robin). Blue filters reduced the warmth of the tungsten to create 'moonlight' beyond the window.

the interior, is a standard way of conveying night-time. But as I developed the picture I thought it should look more like a Victorian illustration, so we cut down on the amount of blue.

Tungsten is basically a warm light, so to avoid a yellow or orange cast in the pictures you have to use blue filters on the lens. This tends to neutralize the warmth of the tungsten lighting, making it more like daylight. We therefore started off with double the amount of blue we needed to make it look like moonlight, then I cut it back to make it neutral.

DW Did you use tungsten for inside?
BE Daylight-balanced tungsten lights.
DW Did you put a light under the lamp?
BE We put a light inside the lamp because there was a possibility the lamp would not appear to glow in the photograph.
DW Did you use a light on the floor?
BE Yes, to light the Christmas tree.
DW Where did you get the background for the table in front of the window?
BE From stock in our studio.

CAMERA	MAMIYA
FILM	FUJI 50 ASA, KODAK 200 ASA
FILTERS	1A, 5 MAGENTA
LENS	120MM
LIGHTS	DAYLIGHT, STROBE SPOT, TUNGSTEN POINT SOURCE LIGHT AND FLAT-REFLECTED LIGHT.

FOOD

Food as a subject matter presents photographers with unique problems. It has to be in pristine condition when the photographer is ready to shoot. But since it takes time to set up a shot, keeping food looking fresh under the photographer's hot lights – particularly a cooked meal – isn't easy, as everyone who has been late for dinner knows!

In addition there is the problem of making the food look perfect to the public. It could take many attempts, for example, to make the perfect fried egg. The yolk must be just right, the white set exactly and the overall shape must look like the kind of egg that everybody would dream of gracing their breakfast plate.

This is where the expert home economist becomes essential to the successful commercial food photographer. The home economist not only has to be an expert cook, but must also have the contacts to enable him or her to find the most obscure vegetable or ingredient, even if it is out of season.

The photographer who chooses to specialize in food also needs to have a fully-equipped kitchen in the studio, with all the appropriate utensils and hardware. The budget for a food shot must therefore allow sufficient time and money for several preparations of dishes.

A versatile and talented photographer such as Christine Hanscomb can turn a relatively simple image into something evocative and romantic, as in this shot of a bottle of Grand Marnier liquer.

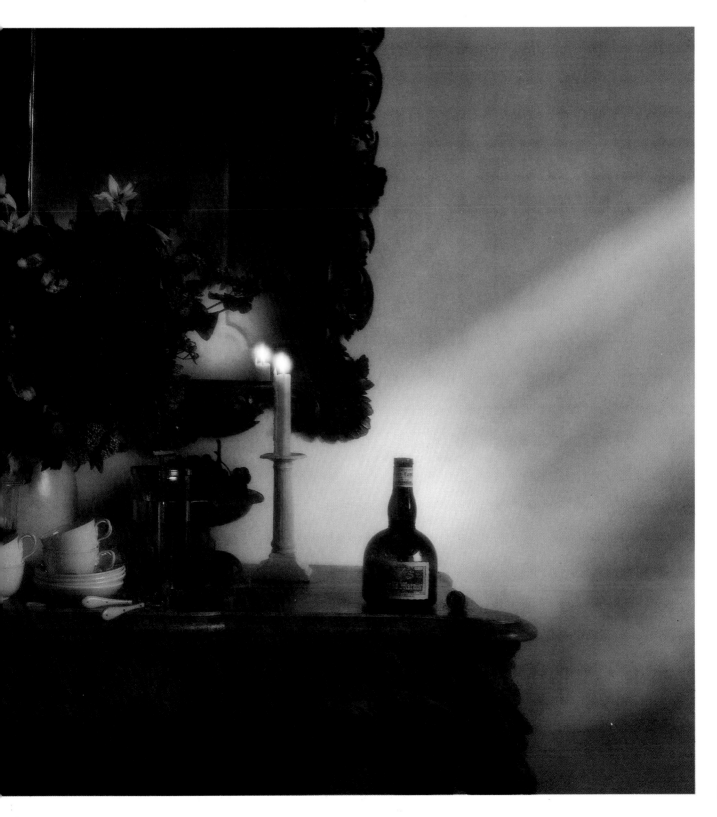

KNORR SOUP

THE CLIENT KNORR SOUP
THE BRIEF TO INTRODUCE THE SOUPS OF THE WORLD RANGE TO EXISTING AND NEW KNORR CONSUMERS
THE AGENCY COLEMAN RSCG
JOINT CREATIVE DIRECTORS ROB MORRIS/ STEVE GROUNDS
CREATIVE TEAM PAUL RIDLEY/ STEVE ELTRINGHAM
PHOTOGRAPHER CHRISTINE HANSCOMB
ASSISTANTS TOM MAIN/ BETH HENDERSON
HOME ECONOMIST LINDA MACLEAN
MODELMAKER MATTHEW WURR

For an image such as this, the photographer will usually light and test for a day before the actual shoot, and the home economist will probably practice several times over to make sure that the particular dish will be perfect on the day of the shoot. There are also several 'tricks of the trade': soup, for example, is often best photographed when it is cold, especially when ingredients are intended to float on the top.

In this particular case there was also a problem in matching the colour of the soup with the pack shot, although this had more to do with the vagaries of the printing process than with the quality of the product. But the advertisers have to beware of the Advertising Standards Authority, who make sure that no artificial ingredients or total falsification are used to sell the product. The product portrayed in an ad must be the product the consumer will find on the supermarket shelf.

In this example there was a model-making element, in as much as the plate was designed to fit the art director's brief. From an art director's point of view, if there are expert model-making facilities at hand it is often easier to 'make' the prop than have a buyer scouring department stores or hire companies to

find an alternative that may be less than adequate. The plate used in this shot started life as a perfectly ordinary, shop-bought article. But it was sandblasted to remove the original glaze, and a white cellulose paint was mixed to match the existing Chinese spoon. The thin blue rim was added and sealed with lacquer. The floral designs and the NSEW symbols were traced down carefully in the correct position and sealed again with two coats of lacquer.

Positive and negative masks were cut to protect the white background, and the designs were then airbrushed onto the surface, using the same blue paint.

Ten coats of lacquer followed to build up a heavy 'glazed' effect, with each coat being rubbed down with wet-and-dry paper. After three days in the drying cabinet the plate was lightly sandblasted with very fine grit and then polished back with 'T cut' (a brand of abrasive car polish) and fine silver polish to give it an authentic antique look.

Interview with the Creative Director

DICK WARD What was your brief on this part of the campaign?
STEVE GROUNDS Knorr have a history of making stocks and soups, stocks in particular, so the whole campaign is based on the fact that you make better tasting stocks and soups using fresh natural ingredients.
DW What made you choose the photographer, Christine Hanscomb?
ROB MORRIS We had seen her portfolio before and she just seemed to be very good at doing food. There seem to be about four or five good food photographers in London, and at any given time there is only one available. We had wanted to use Christine on something before, but she wasn't free. This time she was, so it worked out well.
DW How did you hear of her – was it

through her agent or publicity?
RM It was purely on her past reputation, and mainly because of her calendars that she sends out, which have some really good food shots in them.
DW How many roughs or ideas did you come up with?
RM For the whole campaign, I think we'd done fifty ads before we finally arrived at our solution. We explored various different avenues. We had two different creative teams working on the campaign, so the ideas were whittled down internally before the client saw them.
DW So you brief the creative teams?
RM Yes, us and the account handler.
DW Is there a target market?
SG Primarily those that are already using soup. They will be serving soup, but finding existing soups increasingly less interesting, and so will be more receptive to an expansion in our repertoire.
DW What about market groups?
SG There is a bias toward ABC 1's, around the ages of 35 to 54. Beyond this group we want to talk to those who appreciate the value of Knorr's culinary expertise through other products. These people are interested in trying new food products, especially foreign ones. The objective here is to create an awareness of, and a favourable attitude to, Knorr's Soups of the World range, and to establish distinctive high-quality positioning for the range.
DW What about your timing, from when you get the brief to the time you show the client?
RM We had about a month, from the time we received the input from the planning department to producing and vetting all the creative work and showing the client.
DW Which media will you advertise in?
SG It's the usual spread of good-quality magazines.
DW Is this to reinforce the brand image or sell a new product?

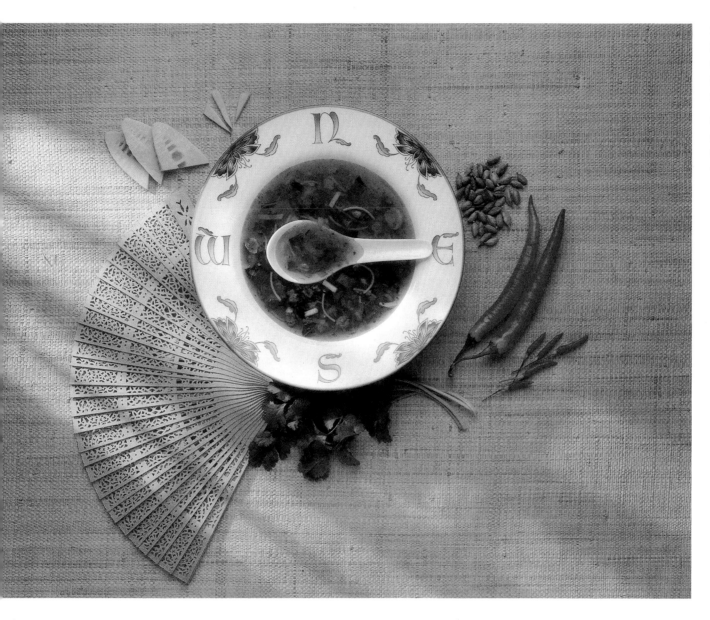

SG It's primarily to reinforce the brand image. The whole campaign is about Knorr Soups of the World. If we are talking about, for example, Chinese Chicken Soup, the ingredients like the mushroom slices, the bamboo shoots and the soy sauce actually come from China and the Far East. Also, there is a Bavarian Vegetable Soup in which the celery and the special noodles come from Bavaria instead of being made up in Norfolk.

Everything has authentic ingredients. The client is very conscious of this marketing point, so what we're trying to do is reinforce the image of a better-tasting soup that is based on quality and genuine ingredients regardless of cost.

For example, there is another type of soup, the 'Cream of' range, where the soup actually contains a roux. Knorr's competitors tend to just put dried butter, dried milk and dried flour into the packet

The final shot for the Chinese Chicken soup ad. A first class example of how subtle lighting and careful propping combine to create a thoroughly convincing image.

and then when the consumer adds boiling water this is supposed to taste like the real thing. Knorr actually make up a proper roux and then freeze-dry it, which makes for a better product.

25

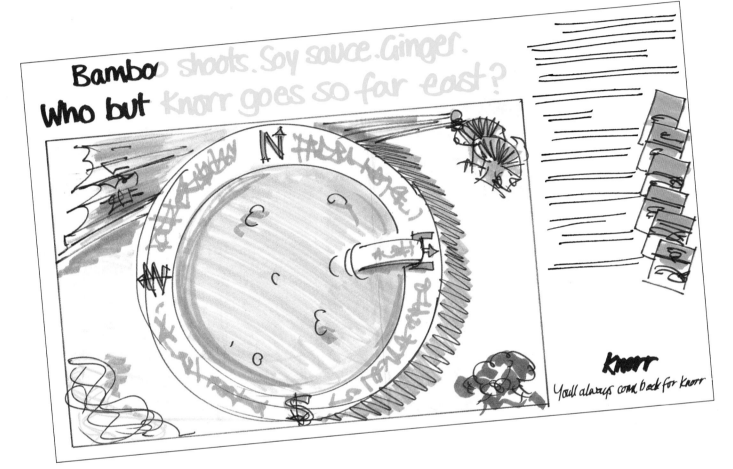

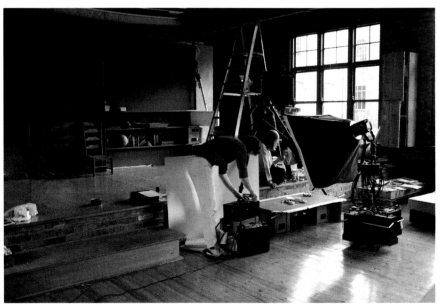

Above: The art director's initial rough establishes basic guidelines for the photographer. **Right:** Setting up for a food shot is a painstaking process, and was completed the previous day to allow time for tests.

DW How long will the campaign run?
RM It's a yearly campaign, but that's not to say we won't build on it and add other recipes as the client produces them.
DW Has it been measurably successful?
SG It's a bit too early to say, as the first ads have only just started running.

Interview with the Photographer

DICK WARD What was your brief on this particular job?

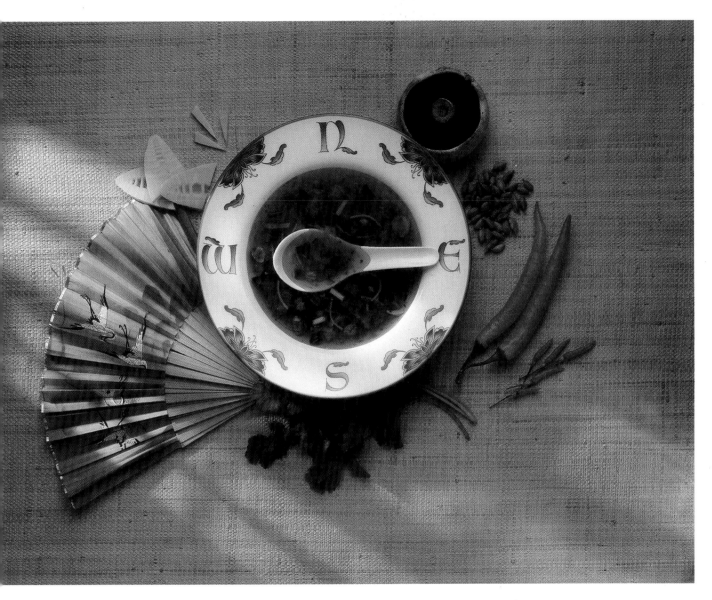

CHRISTINE HANSCOMB The major concern was to have the food looking absolutely perfect. In advertising photography that is usually the main concern.

DW Is that left entirely up to you, or is the client at the shoot?

CH On most shoots the art director is there to keep an eye on everything. In this case, the actual client from Knorr did come to the session, but this is a very unusual occurance.

DW Do you prefer having the client on the set?

CH Usually we say no because we prefer not to have the client. But he didn't stay all day, only for half an hour or so, and in the end it actually was quite useful because he was able to say basically whether he liked it or not. So it saved any reshoots or problems later on.

DW How did you prepare the soup for the shoot?

CH The home economist made the real

The client wanted this shot for the finished ad, although it wasn't the photographer's or agency's selection.

thing using fresh vegetables, so we could see how it looked. We then made the packet soup to get it to look just like the real thing.

DW Do you always have to do this?

CH In this case the Chinese Chicken was absolutely as depicted on the pack, and wasn't doctored. The only thing we had

KNORR SOUP

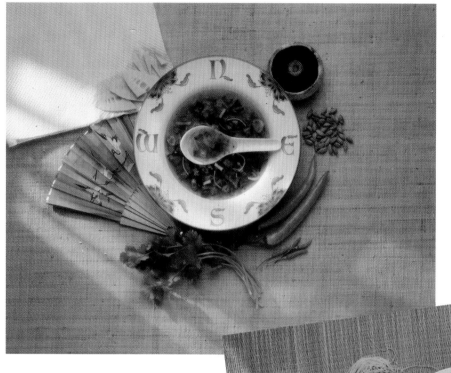

photograph. I enjoy photographing still-lifes and people – sets and interiors and things that demand a technical challenge. I enjoy solving problems.

DW What was your timing on this?

CH We had two days on each shot, and there were six in the whole campaign. The home economist was in for one day per shot. The main shot was done in one day and the day before was spent testing, setting up and pre-lighting.

DW How do you test?

CH We spend a day setting up the lights and sorting out the props, making sure the ingredients are all ready, and mocking up the soup. I'll work out the lighting and

to do was to put in some gelatine to keep the ingredients buoyant, because we simply wouldn't have been able to see anything otherwise.

DW Is that what makes them float in the bowl?

CH Yes, otherwise the ingredients sit on the bottom and cannot be seen. You can stir the soup and see the ingredients, but you'd never catch that on camera. We also photographed it cold.

DW Are there any other tricks of the trade?

CH Plenty, although always in food products one has to use the real product. But, for example, if one of the ingredients happened to be peas, and they were a little mashed up, then you might have to add fresh peas, but you would leave the main body of the product as it is.

DW Do you specialize in food photography?

CH I guess I am more known for food photography than anything else, but that is not to say that it is the only thing I

Top and above: Numerous polaroid tests were made on the shoot, primarily to establish the composition of the subject.

how the props work together, check the angle and composition, and choose the lens. So the following day, when the home economist comes, it's all ready to go, apart from the food. In some cases the timing might vary. Sometimes, on a long shoot, the home economist might be here for a week, but on this job the budget allowed her one day per subject.

DW Did you get a rough to go by?
CH Yes, we had a layout, but it was adaptable to a degree.
DW What other particular problems do you get when you are shooting food?
CH The obvious thing is speed, because you can't let the food hang around for days. It's not like any other still-life, where it's possible to leave something set up and come back to it, look at it again and again and play about with it. It has got to be shot fresh. Even raw ingredients will start to dry up after a short space of time. Also, trying to show the actual food as representing what the customer is going to get is difficult. There are strong restrictions imposed by the Trades Descriptions Act which prevent you from interfering with a product, but in some instances you have to do something to make a product look attractive. So, as I mentioned earlier, gelatine was added to ensure the buoyancy of the ingredients. However, this isn't always the case. In some jobs the client might just want the pack shown, so then it becomes like any other still life.
DW Do you use a props-buyer?

A test shot made during the final stages of composition. Note how the spoon is positioned at the same angle as in the final shot, even though the soup has yet to be added.

CH Yes, I find it's necessary, even for what may appear to be a simple one-off purchase, like a plate. There are often problems where the agency or the client might not like the prop, and it's possible to spend all day trying to find one plate.
DW Is creating a certain atmosphere part of your brief?

29

KNORR SOUP

CH Yes. Hopefully people come to me for a particular style – I enjoy food and believe this affinity with the product has helped me in my work – and a particular look, and because they like certain pictures in my portfolio.

DW Would you describe this particular job as rushed?

CH No. I just don't like having only one day to shoot, I don't like things arriving on the day that I'm shooting. I like to have at least one day beforehand when everything is in-house and everything can be put together. And if there are home economists or actors involved I like to set it up the day before, because often there are unknown and unforeseen problems which are important to solve before you're ready to shoot. For instance, you might suddenly decide that you want to shoot on a different lens, but until you actually set it up and look through the camera and see what the problems are, you can't visualize it. If we are going to need other lights, different lenses, different cameras or different formats I'd rather get that organized the day before so that when everybody arrives we are all ready to go.

DW What camera do you use?
CH On this one I used a Gandolphi 10×8
DW Is that a plate camera?
CH Yes. Basically it's a field camera, but it is fine for what we did on Knorr. A field camera is, as it implies, for the field or on location. Because of its simple structure

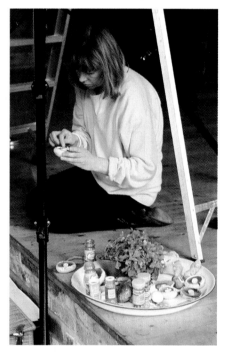

of lightweight wood its movements are limited, compared to, say, a Sinar, the Swiss-made studio camera. However, in this situation, with min/max depth of field, we had no need for movements. So the 10×8 Gandolphi was adequate – although normally I might use the Sinar, with its wider capabilities.

DW What about the lens?
CH CH150 Zeiss. The pictures for this campaign were essentially two–rather than three–dimensional, so there were no depth of field problems, and a standard lens was the natural choice.

DW Filters?
CH Stocking plus 1 or 10Y cc. The stocking diffuses and slightly softens the image reaching the film, and the combination of these two colour correction filters has a warming effect.

DW What film did you use on Knorr?
CH Kodak 6 11 7 for 10×8. I chose this because the shoot posed no particular film speed difficulties, and at 64 ASA the pictures would be acceptably sharp.

DW How did you light it?
CH With an 8000 Bowens, which is a flashlight.

DW Did you have a focusing light?

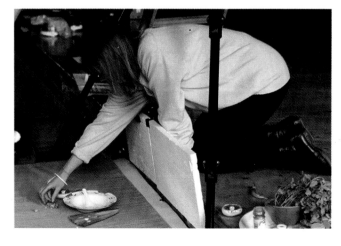

Top: Photographer Christine Hanscomb tries to find the 'perfect' mushroom.

Above left: The photographer makes the final decision on placing props to create the perfect composition.

Above right: The props buyer provides an ample selection from which the photographer can make a selection.

Above: The plate is carefully examined to ensure it is convincing. **Left:** All specialist food photographers must have a fully-equipped kitchen in their studio.

CH No, it wasn't necessary here, but we did have two spot lights and mizar tungsten. This choice was dictated by the need to compensate for the neutral light produced by the Bowens' flash with the warmth of tungsten.

DW How did you position the camera?

CH It was over the top of the plate on a Gitzo tripod.

DW What about the strength of the three lights?

CH One was 8000, and the other two were 2000 joules 750 spotlights.

Above: Even minor props, such as the parsley, are checked to ensure they are in pristine condition for the shot.

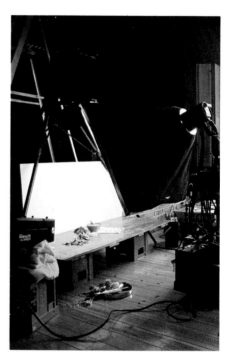

Below: To illuminate the subject, Christine used an 8000 Bowens flashlight plus two spots and a mizar tungsten. The neutral light of the Bowens compensated for the warmth of the tungsten and a reflector was positioned opposite the main flash head to bounce light onto the subject, thereby giving a better balance to the overall light.

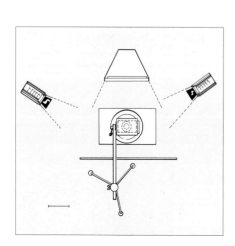

Top left: Careful positioning of a spot is a key to effective lighting. **Top centre:** Checking composition can involve quite a climb! **Top right:** The set is complete and ready for the shot. **Above:** All four shots are examined to see if they work together. **Right:** The Chicken Noodle shot shows the consistent quality that flows throughout the series of the Knorr ads.

DW How did you place them?

CH One was from the righthand side, and the other two were opposite.

DW Did you use any reflectors?

CH Yes, there was one opposite the main flash head to bounce light onto the subject – overall, this balances the light better than having flash operate directly on the subject.

DW What about speed?

CH We gave it a time exposure, so the setting was T and we used about four flashes and 20 seconds exposure.

DW Aperture?

CH 45.

DW Are all the technical decisions left to you?

CH Yes, apart from the art director saying that he might want the soup a bit brighter, or something moved, or something darkened. But it is still a technical decision, because I have to decide how I'm going to achieve what he wants.

DW How many people do you have on the set?

CH Myself and two assistants, the home economist, the stylist and the art director and, in this case, the actual client.

CAMERA	GANDOLPHI 10×8
FILM	KODAK 6 11 7, 10×8
FILTERS	A STOCKING
LENS	150 ZEISS
LIGHTS	8000 BOWENS (FLASHLIGHT), TWO SPOTLIGHTS, ONE MIZAR TUNGSTEN BOWENS

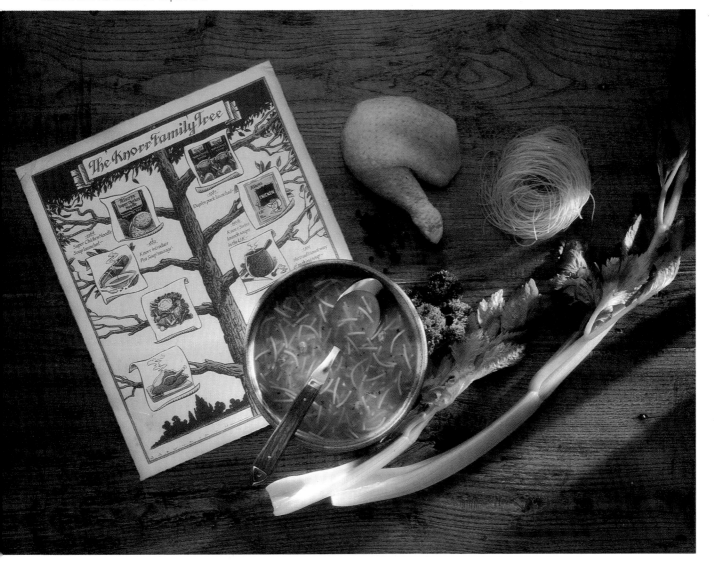

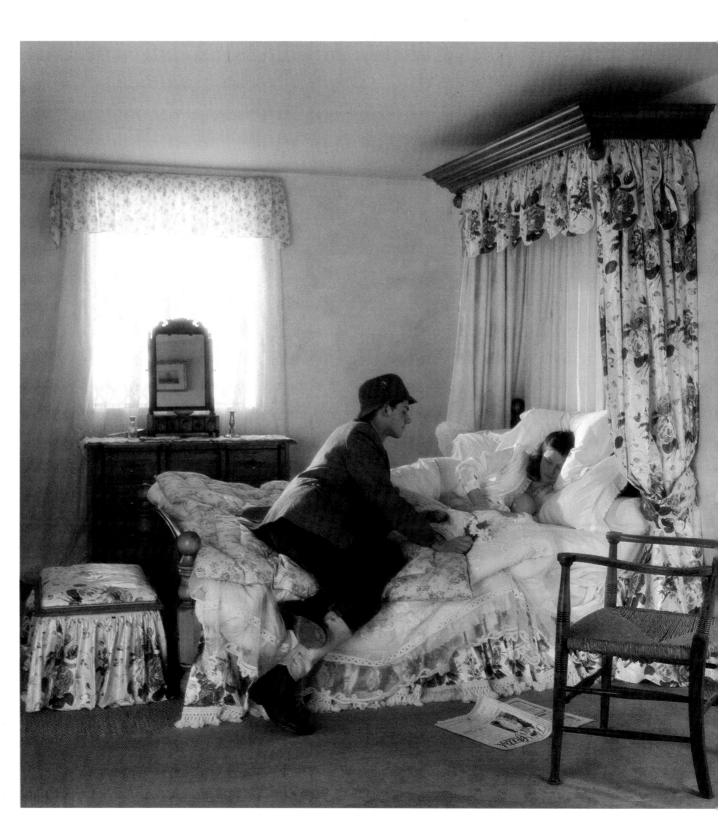

One of the major differences between interior photography and location work is that the former affords considerable control over the working environment, whereas the latter often presents compositional and lighting restrictions that are difficult to overcome on site. In the studio the photographer has more of a free hand to create his own effects, without having to worry about interference from the weather – a freedom that applies whether he is working with an existing interior or a purpose-built set.

However, existing interiors are not without their restrictions. The photographer must create whatever effect that is required within an environment that can't be interfered with to any great degree. For example, it would be unacceptable to substantially alter someone's property simply to create a particular effect – unless of course a deal has been struck whereby the owners of the property have agreed to wholesale changes, such as complete redecoration, in advance and at the hirer's expense.

Indeed, it is often the substantial costs of such arrangements that make set-building in a studio a more economical and therefore preferable alternative, especially if finding and travelling to a location are taken into account. Moreover, if a set is built from scratch the photographer can, working from the art director's roughs and in conjunction with the set-builders, eliminate various lighting difficulties and establish an appropriate composition and atmosphere from the outset.

A shot by photographer John Mortimer taken for 'And so to Bed Ltd.', inspired by a painting, 'The First Born', by Fred Elwell.

SMALLBONE

THE CLIENT SMALLBONE
THE BRIEF TO REINFORCE THE
SALES OF
TRADITIONAL,
HANDPAINTED, HIGH-
QUALITY INTERIOR
FITTINGS
ART DIRECTOR PETER SHEPHERD
PHOTOGRAPHER JAMES MORTIMER
ASSISTANT TIM KENT
SET BUILDERS TIM, PAUL
PAINTER ERIC

For this campaign the client, Smallbone (who were acting as their own agency), felt that it was imperative that the new product they wished to launch was shown in a modern setting. So, because a suitable location couldn't be found, they decided to build a set in the studio.

However, shooting in a specially constructed set can present as many problems as shooting on location. In this instance, the photographer wanted to artificially create the effects of natural daylight and, at the same time, make the set as visually inviting as possible. This created particular lighting difficulties – notably the need to overcome complicated reflections created by numerous mirrors used throughout the set. The solution to these problems demanded a high level of ingenuity and competence on the part of the photographer.

Interview with the Art Director

DICK WARD You work for Smallbone, so you don't actually have an advertising agency?

PETER SHEPHERD As we manufacture everything ourselves, and have our own showrooms, installers and advertising department, it seems logical to handle all our own advertising as well.

DW Have you ever used an advertising agency?

PS Yes, and they turned out a clever campaign, but it wasn't really close enough to the company. For five years my job has been to know about every aspect of the business and know what points need to be sold at any given time. We've found that this way we get a much more responsive approach to the manufacturing and sales needs of the company.

DW Who actually comes up with the first concept on each campaign?

PS We don't have a campaign as such, but have had continuous advertising for about five years. Continuity, as far as we are concerned, is extremely important. Suddenly saying 'this is next year's campaign', isn't particularly helpful when you are trying to show continuity of design and tradition. I designed the basic format several years ago, and although we constantly modify it, change the type face slightly, or add a caption and make minor modifications, it is well known. The most important thing is the photography.

DW How many basic roughs or ideas do you come up with?

PS We have a basic structure for the advertising. On single pages it's a headline with a subhead, large picture, caption, lists of showrooms and a coupon. We've debated whether to get rid of the coupon for some time, as it's thought not to be the classiest thing in the world – so it's designed to look as editorial as possible.

DW Is that how you measure the response to the ads?

PS We closely monitor the response we get from each ad, which tells us if a particular range, photograph or look is a success. This helps us decide what we will do next, and it also helps to tell us how the magazines are doing for us.

DW When you were with the agency did they use a coupon?

PS I wasn't with the company then, but there always has been a coupon, as it's a business which depends on a direct sales operation.

DW What about your target market?

PS People who have houses that are worth over a certain amount of money – say £300,000 in London, and rather less than that in the provinces – and which go up in value every year. Traditionally,

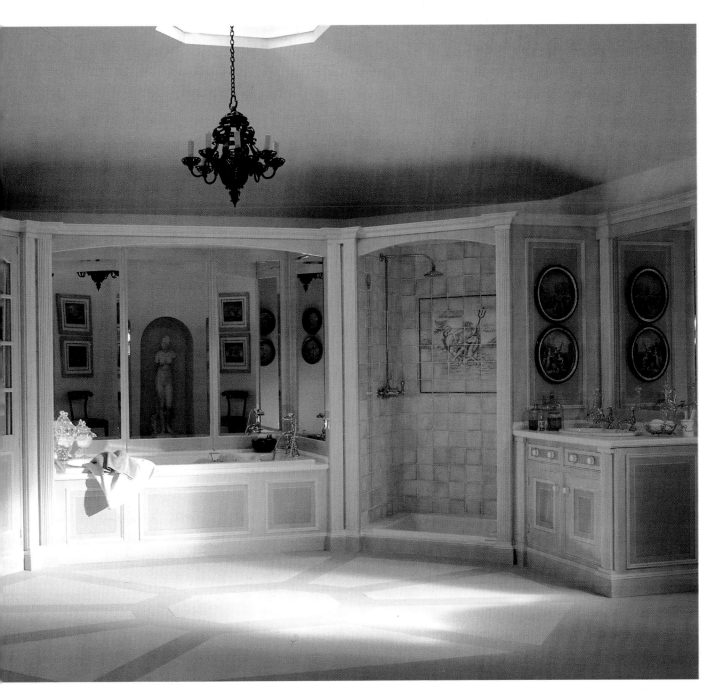

advertising people would classify them demographically as ABC 1s, but outside that group there are many people who can and do buy Smallbone.

DW So the cross-section is the top end of the market?

PS Yes, our market is those people who tend to read the top magazines that deal with interior design, like *Homes and Gardens* and *Interiors*.

DW What will be the media approach in the States?

The final shot for the Smallbone ad suggests the presence of natural light and, with the help of carefully placed props, a convincingly realistic interior.

PS We have modified it slightly for the States, as it's a new market for Smallbone. The captions have been changed a little and the copy is used to promote the Smallbone name and particular aspects of the business, such as the fact that we distribute nationally to a far greater extent than in the UK, where our name is already well-known. Also, it is important to get across the fact that the furniture is actually made in England. In England, all the advertising is supposed to do is bring in an initial inquiry. What we want to do is make sure people know who Smallbone is, and get across the fact that the product is handmade. The photograph is meant to stimulate people to send off the coupon and see the brochure, which is the critical selling tool. The brochure goes into a lot more detail about what we do, so the advertising is supposed to have only an initial effect.

DW Do you use James Mortimer on the brochure as well?

PS Yes, when we shoot advertising photographs they eventually go into the brochure. The photographs that we use are a mixture of sets and showrooms, although we used to do most of the photography in people's houses.

DW What made you change to using sets?

PS Basically, we found that particular architectural features in houses can suddenly become unfashionable. The good thing about sets is that they can be very immediate. We can actually decide this is what we want to do now. In fact our advertising sets tend to influence people as to what they actually build in their houses.

DW Will you be adjusting your image to the current trend toward 'hi-tech' and laminates?

PS There used to be a big demand for

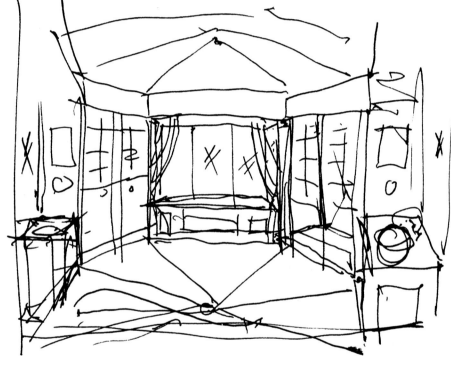

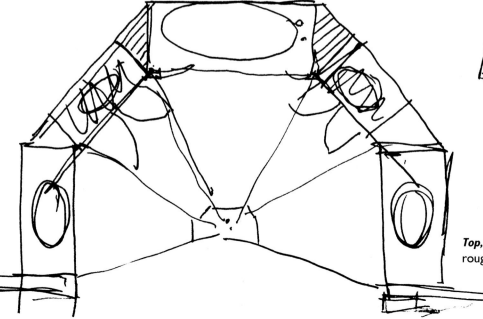

Top, left and above: The Art Director's roughs establish the basic look of the set.

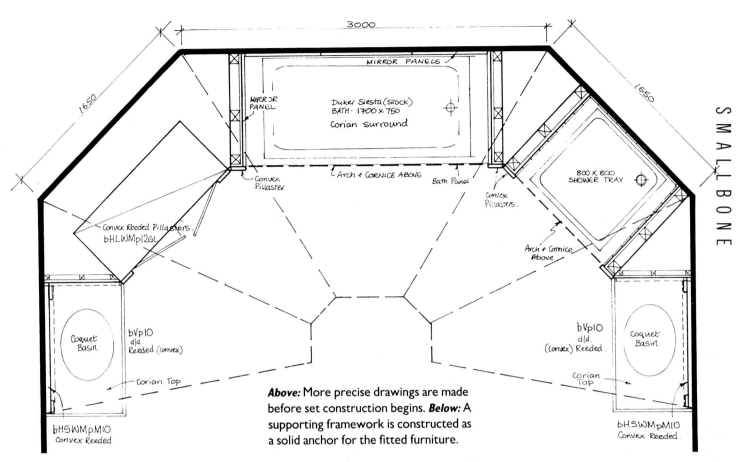

3000

1650 **1650**

MIRROR PANELS

MIRROR PANEL

Duker Siesta (STOCK)
BATH - 1700 X 750
Corian surround

800 X 800
SHOWER TRAY

Convex Pillaster

Arch & Cornice ABOVE

Bath Panel

Convex Pillasters.

Convex Reeded Pillasters
bHLWMp12GL

Arch & Cornice Above

Coquet Basin.

bVp10
d/a
Reeded (convex)

bVp10
d/d.
(convex) Reeded.

Coquet Basin.

Corian Top

Corian Top

bHSWMpM10
Convex Reeded

bHSWMpM10
Convex Reeded.

Above: More precise drawings are made before set construction begins. **Below:** A supporting framework is constructed as a solid anchor for the fitted furniture.

'high-tech' kitchens in 1980 when Smallbone first began. German kitchens totally dominated the top end of the market and what Smallbone have done is to push the frontiers right back. We don't see a lot of competition at the moment from 'hi-tech' laminated kitchens. I'm not an anti-modernist, or saying that I like only traditional things, but if you have an expensive house in this country it is reasonably unlikely that it will be modern. Most of them have traditional mouldings and cornices and all the architectural features you would expect from an old house. So putting in a 'hi-tech' kitchen and treating it as a laboratory isn't what most people want. They want kitchens and fitted furniture that reflect the architectural features and the quality of the property.

DW How do you decide what you're going to shoot for each ad?

PS We were actually planning this particular ad three months ago, and as we're tying to show a new layout there were a lot of problems. For example, we

had to design the semi-octagonal set in such a way that the camera and lighting equipment wasn't reflected in the mirrors – which is always a problem in bathrooms. But when such problems are finally resolved the set gets built in a

week, although sometimes the painting means that it takes a little longer. We try and use a set as an opportunity for experimentation. In this case we're showing green and cream together. The layout of the room and the lighting are

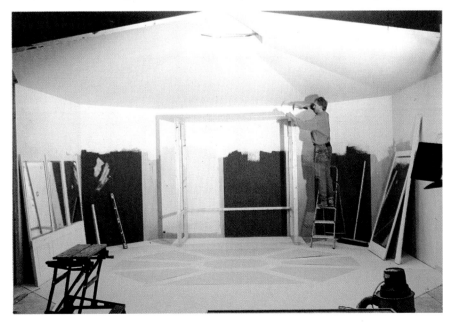

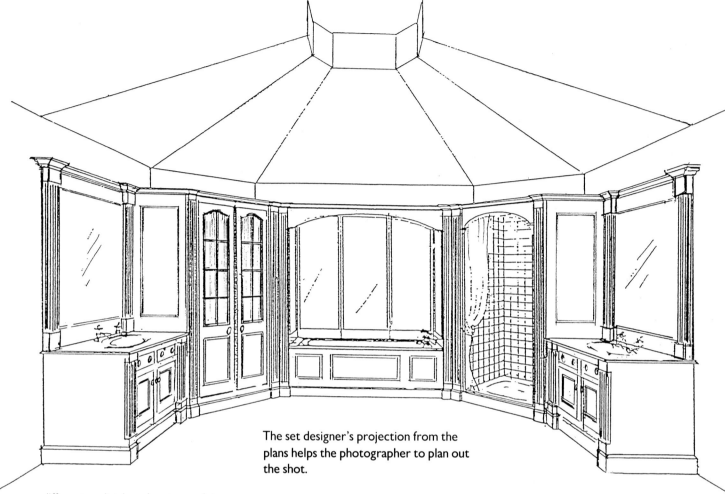

The set designer's projection from the plans helps the photographer to plan out the shot.

different, so it takes about a week to build, about a week to paint, and a week to photograph. That's assuming there are no unforeseen problems. When we photograph a set, we always leave it up for another week in case we need to reshoot.

DW How long does each ad run?

PS As long as there is a lot of interest in, and response from, the magazine. As soon as it falls away we stop using it.

DW How many people are involved in a shoot?

PS We use two set-builders and then two fitters. We employ the fitters, and use freelance set-builders, for all our set building.

DW Do you advertise on the continent?

PS No, we haven't advertised in Europe. At this stage it isn't the market we're aiming for — we'd rather establish ourselves in the States. We sell an English look which is successful in America, particularly on the East Coast. The English

The furniture is masked off and the walls are given two or three coats of paint.

Masks are used to create the desired pattern on the floor.

look is what people like, it's fashionable over there, and our furniture looks quite 'New England' anyway.

DW Any particular reason for that?

PS There are logistical problems and language difficulties. When we go to someone's house, the special designs have to be made. Then they have to be shipped out and delivered. And we have to find fitters and painters who are reliable, so it's not easy. However, we've had some business in the South of France and we've done a kitchen in Italy.

Interview with the Photographer

DICK WARD What was your brief?

JAMES MORTIMER Just to make the furniture look nice – some of the stuff we've done for Smallbone has been quite avant-garde and often wins awards.

DW What was the timing on the whole shoot?

JM It's a difficult question. We should have shot these things before Christmas, but there's an enormous amount of work to make the products in the factory, as they are all new – and some are almost in the prototype stage.

DW So they are all made specifically for the shot?

JM Yes, and sometimes they are actually put up in Mr Smallbone's kitchen, because to build a set is almost as expensive as building a real kitchen. Also, the cupboards have painted finishes, and can't be painted until they are erected on site, so we're in the studio for far longer than you'd think.

DW We don't mention money, but when you quote do you quote for the whole time you are involved? In other words if the set takes a long time to build do you get paid?

JM In that case I charge a day rate, which we negotiate. They keep on paying me

the day rate, but on occasions, if it goes over the estimated time, we do a deal, and I might charge a half-day rate.

DW Do you have any input in the set design?

JM With these, no, because they are actually made in the factory. But on some sets, which are made up on site, yes, very much so.

DW You have actually designed how the set's going to work?

JM We've discussed it and worked it out with drawings and sketches. But where it concerns fitted furniture, that's almost always the client's job.

DW What's the timing from the brief to the shooting?

JM We were discussing this shoot about four months ago.

DW How do you begin to approach something like this – do you look at the room set after it's built, or the location, or look at the plan? How do you decide how

All the colours for the set are custom-mixed; not taken straight from the can.

The floor is covered for protection as the rest of the set begins to take shape.

you're going to light it?

JM Basically there are two ways we could have done it – as a night shot, or as if it were daylight. In this case we needed a lot of daylight as we were using a lot of very elaborate mirror reflections reflecting backwards and forwards. We've often given ourselves enormous problems when incorporating multiple reflections – sometimes so many of them that people think we're mad. But in the end it looks nice. Some people can't believe that they are shot in the studio, because the reflections show all sorts of things, which make it look just like a location scene.

DW Does this apply to this particular job?

JM Not particularly, but we have got a lot of reflections. The terrible thing is that modern mirrors often give distorted

The finishing touches are made to the floor.

reflections. Although they're bevelled and look very nice they distort badly, making every reflection curved.

DW How did you get your reputation for doing interiors?

JM Way back in the 1960s, when nobody did interiors very much, I used to work for *House and Garden*, and did things with elaborate sets. When I look back on them they were dreadful. Elaborate sets are very expensive because they involved the photographer's time, the studio time and time to build the set. The ceiling in the one were doing now is a set-builder's nightmare, because it is an octagonal ceiling with arches.

DW How long did it take to build?

JM They prefabricated some of it beforehand but it actually took about ten days, because it involved not only set builders but also painters and the Smallbone fitters. There was a big team.

DW What kind of problems do you anticipate when doing an interior shot like this?

JM Is the studio big enough to contain the set? In actual fact I would have liked to get the lights much further back in this one. Sometimes, the elaborate paint effects don't show up, or we find that the colours have not come out quite as they had been envisaged. They have even gone as far as changing the colours completely and repainting them so that they come out correctly on the film.

DW That's after you've done a colour test?

JM Yes, after we've done a colour test we have been known to change the colour quite drastically in some instances. This means quite a lot of work, particularly, when you have dragged and stippled effects.

DW Is that because of the colour corrections on the film?

JM No, but the art director has thought, when he's seen the shot, that it's not the colour it should be. Sometimes even with filtration it's still not right, so we change it until it comes out the way he wants.

DW How do you test then?

JM You try to do it as early as possible, but it is difficult to get in there until the set is actually finished and painted.

DW What lighting do you use?

JM Mixed lighting, quite often tungsten and flash and HMI.

DW What's HMI?

JM I forget what HMI stands for, but it's a sort of daylight spotlight with a single bulb which produces pure daylight. The light in a studio set is usually mixed, with funny light sources and with little Norman flashes (very small, low – powered electronic flash guns) lighting up bits here and there. This means that quite a lot can go wrong in the colours. But if it's completely wrong I can either filter it or adjust my lighting.

DW Do you have your trannies sent back from the lab in a rush turnaround, or do you also test with polaroids?

JM Polaroids are useless for testing colour – they can tell you if the lighting balance is

all right, but that's all.

DW Do you get a rough to work from?

JM Yes, but it often bears no relation to the shot. In this case it did to a certain extent, because the sets were tight and had to be fitted to the space. With fitted furniture you are limited, as you can't alter its position.

DW So you must always move the camera?

JM We have been known to alter the set, when we've got the camera up. One instance was when we had a set that was

Left: Realistic 'cracks' are painted on the statue. **Below left:** This corner, only visible reflected in a mirror, was finished as carefully as more prominent areas. **Right:** The art director selects from the props. **Below right:** Numerous props were supplied.

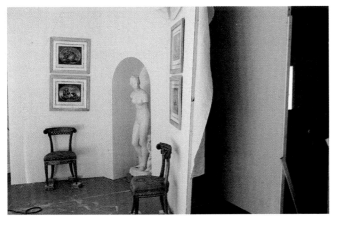

very tall – some 16 feet. It was a shot based on the Princess and the Pea, but even that wasn't tall enough for what I wanted to do, so we had to raise the whole set, which added another three or four days to the shoot.

DW What's your camera?

JM Mainly we've been shooting on 2 1/4 square Hasselblad, because we've had so many variations. I decided that the results were just as good as using 4×5.

DW Would most photographers use a larger format?

JM Sometimes I have used a 10×8 plate camera, as well as a 4×5, but I think a lot of photographers are amazed by the size of a 10×8 film. It's wonderful to get a big trannie like that and they forget about the creative side of it. If you're doing hundreds of sheets of film, it costs a lot of money. I believe that if you have a good platemaker and good printer it doesn't make any difference at all. I also feel I have more freedom, being able to suddenly change the lights, and do several more shots, and a 2 1/4 is good for that.

DW What lens do you use?

JM 50mm.

DW What film?

JM I was using Fuji 100 d.

DW Any reason for that?

JM We have a green set and we seem to find good results with Fuji as far as greens go, and it appears to be more consistent than Kodak.

DW What about aperture and speed?

JM Aperture is about 11.5 and speed is related to the HMI; an 8th of a second. Although it's not as simple as that. Sometimes we use a switching-off technique, in which we switch off the HMI and give a long exposure under another light, and add or subtract light as necessary. The trouble is, if you switch off the HMI it takes time to warm up again.

DW Any filters?

JM A five cyan. Cyan is a blue-green subtractive colour, complimentary to red.

It transmits the blue and green components of white light, but not the red component – so photographed greens appear more acidic.

DW Lights and light source?

JM A trace laid about three inches from the ceiling, over a skylight that we made. The trace helped to make it an oval shape. The 2.5 HMI makes a pool of light on the floor.

DW Is that to suggest sun light?

JM It gets more complicated. Some of this light is shielded off with bits of grid spot, some has coloured gels, such as blue and cyan. So the light is not direct from the HMI but fiddled with a lot. There are bits and pieces of filters and gel all over the barn doors (the metal flaps on the front of the lamp which control the way the light falls). We wanted it to look as if there was really bright light coming down and scattering all over the floor, and to suggest that it was coming from a skylight.

In front of the camera there had to be some fill in (flash or reflector light used to lighten the shadows in a picture). So underneath the camera there is a circular

Top left: The set is dressed to create a 'lived-in' feel. ***Top right:*** Final adjustments are made to the floor. ***Above:*** The set is checked for subtle errors through the viewfinder.

44

reflector, and the camera is hidden from the mirrors by two flats which are painted the same colour as the rest of the set. This leaves just enough room for the camera to poke through the angle of them. In front of the camera, and low down, is the only place you can put any light at all without it being reflected in one of the mirrors. I use a tiny Norman flash, which is only 100 joules, bounced into a reflector.

It's difficult to get such a small amount of power on a big flash unit, and the heads on the Norman are so versatile that you can stick them anywhere. They are also battery-powered, so are good on location.

DW You have a very crowded set – is there any particular way you control it?

JM To stop people falling over sync leads (the electronic cabling which ensures that the lighting units are triggered in sync with the camera shutter) all the lights are triggered off by an infra-red flash lead, a little flash gun mounted on the camera, which I find very useful.

DW Are all technical decisions left to you?

JM Yes, but occasionally they might ask if we could put in some more light or make something a little darker.

DW How many people are there on the set?

JM Me, the assistant and the art director. Because of the problems of keeping control of even the smallest matters of detail on this type of set, we find that minimizing numbers is for the best.

CAMERA	2¼ SQUARE HASSELBLAD
FILM	FUJI 100 d
FILTERS	5 CYAN
LENS	50mm
LIGHTS	NORMAN FLASH TUNGSTEN, FLASH, AND HMI

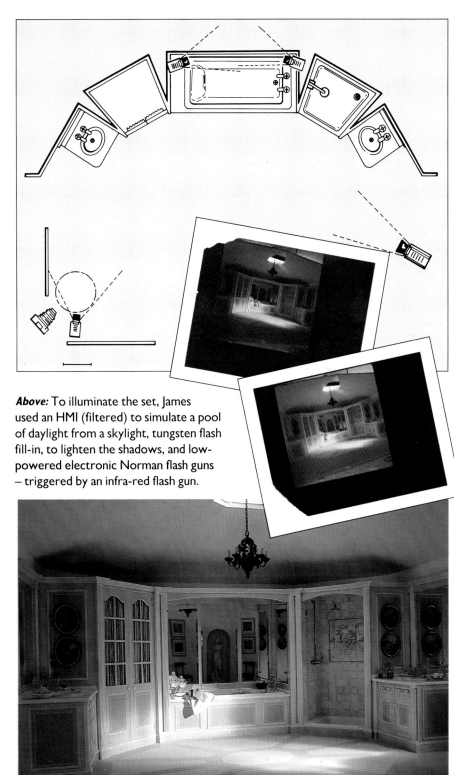

Above: To illuminate the set, James used an HMI (filtered) to simulate a pool of daylight from a skylight, tungsten flash fill-in, to lighten the shadows, and low-powered electronic Norman flash guns – triggered by an infra-red flash gun.

Commercial model-making is approaching its heyday as more and more agencies explore the exciting options that using a three-dimensional image provides. The reasons for using a model may not be merely creative, but also necessary. For example, it might be essential that an object cannot be identified as being the design or make of a particular manufacturer. The challenge to modelmakers in this case is to create a convincing object that is instantly recognizable but does not have a single component that identifies it with a specific brand.

From the modelmaker's view-point, every brief involves a different challenge; he is not aware from one day to the next what he might have to create. The skills he needs are formidable as he must be able to interpret a brief and immediately work out the most efficient way to make whatever object is desired in whatever material. For instance, there are ways of making perspex look like metal, or of creating a worn or rusty appearance, and countless other methods of making a complete illusion from a three-dimensional object. A modelmaker might be called upon to simulate a wood carving or a marble statue, but the range of materials he can use will range from plaster to plastic, from wood to cast iron. The trick for the photographer is then to show the model in the most realistic or dramatic manner possible.

A shot by John Parker typifying the sophisticated technique he brings to still-life photography.

BENSON & HEDGES

THE CLIENT GALLAHER
THE BRIEF TO CREATE AN IMAGE
WITH IMPACT THAT
REFLECTS THE CLASSIC
IMAGE OF B & H
THE AGENCY CDP & PARTNERS LTD.
ART DIRECTOR NIGEL ROSE
PHOTOGRAPHER JOHN PARKER
ASSISTANT JOHN ROUGHAN
STYLIST KARIN OTTE
MODELMAKER MATTHEW WURR

Cigarette advertising presents a unique challenge to the agency because the product is in great demand by a certain segment of the population, and yet can evoke extreme animosity in another. So, the problem is to create an ad that will appeal to the consumer and reinforce the brand, yet at the same time be as inoffensive as possible to the anti-smoking lobby.

The agency is also restricted by a complex series of rules and regulations controlling the advertising of cigarettes, which are comparatively recent in origin.

There have been ads in the past in which people have stopped playing tennis and immediately had a cigarette. Way back in the 1930s there was a famous ad featuring a couple in evening dress, lighting each other's cigarettes on the dance floor!

However, these images would be unthinkable today, so the creative art director has to find a different route. The first task for the agency is to create an identity for the brand. This doesn't necessarily mean that the brand is immediately identifiable from the first ads, but relies on an identity and awareness being built up slowly over a period of time. With a government legislation that demands a health warning on all tobacco advertising, the whole style and content of cigarette advertising has had to change, the most important factor being the use of the health warning to make it obvious the ad is for cigarettes.

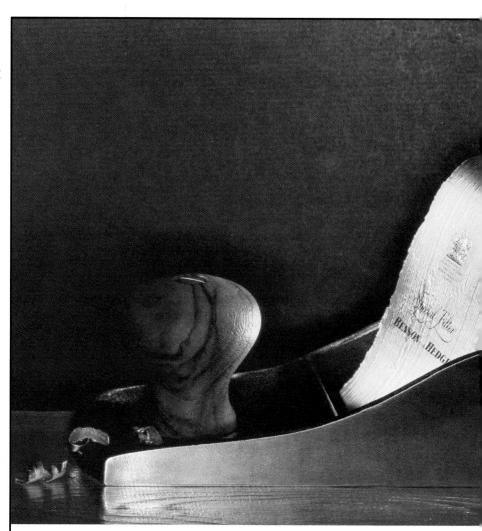

Warning: SMOKING WHEN PREGNAI

The Benson & Hedges campaign has been running for 12 years or more, with increasingly sophisticated and subtle imagery, gradually reducing the associations with tobacco. As an example of contemporary graphics the posters are excellent, and are produced with creative thought and dedication that is second to none. Brand awareness has been achieved to such an extent that Benson & Hedges outsell their rivals by a huge margin.

The target market of this product is also interesting. All the advertising is aimed at the committed smoker; there is no suggestion that this campaign is

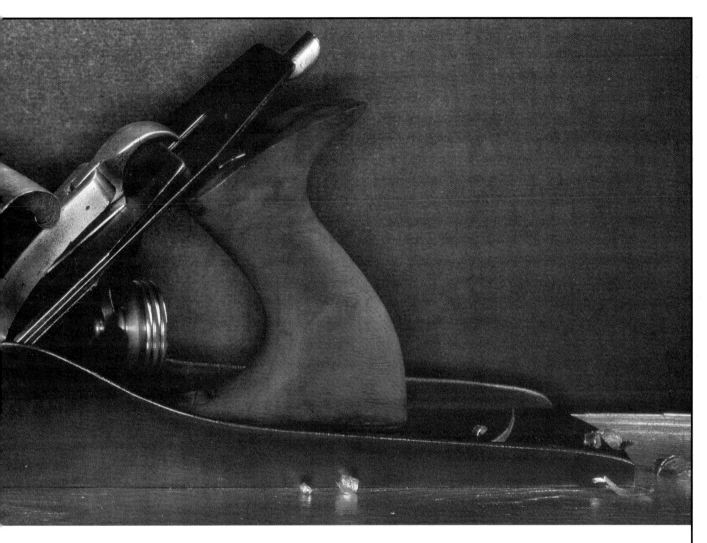

ODLE TAR As defined by H.M. Government
AN INJURE YOUR BABY AND CAUSE PREMATURE BIRTH
lth Departments' Chief Medical Officers

seeking to convert non-smokers to smokers, but rather to convince existing smokers that Benson & Hedges is the 'right' brand. The Benson & Hedges campaign has set a style that others seek to follow, and has established new standards in art direction, model-making and photography.

Interview with the Art Director

DICK WARD As this campaign for Benson & Hedges has got quite a long history, what was your brief on this particular ad?
NIGEL ROSE It's the same brief as we have had for the last 12 years, and that is

The finished ad from the shoot for Benson & Hedges maintains the high standards set by their long-running campaign.

49

to do something stunning and arresting. So there is no real creative constraint or creative dictum that's stipulated, as long as we make sure that we stick to the code of practice for cigarette advertising.

DW What is the code of practice for cigarettes?

NR There are certain do's and don'ts that we have to adhere to. For example, you cannot portray pleasure from smoking, or imply that you'll become a better person, or get the girl. It cannot be shown to be healthy or linked with sport or outdoor activities.

So, every time we do a new subject, it goes before the ASA Committee Secretariat, and is approved or not, as the case may be. The same thing applies once we have actually taken the photograph. The rules are fairly complex, but within that framework it does enable us to produce a unique campaign. This has been going on for almost 12 years, and we've covered more than 70 subjects in that time. I think we've set a very high standard. I think we set the pace and the others merely follow.

DW How many roughs do you put forward at a specific time?

NR We generally do about six subjects a year. I'm not the only one who works on them, other people do occasionally, but I've done an awful lot of them. We tend to come up with between 12 and 20 ideas for our own internal approval system. The internal system then shoots them down or approves some, so hopefully we'll have eight or nine subjects to take to the client for approval. Out of those we'll probably get half a dozen a year. I must stress that to produce work of this calibre you have to have the client with you. Gallaher have been with CDP for over 25 years now and they are an exceptional client. They trust us, so it's not an us-and-them situation. The client should also take credit for allowing this sort of creative work.

DW Did the concept of the campaign come about because of the associated problems with advertising cigarettes?

NR Yes. Prior to this campaign there had been a very famous Benson & Hedges campaign that had been running for 14 years.

DW What was that? Can you refresh my memory?

NR Yes. They were single-page ads, in quality magazines, and they all featured a packet with a copy line — something like 'silence is golden' — which was shot on the Côte d'Azur, with bottles of wine, grapes, the sun setting, and the pack on the table. They were always beautifully photographed, as we used the best

photographers. It was always a play on the golden theme. There was another one with the pack on the top of a mountain with snow frozen over it, and the copy line was 'frozen asset'. They were very much admired and imitated, so that was the reason to change, because every art director was going up to every photographer and saying 'Give me a B&H'.

DW I presume you couldn't show a situation like that now.

NR No. It can't be seen to be overtly aspirational. Also, the rules changed, so that you couldn't say anything about cigarettes. That's when we decided to end the copy line, as we were getting

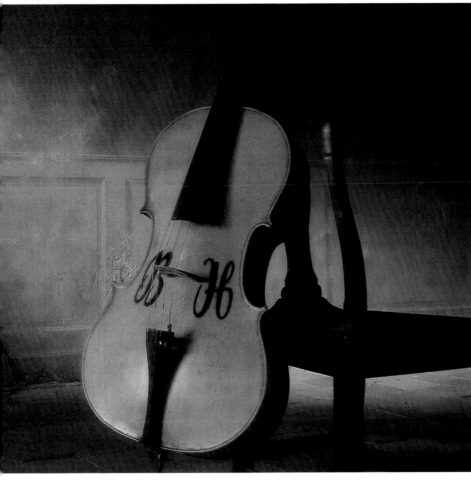

Left: A distinguished predecessor from the long-running campaign; the B&H Cello, by Nadav Kander. **Below:** Another famous image from the series; Max Forsyth's Chameleon.

subjects that were increasingly turned down. At about the same time the EEC changed the tax law on king-size cigarettes, making them the norm rather than the exception.

So, we had to find a new campaign that would make an impact and yet be less easily imitated. So the first surreal Benson & Hedges ads came into being. There was quite a furore at the time, with three new subjects running all at once. The rest of the trade couldn't understand what was going on, and were saying we'd gone off our heads dropping that wonderful campaign. It was thought we'd thrown the baby out with the bath water, but gradually people began to warm to them and even looked forward to seeing new subjects, as they were challenging. People liked to puzzle them out – they even became a topic of dinner party conversation. They also started to work; the brand share went up, and now we

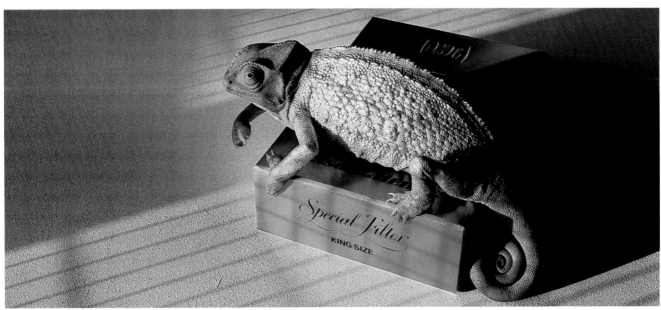

outsell our nearest rival by twice as much.
DW So it's a brand leader.
NR Yes. It has been for some time and it's two or three pence more expensive, so we must be doing something right.
DW What is the target market?
NR Everybody. If you are a smoker, if you like a cigarette, then smoke B & H.
DW Are you assuming a certain intelligence on the part of your audience?
NR Yes, we like to think people will figure out the puzzle.

DW What's the media spread?
NR We're on 48-sheet poster sites (billboards), which we certainly weren't on the previous campaign. It was a major creative step to go onto posters – 11 years ago we hadn't done that. We also go in all the usual Sunday supplements, together with the *TV Times* and *Radio Times* and all the quality magazines. However, we don't go in any magazines for the under-20s as we're not aiming at young people.

DW Do you go into any of the lesser-quality magazines?
NR I can't be sure of the exact media spread, but we're generally in magazines of all qualities. We don't see ourselves as elitist, but as an everyday cigarette.
DW How do you reinforce the brand and constantly keep it in its market position?
NR I don't think we're trying to get people to smoke, I think we're saying that if you do, then smoke Special Filter.

Kevin Summers shot this startling image in 1987, keeping up the imaginative tradition of the campaign.

unlimited time, so what tends to happen is that they quote a number of days for the job, say four or five days, and if they go beyond that it's up to them. Usually we do have plenty of time ourselves, as we're producing only a certain number a year. So a photographer can take as long as he wants, within reason. But we couldn't pay them for unlimited time. For example, I've done some that have taken two or three weeks, but I couldn't pay a photographer his day fee for three weeks. That would be far too expensive. If they get it done in the desired time, fine. If they go over, that's up to them, and they are invariably happy to do so if necessary, because they see it as an advertisement for themselves.

DW How much time do you get from the time it is approved and when you have to commission a photographer?

NR It's an unusual account because we work well in advance, as there is the internal vetting process it has to go through. We also make sure that we have enough subjects for the next year. We work about seven months in advance, because we like to have things in reserve. In that sense, because it is an ongoing thing, the brief is the same. It's not as though we have to do new campaigns. We know the time patterns involved, so it's a luxury in that sense for all the people concerned, from the art director to the photographer. We also take a lot of trouble over the printing; we will have four or five proofs before we go to a final proofing.

DW Do you choose the model-maker or does the photographer?

NR There are a number of model-makers who tend to crop up on most jobs. Although I would never dictate to a photographer that he should use this

DW How do you choose your photographer?

NR It should be a simple question to answer, but the simple ones are never the easiest. I like to see great pictures in their portfolio. I don't always stick to the tried and tested, because John Parker's had hardly any commercial work in it at all. They're all personal pictures, so I went purely on the strength of his personal work. I thought they were stunning and appropriate for this particular subject.

DW That's unusual really. Do you often take risks like that?

NR I don't really see it as taking a risk, because John had demonstrated that he was capable of giving me what I wanted. There were particular pictures in his folio that sparked off something in my head that connected with this particular concept. I don't think I really took a risk. Maybe he felt he was, I don't know.

DW How much time did you have?

NR It's impossible to give a photographer

modelmaker or that one. In fact the photographer usually suggests a modelmaker and he'll probably be one of the people we work with anyway.

DW Do you think that cigarette packaging is important? Because I remember when I was a kid, people used to carry cigarette cases, and they would take their cigarettes out of a packet and put them in the case, and the case used to be the impressive object. Now it's the packet.

NR Well, the B&H pack has become a classic, in that it's been around a long time. When we were given the brand that packet existed. That's what makes it so distinctive, and the gold certainly helps.

DW With the current climate of opinion involving cigarettes, where almost everywhere in the world there is a strong anti-smoking lobby (with the exception of places like Holland, where everyone over 12 seems to smoke), how would you approach the problem of selling cigarettes if the government decided to ban advertising?

NR If the government said 'That's it, all cigarette advertising is banned', we'd stop.

DW But do you think you could get away with a picture that was so subtle that people might just make the connection?

NR We wouldn't. I've been asked that question many times. It would be dishonest, and it would be flouting the rules. I take your point; that if you look at these they're just pictures. And if you put a strange picture up, people might assume it was B&H, but we always keep to the rules. We're too aware of our own reputation and that of our client.

Below: Nigel Rose's marker rough was a useful starting point for the model-maker and photographer. *Opposite above:* Mathew Wurr's working drawing breaks down the model into its component parts. *Opposite below:* A polaroid of a plane, taken to see which parts had to be altered to ensure the model couldn't be identified in the ad.

Interview with the Modelmaker

DICK WARD Could you tell me what your brief was?

MATTHEW WURR We were given a layout of the 48-sheet poster. Originally, it was to make a wood plane with a gold wood shaving curling out of the top, which was also the Benson & Hedges pack. It was one of the first ads for a long time to use the actual pack, as they have been using more obscure ways of portraying the B&H logo. It had to look used, so I thought it was nice that it was an old jack plane not a new plane. The only thing that Nigel Rose stipulated was that it mustn't be identifiable with any manufacturer. So first of all we looked around antique shops to find old planes, and then cobbled together a plane from various bits. The stylist did all of that to start with, and we worked on it and put one together. Everyone thought it was fine, but the art director was still worried that pieces of it were recognizable. I said, obviously there's a piece here that's made

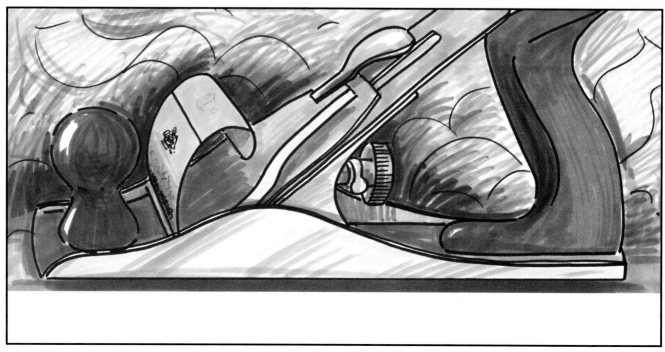

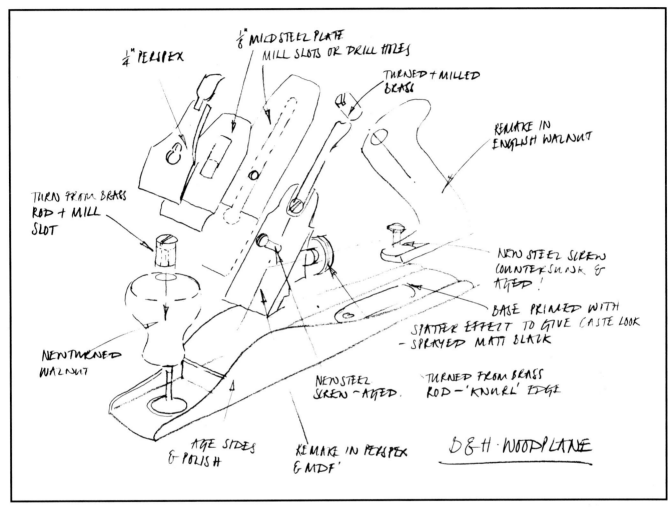

Drawing labels:

¼" PERSPEX

⅛" MILD STEEL PLATE
MILL SLOTS OR DRILL HOLES

TURNED + MILLED
BRASS

REMAKE IN
ENGLISH WALNUT

TURN FROM BRASS
ROD + MILL
SLOT

NEW STEEL SCREW
COUNTERSUNK &
AGED!

NEW TURNED
WALNUT

BASE PRIMED WITH
SPATTER EFFECT TO GIVE CASTE LOOK
- SPRAYED MATT BLACK

AGE SIDES
& POLISH

NEW STEEL
SCREN - AGED.

REMAKE IN PERSPEX
& MDF'

TURNED FROM BRASS
ROD - 'KNURL' EDGE

D&H · WOODPLANE

by such and such manufacturers, so he tried to get clearance from them, but they refused.

So, it was back to the drawing board. We decided that we were going to have to make it from scratch. Even though there are elements there that could be slightly recognizable, every part has been made by us and isn't actually like any manufactured plane. We completely remade new walnut handles front and back, and the base is nothing like any plane; the shape has been altered and it's been sprayed to look old and pitted.

DW What materials do you work with?
MW Mostly wood, steel sheet, perspex and brass. The lever cap, just behind the

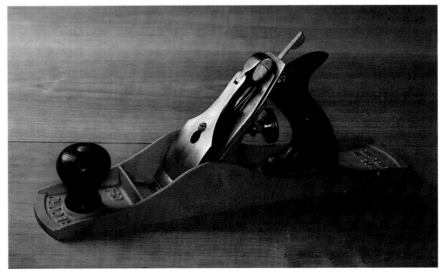

pack, is perspex. The little piece that goes on the blade depth adjusting nut is also perspex.

DW How do you shape the perspex?

MW It's cut on a fretsaw and then hand-shaped, filed and polished. The blade and cap-iron are made from new sheet steel.

DW How do you get it to look old?

MW We pit it, sandblast it and then use an aluminium spray finish with zeebrite, which is a black lead polish. The screws were freshly turned on a lathe and a slot was milled in them. Without exception, everything there is made from scratch. So if anyone said 'That's our plane', we could say 'No it's not, we've made all of it'. We weren't quite sure what to do with the background, but we know of a new technique by which we can actually gold-plate onto wood. We did two test planks, one of which worked very well.

DW How is this done?

MW The wood has to be silver-plated first, then gold-plated on top. But first of all it has to take an electric charge, so a magnetic substance is sprayed onto it and then it's immersed in a tank and plated in the normal way.

DW How did the wood shaving work?

MW Nigel Rose was concerned that the crest should appear embossed, the way it is on the pack, and everything had to be readable. So the tricky part was how to get a wood shaving to look like a wood shaving, and still retain the qualities of the cigarette pack. We tried a number of things and eventually plumped for embossing into B&H gold foil card. We prepared bits of wood first of all, and sandblasted very deeply. John Parker took some line shots (a darkroom

technique involving a very high-contrast emulsion film) of that to produce some very graphic positives, which emphasise the outlines. We did five or six different ones, and then chose the best one by narrowing it down to shapes that looked nice, and so on. Then I got artwork for the logo and the pack and we stripped the two together and made it up as one artwork. We made some Binders Zinco (a deep-etched zinc plate used for embossing) and carefully worked out a way of embossing into it.

DW How does that work?

MW Basically, all the black areas are indents in a deep-etched plate. These appear raised on the final gold foil, just as the B&H crest is on the actual pack. We still found that it looked too crisp, so in between that we stamped the shaving with a woman's stocking between the Zinco and the foil, which gave it this slightly soft look. Then we worked on the edge to make it look feathered, and put in the split line (gap between the flip-top lid and the rest of the packet) by hand.

DW Just by using a little bradawl point?

MW Yes, by making a little perspex pointer the right size. The trickiest problem was getting everything to register accurately. There was a lot of experimenting and working out on the plate that went into the binding press, positioning it so that the logo embossed exactly where it was printed, and so on. We probably made about 50 samples, and as each process evolved gradually, another half-a-dozen were lost because they weren't very good, until I narrowed it down and gave John a choice of six or seven. To get the curl we just steamed it round a bit of dowelling, and then sprayed the inside gold to give it a warm glow.

DW How was it fixed to the model?

MW It was attached with Blue Tack on the set, so we could make positional adjustments in front of the camera.

DW How were the little shavings done?

Left: A line print of the wood grain effect produced for the ad by the model-maker. **Right:** The wood grain effect was eventually embossed onto the fake wood shaving.

MW They were made up out of some spare gold foil. It was John Parker's idea, to liven up the shot.

DW Was there anything else that had to be done?

MW It was just a question of knocking back a few bits here and there, as they were a little bit bright.

DW How long did you have for this job?

MW We actually had quite a long time on this, mainly because of the false start. So we had a month, but this was over a two-and-a-half month period, which is quite a long time, but there was a lot of experimenting to do. We had to work out this special gold-plating technique, which I wasn't sure was going to work. The plane was no problem – that's the kind of job that we get regularly. We all work out how to do it and just discuss it further as we go.

DW It's very interesting. Looking at that, no one would imagine the work that went into it.

MW Well, I'm not sure that we needed to do that much work on the plane. The problem was that by the time the agency had alerted the plane manufacturers to the fact that there might be an ad using one, we felt that rather than risking it we really should make it right from scratch. That is the challenge in model-making, but as far as we're concerned, as long as there is time, and a budget, we can solve any problem.

Interview with the Photographer

DICK WARD What brief did you get from CDP?

JOHN PARKER To photograph a wood plane with a shaving coming out of it. The curling Benson and Hedges packet, which is a bit metallic, had to look similar to the pack itself but also show wood grain. It only came out right after doing a lot of experiments.

DW Did you work that out?

JP Not really, it was a joint effort with the modelmaker, myself and the art director.

DW What was your timing on the whole thing, from getting your brief to doing it?

JP From the day I got the job to finishing it was about three-and-a-half months. Most of that was an organizational problem, as the modelmaker had to make the plane from scratch in the end.

DW Why did you have to do that?

JP For reasons of copyright. None of the major manufacturers want to be associated with cigarette advertising, so the plane had to be unrecognizable.

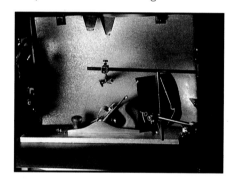

With the plane in position it became clear how near the lights and matts needed to be placed.

A view from the other side of the set with the background removed, demonstrating the crucial positioning of the lights.

DW Cigarette advertising is very sensitive.

JP It's more and more so, with many manufacturers not wishing to be associated with cigarettes.

DW So that's how you began to approach the job – you had to find all that out for yourself?

JP No. First of all the stylist went out to

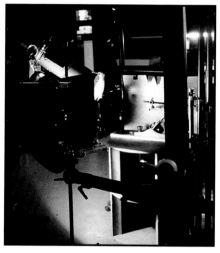

The camera in position with the background matt in place – note how confined the set had to be.

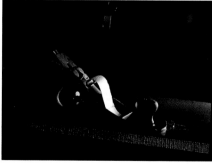

A shot clearly demonstrating how the wood shaving was lit separately from the body of the plane.

look for a selection of planes, so that Matthew, Nigel and I could see which one we liked best. We all agreed that the standard plane was the right thing to make it stand out immediately.

DW It's a classic wood-working tool. Did you have a drawn rough from CDP to give you proportions and ideas?

JP Yes.

DW Once you had the model, how long did it take you to set up and test?

JP Well, you test all the time until you finish the film. I suppose the horizontal shot took about four days.

DW Did you find any particular problems on this, as opposed to any other still-life?

JP The organizational part, not the shoot.

DW Do you specialize in still-life?

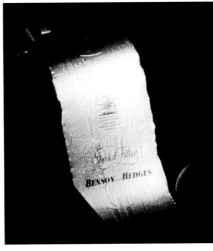

A separate light was deliberately positioned to help define the grain of the wood.

Above: This shot clearly shows the effect of the separate light on the shaving.
Below: Having completed all the tests, John Parker is ready to shoot.

Above: To illuminate the subject, John used spotlights and flash. An opaque screen diffused light on the shaving and a warming filter brought out the gold.

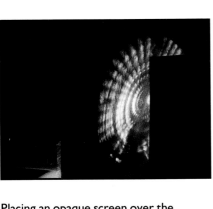

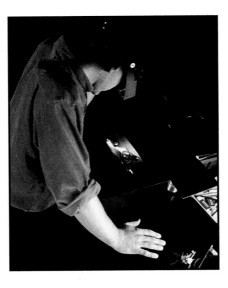

Placing an opaque screen over the spotlight diffuses the lighting on the shaving.

Possible crops and exposures are painstakingly checked before the final shoot.

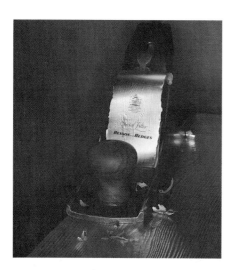

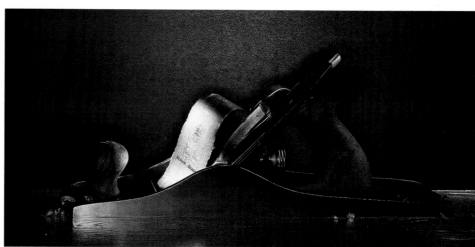

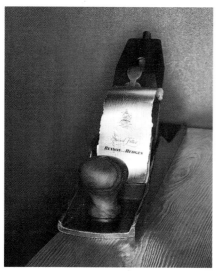

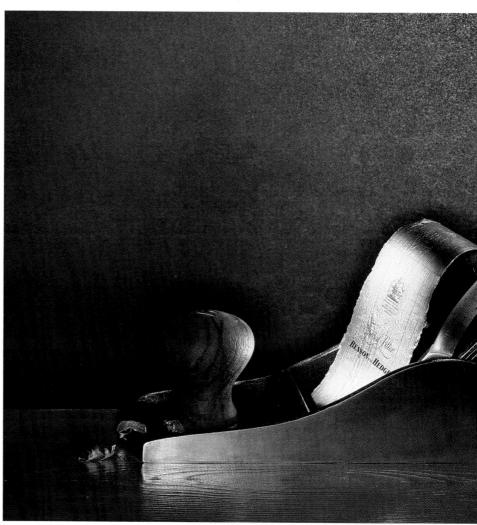

Top left and above: Two of the many test polaroids taken on the shoot – the gold shavings have been added in the top one, but the lower picture is closer to the desired effect. **Top right:** The final shot of the side view of the plane, with the background lightened by slight adjustment of the exposure. **Right:** A side shot of the plane before the exposure change had lifted the background.

JP I have in the last few years.
DW On the technical side, what sort of camera do you use?
JP A Dierdorf.
DW What sort of lens?
JP Symmar 360mm.
DW And the film?
JP Kodak 6117.
DW What aperture did you use for the final shot?
JP It was all on an open flash at F 45.
DW So that means your lens is open all the time?
JP Yes, that's right.
DW What about a filter?

JP It was 81c.
DW Is that a warming filter?
JP Yes, it's a light-balancing filter used to increase the colour temperature slightly for a warmer (redder) tone. It also tends to blend all the components into a pleasing overall effect.
DW Why did you use a warming filter?
JP It was to help the gold. It all blends in to make more of a pleasing picture. Then it's a case really of balancing the lights to get the right atmosphere.
DW Were those decisions left to you, or did the art director tell you he wanted a cosy, friendly-looking plane?

JP He just said to do it how I wanted to, although there were times when I was struggling, when I was going down the wrong track. Then Nigel came along, and saw an earlier test and said 'That's the way to do it'. So sometimes that extra eye is needed to tell you you were right before.
DW I notice you have used a small reflector above the model. Can you explain the reason for that?
JP It's reflecting off the spotlight to highlight the top of the gold and help turn the top of the shaving. At the same time, I had to give that 24 flashes and the actual main body of the plane only needed four flashes. So when I did the shaving, I blacked out the rest of the area with black card, and allowed the light to bounce off the reflector above the subject.
DW What's the background?
JP Just a normal roll of paper, but there is a fill light at the back to light the back of the wood.
DW What about the little curls?
JP That was an idea that came to me when we started shooting, as it looked a bit too much like a still life. So these were something that gave it a bit of life.
DW What height do you work at?
JP Just comfortable for me to sit at. I don't feel like standing up if something is going to take four days!

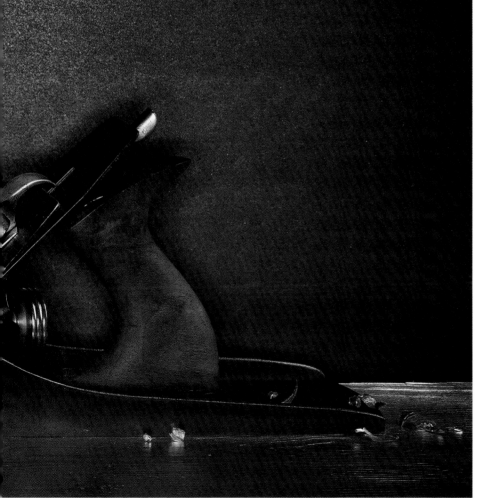

CAMERA	DIERDORF
FILM	KODAK 6117
FILTERS	81c
LENS	SYMMAR 360 mm
APERTURE	f45
LIGHTS	SPOTLIGHTS
	FLASH

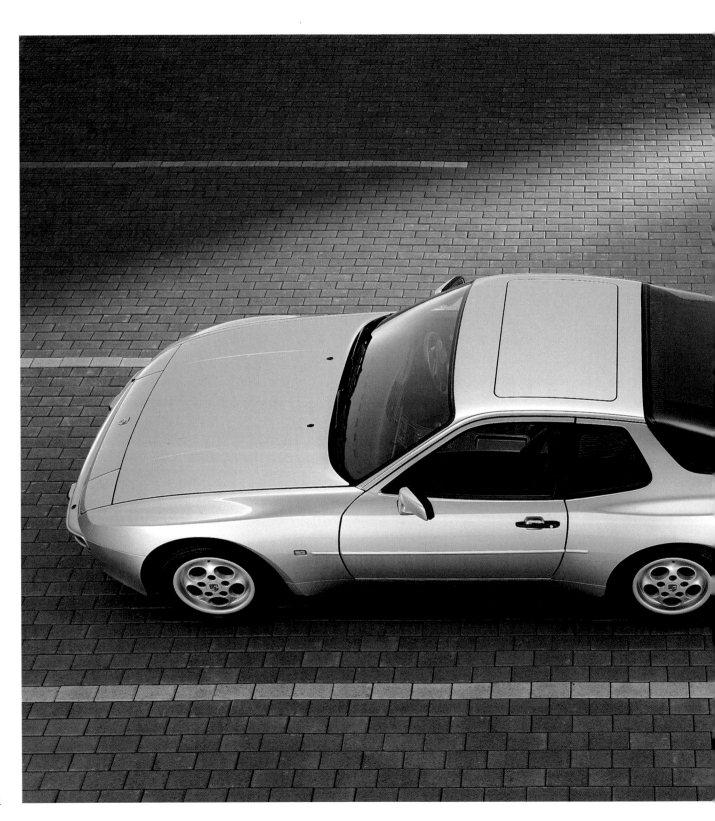

Car advertising has evolved continuously over the last 30 years. In the 1950s and early 1960s most car advertising was illustrative rather than photographic. The style followed America: the cars were stretched and widened; a separate specialist artist painted the figures in the advertisement, which was reduced in scale, and yet another artist painted the background. The most common theme was of a happy family enjoying a day out, or loading their possessions into an estate car, smiling blissfully. This style often resulted in blatant absurdities, with a Mini being made to look as big as a Ford Fairlane. Today it is doubtful whether these ads would pass the Advertising Standards Authority.

Gradually, photography predominated in car advertising because the buying public was becoming more aware of cars and demanding more information from advertisers. The happy-family theme faded as cars were aimed at narrower markets. Terms such as GT began to be used on everything from the most expensive sports model down to the average runabout. Cars began to be set in all sorts of situations; on top of mountains, in the middle of a glacier, or thundering across the desert, as the advertisers fought for the customer's attention in an ever-more competitive market. The photography generally became more and more exotic and, at the same time, more technically advanced. Cars were treated like film stars, polished and preened and placed in every conceivable scenario.

In this shot from the Porsche ad by photographer Jon Cox, all the bricks were specially laid for the shoot as it was impossible to find a perfectly clean and satisfactory ground already in existence.

THE CLIENT PORSCHE CARS GB LTD
THE BRIEF TO CREATE A DOUBLE-PAGE SPREAD AD WHICH CONVEYS THE SUPERB PERFORMANCE, DESIGN AND SENSE OF LUXURY OF A PORSCHE

THE AGENCY BRAHM ADVERTISING
ART DIRECTOR CLIVE RAND
COPYWRITER MIKE BLACK
PHOTOGRAPHER JON COX
STUDIO MICHAEL RYAN

Porsche's advertising in the UK is interesting because it was one of the last nationwide car campaigns to use illustration. The illustrations were not the traditional type, but were strong graphic images of the cars. However, research finally showed that the car needed to be shown more realistically, and so the campaign switched to photography in September 1986. Since then, the creative team and the photographer have established a distinctive style that is very much in keeping with the product.

This car, the 928, is a superb piece of engineering and design, with the advertising geared to the top end of the market. So, the ads must be informative. At the same time they have to make the customer feel that if he buys and runs a car like this he has accomplished a great deal in life.

The overall impression of the ads is one of 'hi-tech' engineering, yet at the same time they have a familiarity that the customer can identify with. The car is dominant in the image; placed in a futuristic, although simple, set that nevertheless demands elaborate planning to build.

In this particular photograph the technical problems involve the photographer making two separate shots – one to achieve the right exposure on the car and another to get the right exposure for the background.

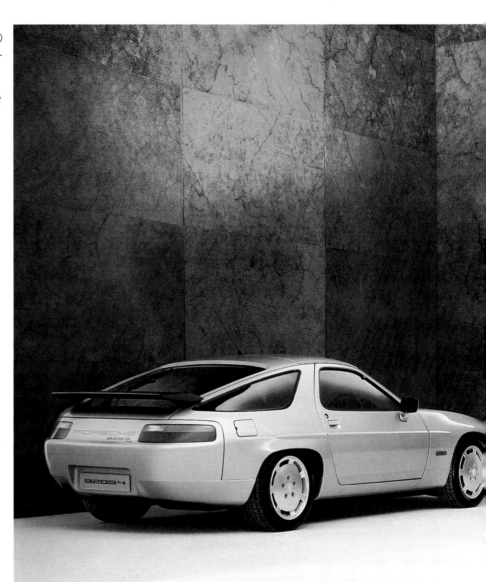

Interview with the Art Director

DICK WARD On a campaign like this, that has been running for some time, what is the background story?
CLIVE RAND I have personally worked on the Porsche account since 1978. Before that time their advertising had been quite low-key, mainly small black-and-white press ads. The first work we did for them was a departure as far as car advertising went at the time, as it was the only major car campaign that used illustration. We did this to differentiate ourselves from all the other car advertising, which tended to be photographic.
DW What made you switch to photography?
CR The advertising research was beginning to indicate the need for a change of direction. That was in 1984. We had more need to show the cars realistically, so the obvious way was to

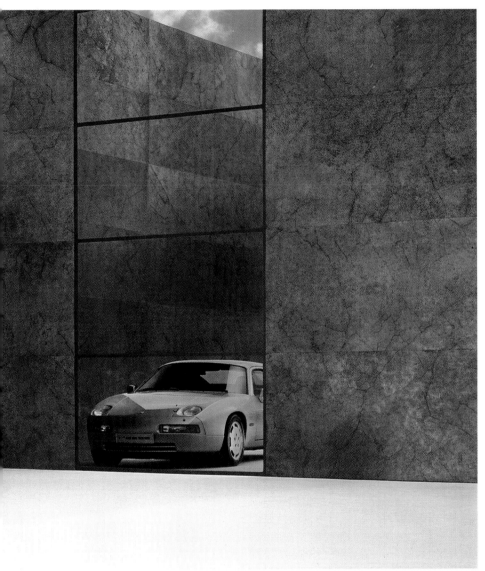

went on location in areas like Cornwall and northwest Scotland.

DW What is your target market?

CR Very complicated. For the 928 it is obviously people who have the money, who are interested in driving and performance too, and whose leisure activity is their driving. Typical owners of the 928 are self-made people who want to make a statement about themselves through their car. They want to see the car well-realized, and to be able to explore the car in the ad. The research finally led us to Jon's style of photography, which shows the car in a clear and precise way and yet in almost minimal graphic situations. The styling makes the statement. The car doesn't necessarily have to be big, but it must be the hero of the picture, with the background complementing it.

DW Why have you switched to solely studio shots?

CR The problems on location can be tremendous. You could spend four days waiting for the right weather. At least in the studio you can control the environment and, more especially, the light.

DW Do you do a rough.

CD After Mike Black and I have sketched out our concepts – usually just a scribbled headline and some rough 'thumbnails' of the picture – I need to concentrate on the car, to show whatever setting is going to work properly. So instead of working with magic markers, which is how an art director usually starts to put down visuals, I use models and make up dummy sets and shoot them as concept visuals.

The great thing about using these shots is that Jon Cox and I are able to discuss the shot very early on in great detail. Having a slide up on the screen even enables us to talk to the retoucher about possible problems that might arise, and how we can get over them. More importantly, we can show them to Brian

switch to photography. But the following year we still felt that illustration was very important for Porsche, as we still wanted to differentiate, so we used Michael English, who is best-known for photo-realism but is also an illustrator.

DW His style is hyper-real. Is this what eventually led you to photography?

CR The main problem with using an artist like Michael English is timing. Because his work is so ultra-detailed, and he is so fastidious, his work takes a long time, and

For this finished shot weights were put in the car to give it the same profile as if it were in motion.

we were not able to complete all the images for one campaign at the same time. We need to produce up to eight pictures in about a ten-week period to meet the advertising deadlines. Working with an artist made it very difficult to run a coherent campaign. The following year we finally opted for photography, and we

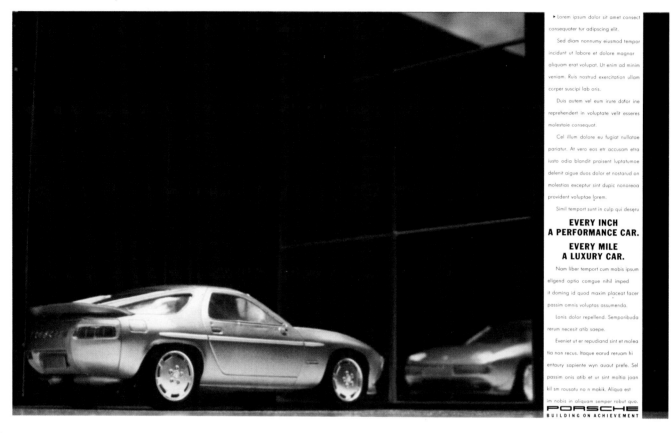

EVERY INCH
A PERFORMANCE CAR.

EVERY MILE
A LUXURY CAR.

PORSCHE
BUILDING ON ACHIEVEMENT

Bent and Adam Tindell at Porsche. They can get a much clearer picture of what we're doing from transparencies rather than from a marker rough. They can also look at a range of subtley-different angles with us and participate in the creation of the final picture concept.

DW What made you think of doing a rough with models?

CR It's surprising how, when you're shooting the car for real, it actually fits the original rough model picture very closely. Models are amazingly accurate. Model shots also give us a good indication of where it's all going to fit in the studio. It's still difficult to envisage how big the set needs to be, as we often need to spend two or three days there roughing the whole thing together. We'll then do two or three tests before we get to the final result. The trace done from a model isn't far away from the real thing, but the most

important thing to bear in mind is where the gutter is going to fall in the finished ad, because these are double-page spreads.

DW How are you actually briefed?

CR We do a lot of research about people's perception of the car and our past advertising. We also do a tremendous amount of work with Porsche themselves on how the cars, and indeed Porsche, should be presented in the advertising. After all that, we arrive at what is called a 'positioning statement', which is a long description of the essential points we must communicate about the car. The statement itself will never be seen by anyone other than ourselves and Porsche. Once we've agreed on what we are trying to communicate, then it's a question of picking out what headline we need to lead the reader into the ad, and what copy points we need to make in the body text, to substantiate and support

Clive Rand's finished rough employs a model car to establish the desired mood and feel for the actual shot.

our proposition.

Another aspect that's very important, and I think unusual, is the dealer's interest in the research and the fact they see some of the visuals even before we go to shooting. So we get useful feedback from the 'front end' of the business. They take a small portfolio away with the advance pictures, which can be incorporated into their modular showroom display panels at a later stage.

DW What's the idea of the car's reflection in the mirror?

CR What we're trying to do with this 928 S4 advertisement is show two aspects of the car. The headline is 'Every Inch a Performance Car, Every Mile a Luxury Car'. The car's looking at itself in the

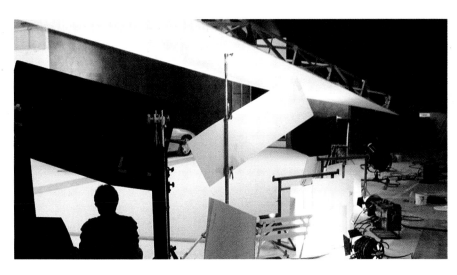

Numerous matts were needed to control reflections on the car.

mirror; that's the idea of the two sides of the car's personality, the luxury side and the performance side.

DW Is it diffiult to find the right studio?

CR Yes it is. Good studios are few and far between. We have been shooting in Germany, but in this case we had some logistical problems, so we had to find a studio in England.

DW What about the difference in price and the logistics of shooting in Germany?

CR It's about the same as working in London. In fact, hotels are cheaper in Germany. The biggest expense is actually shipping the cars across the water to the studio. But because we use Porsche's own transport company, certain savings can be made through efficient planning.

DW When you set up something like this do you have any insurance problems?

CR With respect to the vehicles themselves, no. Because they are specialist studios they have a blanket policy to cover all risks.

DW How did you choose Jon Cox?

CR Having worked with Jon in the past, I felt he was someone I could trust to get the car absolutely perfect and to show all the detail, as well as understand the

concepts. He has a tremendous repertoire of techniques to make a car look right. It is possible to find other photographers who are very good on atmospherics, but they may get the car wrong. Jon is a car specialist who has worked for a long time on Ford in Germany.

DW What sort of time are you talking about to do all the tests?

CR We estimate anywhere between two-and-a-half and three days to do a set-build and lighting. It probably takes two tests or maybe three to achieve exactly the right results, which we could do at various stages of the set-build. The initial lighting test would be done at the end of the first day or the middle of the following day. My problem is the very nature and size of the set, because it's got to cover a double-page spread, and still allow room for the column text. This means we have to be some distance away to achieve the perspective on the car, and as we like to take the picture right over the spread with the one column copy, we need a huge set.

DW Has the campaign been measurably successful so far?

CR It has been very well-received by the dealers, who are a very good indicator of whether it will work in the marketplace. It

was researched very well, and is communicating the right messages. The message coming back from independent researchers is to carry on with what we have been doing in the last two years without changing too much. In fact Porsche in Germany are using UK shots

Clive Rand and Jon Cox examine the car intensely to ensure all the reflections are correct.

for other uses, so I think you can say our approach is successful.

Inteview with the Photographer

DICK WARD Do you have your own studio?

JON COX No, because of the nature of my work I mainly do cars or other vehicles, so I have to travel a lot. It would be too expensive to run a huge car studio.

DW Is there a problem in finding available studios?

JC Very much so. Car studios are few and far between and although there are more being built, there is always a waiting list to get in to the good ones. This is why

Michael Ryan opened this studio. He realized there was a need for a good facility like this.

DW What about building your set? Are you totally in charge of that?

JC Yes, but obviously liaising with the art director and client.

DW Do you choose the people you want to build the set?

JC Only in the sense that the choice of studio of course depended on their set building experience.

DW How do you work out your quote?

JC Clive Rand and I talk it through after doing the tests with the models. In this instance I managed to work out the quote, for two days of photography and two days of set-building.

DW Do you have to pay for set-building out of your budget?

JC No, the agency pay that, but I have to sort out how it's going to be done and where we are going to do it.

DW What about the logistics on this? Who makes sure the car arrives at the right place at the right time?

JC Well hopefully, I try to put as much pressure as possible on the client to do that.

DW Do you transport all your own gear?

JC Yes. I only have to bring my cameras, as the lights are all part of the studio deal. Some studios have their own lights and others will hire them from specialist lighting organizations.

DW What was the timing on the whole thing?

JC I first saw the rough model shot about four months ago, as one of the concepts. This ad will appear in about three months.

DW How long have you hired the studio for?

JC It has been hired for a week.

DW Once you've got the car in position and the set has been built, what is your next step?

JC We are trying to create the effect of

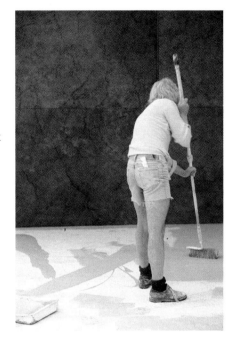

Left: The floor is painted until the correct colour balance is achieved. *Right:* Mirrors are checked for trueness and cleaned to ensure accurate reflections.

the car parked in a small alcove outside an office building. If you look at the visual, it looks as if much of the lighting has to come from above, and possibly a little from the side. So I had to bring in more lighting from the side or from the roof. It's not a back-lit shot. I've got to imagine an open sky above, as that is where the bulk of the light is coming from.

Once the car is in position, I will spend longer getting the camera angle exactly right to make the car look good and match the layout. It's a two-page spread, so it is difficult to get it right first time round. I'll shoot several black-and-whites from different positions, just negatives. Then I'll process them, and Clive and I will check with a trace to make sure they fit the layout. When we are happy with the position I'll really start to light the car. On most of these black-and-whites the top reflector flat is higher than we'll finish up

with. Once the position is right I need to bring that top reflector flat right down to get some light on the car.

To try to do the car and the set as one shot is difficult, because to get the lighting exactly right on the car means it won't be right on the set, and vice versa. Clive Rand has to be on the set all the time so he can see little reflections that he might like to appear in the car. The problem with this particular car is that it has curves everywhere; there are very few straight lines. The rubber strip along the side is literally the only straight line on the car.

What I am trying to do with the top reflector flat is echo the fact that the roof, which stops just out of the picture, is open, and also give some kind of straight line somewhere that will complement the contours of the car. Then I'll make it look as if there's light literally coming over the top of the building.

If you look carefully at a car parked outside there are all sorts of reflections in it, from everything else surrounding it. You can often see a roof line reflected in the bonnet or roof. So I've got to try to

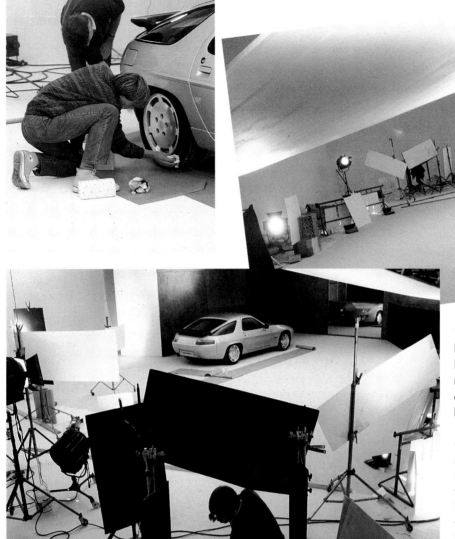

Top left: The car is cleaned thoroughly before the shot. **Above:** A wide range of lights and matts were used. **Left:** The masks and matts were employed to create shapes and reflections in the car body.

Often when I'm outside on location, shooting sunrises or sunsets, where I need quite long exposures, I'll still use tungsten and convert it back to daylight.
DW Why was it necessary to expose for two minutes?
JC I could put more and more light on the set to decrease the time, but it's not really necessary. Despite the movement on the camera I still need f.64 to get everything sharp, although the larger apertures are better from a time point of view. F.64, by definition, is a very tiny hole, so I need a longer period of time for the light to expose the film, and as this is 18 ASA it's slow. The slower the film, the better the definition, and as a lot of this work is going to be retouched I want the largest size transparency for the retoucher to work on. That inevitably means slow film.
DW Why are all of the lights bounced, apart from one?

achieve this in the studio, I've got to try and echo the set, which is meant to be a building, so I need some straight lines reflected on the car.
DW The actual shoot took about two days?
JC That is what I normally allow for this sort of work.
DW What sort of camera do you use?
JC An 8 × 10 Sinar.
DW And the lens?
JC In this particular shot, 360mm.

DW Film?
JC Ektachrome, tungsten.
DW What is the ASA?
JC That is something you only find out by testing. The advice sheet that comes with the film advises 18 to 32 ASA
DW Why do you use such a slow film?
JC This type of film is far more tolerant and controllable on long exposures. If I used a daylight film and converted to tungsten, the exposures and colour would be up and down all over the place.

JC When you look at a car studio wall it's curved where the wall meets the floor and ceiling. If it was a straight line, it would be echoed somewhere in the reflection on the car and spoil the panels. If a direct light is used, a reflection is created which produces a very hot spot somewhere on the car. The panel areas are all basically mirrors, just of a different colour and shape. So if I light the wall or ceiling or something like that I can tone and gradate that light, which is then reflected in the side of the car. Using reflective tungsten light rather than direct tungsten light enables me to try to simulate that car in the street with that beautiful sky reflected in the bonnet.

DW Why do you use tungsten light?

JC Most people who shoot cars shoot with tungsten, because it gives you a much better degree of control that you cannot get with flash or strobe.

DW Do you use any filters?

JC I usually use a correction filter, in this case a 5 red, which gives a small alteration bringing the film closer to neutral. Without it the film is rather blue and cold. As far as effect filters, I sometimes do use them, but rarely.

DW What aperture and speed did you finally end up with?

JC At 18 ASA it is going to be slow. My final exposures on the car were two minutes at f.64. On the background I did a bracket from four minutes down to 90 seconds.

DW Are all the technical decisions left to you?

JC Yes, when you're talking about aperture, speed, etc.

DW How many people are there on the set:

JC Usually myself, my assistant and the art director.

DW Is that all?

JC Yes. Most studios provide a resident assistant, and some photographers use two assistants. I must admit there are

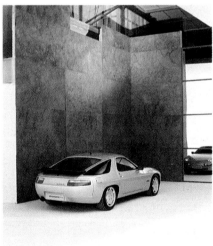

times when it would be nice to have two, but basically one assistant is enough for my needs.

DW How did you get the marbling effect on the panels?

JC We photostated the marble and sent it with a marble sample to Roger Vinney, a freelance scenic painter.

DW Are there any other particular preparations you do before you photograph?

JC Yes. When a car is new the suspension is always high. So it means I've got to weigh the car down, because otherwise the clearance between the body and the wheels is too high. I've put weights in the

CAMERA	8 × 10 SINAR
FILM	EKTACHROME TUNGSTEN, 18 32 ASA.
FILTERS	5 RED
LENS	360 mm
APERTURE	f.64
LIGHTS	TUNGSTEN

Left: To illuminate the set, Jon used a battery of tungsten lights (which are easier to control than flash or strobe). All of the lights were reflected, bar one, off the walls and reflectors and back onto the car. This allowed Jon to tone and gradate the light and avoid hot spots. A top reflector was used to bring light down from above thereby suggesting daylight coming over the top of the building, and a red filter neutralised the coldness of the blues.

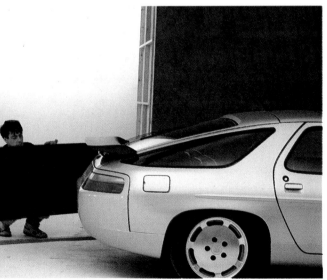

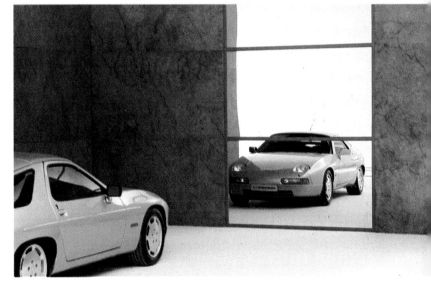

car to lower it – in this particular case I used boxes of nails. I've also painted the inside of the wheel arches black to improve definition.

Opposite top: Jon Cox uses a black hood while examining the shot to avoid being distracted by the lights. **Opposite left:** The car has to be moved on several occasions and masking tape is used to ensure it is replaced in exactly the same place. **Opposite right:** The set is built to this height to ensure there are no gaps in the reflections. **Above left:** The photographer's assistant uses a black matt to create a shadow on the car. **Above right:** Before the set is built to a sufficient length, the reflection shows up as white.

Advertising for alcoholic drinks is now facing similar problems to those encountered over the last decade by the advertising of cigarettes and tobacco products. There is a growing and ever-more-vociferous lobby in the Western World campaigning for a ban on all advertising for alcohol. Needless to say, advertisers and photographers are strongly opposed to such a ban, for if the total sum spent on drink advertising in any given year was lost to the industry there would be a very large hole in agency turnover and a substantial reduction in the work available to photographers, artists and illustrators.

While a complete ban on advertising alcohol is some way off, current restrictions are considerable. For example, the consumption of alcohol cannot be seen to be directly linked with sexual prowess or social or business success. And whilst advertisers have overcome this obstacle by associating the product with images evocative of a sophisticated lifestyle, even this approach may be banned in the near future.

In the face of this, many manufacturers will seek to sponsor sporting or cultural events to promote their brands, although in some countries even this outlet is being denied them. It will be a sad day for advertising in general if and when such a ban is enforced, because apart from the financial aspect, some fine creative work has gone into advertising the product. For better or worse alcohol is an integral part of the western way of life. As such, there is a strong case to be argued that it should continue to be marketed in a responsible and creative manner.

Photographer Ken Griffiths' evocative shot, taken from a series of work in progress entitled 'Panhandle', underlines the need for all top photographers to maintain variety and creativity in their work.

What is makes Sa Manz such a dr Water, o

About 20 kilometres north-west of Jerez lies the small fishing village of Sanlucar de Barrameda. It is here, and only here, that the uniquely dry Manzanilla sherry is made.

Sanlucar's coastal position gives it a cooler, more humid climate than that of Jerez.

Ideal conditions, in fact, for the development of "flor," a film of yeast that forms naturally on the surface of the sherry in the cask.

Not all sherries develop flor, but those that do are destined to become drier and lighter than those that don't. And none is drier or lighter than Manzanilla.

Served chilled, as it should be, it has a crisp freshness that makes it the perfect aperitif. Some aficionados even claim to detect a faint salty tang on the palate.

that
sbury's
illa
herry?
ourse.

e opened, the bottle should be
he refrigerator and the contents
ed within three weeks. (Not a
ask.)

ould also be no more than six
old when you buy it.

ke most wines, sherry does not
with age in the bottle.

ainsbury's, you can be sure the
illa you buy will be in the peak
ion.

supplied to us by one of the
utable bodegas in Sanlucar, and
ensures that it doesn't sit on the
very long.

ed, a bottle of Sainsbury's
illa costs no more than a bottle
ary sherry. Which makes it one
t's easy to acquire.

od costs less at Sainsbury's.

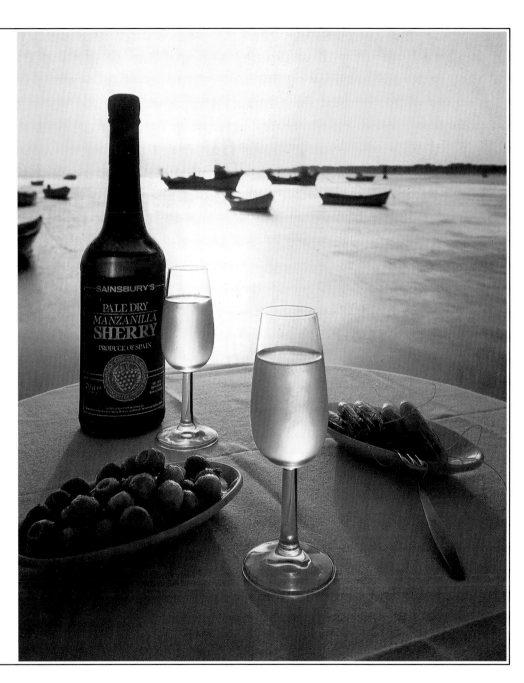

GORDON'S GIN

THE CLIENT	ARTHUR BELL DISTILLERS
THE BRIEF	TO PROMOTE GIN AS A DRINK WITH GREAT 'MIXABILITY' TO A NEW, YOUNGER MARKET AS WELL AS TO AN OLDER, ESTABLISHED ONE.
THE AGENCY	LOWE HOWARD SPINK
ART DIRECTOR	SIMON MINCHIN
COPYWRITER	ANDY IMRIE
PHOTOGRAPHER	KEN GRIFFITHS
ASSISTANT	GIOVANNI DIFFIDENTI
LOCATION-FINDER	JAN DAVIS
LOCATION	SLEEPY HOLLOW COUNTRY CLUB
RETOUCHER	STUDIO 10

As part of a long-running campaign, this shot aims not only to reinforce the brand image, but also to try to find new markets for the product by suggesting different mixers for it. The established market for this product is stable, but the client wants to attract younger drinkers as this sector of the market is constantly increasing and tends to spend more money. So, even though the ad features the most traditional mixer – tonic – the image that has been chosen is aspirational. Tied in with a game that is the fastest growing participation sport in the western world, golf, it reflects opulence and luxury.

The photographer's problem on a shot like this is to achieve a first-class result with the still-life, without the tight control of a studio environment. Ken Griffiths, the photographer, has cleverly succeeded in this without any extra lighting, using only reflectors to maximize what light was available. It was impossible to create this shot in one, simply because of the depth-of-field, so the foreground shot was stripped onto the background by a retoucher. The sky was also added later, because on location the day was misty and the sky was washed out. Weather conditions are something no

photographer or art director can control and they pose a great risk in location photography.

Interview with the Art Director

DICK WARD What was your brief on this particular job?
SIMON MINCHIN Gordon's have been running this series, called the 'mixability campaign', for a couple of years now, the idea being to increase the number of mixers people will have with gin. It's about trying it with different mixers, drinking it in different situations and at different times of the day.
DW Gin and tonic, though, is the traditional gin drink.
SM Yes. It just sprang up. We had a load of ideas on the wall, and this one was such a classic it possibly should have been the first one of the campaign. We were very keen to do it, but the client had some reservations at first, as they thought it might be 'classically gin' in the wrong sense, and appeal to older, more traditional gin drinkers.
DW Do you mean this particular image?
SM Yes. If you put yourself in the client's position, gin and tonic and golf is not exactly moving them into the 1990s. But then again it's the most popular mixer, and golf is the biggest growing participator sport among 20- to 30-year-olds. So there are lots of things that make it right, and we didn't do it with plaid trousers and a scrappy old golf course.
DW What made you go to the States for a location? Aren't there enough golf courses in the UK?
SM There were two reasons. Firstly, because the courses are more interesting there. It's partly that they are more

The finished ad maintains the sophisticated imagery of the Gordon's campaign and appeals to both a new and an established market.

G'n'T

manicured. This one is just fantastic, you could almost play snooker on it! Secondly, we were more likely to get good weather in that part of the States at this time of the year.

There are an awful lot of flat, grey days here in the UK, and to spend two weeks in Scotland or somewhere and not be able to take the picture would have cost as much, or more, as going to the States.
DW When you're doing location shots, do you have any insurance problems? If you had two weeks of rain and you couldn't get a shot, who would be responsible for this?
SM Weather insurance is phenomenally expensive. In general, weather is just something you have to live with. We couldn't have shot this in the rain, but as long as we had some light there was always the option of stripping in the sky afterwards. On this occasion we had sun peeping through clouds, which gave us perhaps three or four hours of light over the three days on the background shot. This meant everyone on the set had to

be very well prepared. Everybody had to know exactly what they were doing, so that when the light was right we could take advantage of it.
DW It's said that art directors are particularly aware of the weather!
SM I am when I am sitting there watching the sun disappear behind a cloud.
DW Is it more important to you to have the atmosphere of a good location or a good pack shot (an image of the product)?
SM Both. The pack shot comes up very large, but it's important for the product to fit into the picture, to be part of the overall composition.
DW How many rough ideas did you come up with originally?
SM I suppose about 14 or 15.
DW Was that for presentation within the agency?
SM Yes, but then we did some editing and whittled them down to ten or so.
DW Were these different concepts on one thought?
SM Each of them would have been an

The Art Director's rough serves as a guide to the photographer.

expression of a different mixer – apple juice, cola, bitter lemon, whatever. We could have produced some nice ads with rather strange combinations, say, gin and cola. But it gets to the point when you are making up new drinks which may or may not be acceptable. Obviously this is a problem that G n' T avoids.
DW And how many roughs do you actually show the client?
SM I think we presented three or four to the client, which we all liked as ideas and which were ready to be produced as projects.
DW How long do you get to come up with the ideas?
SM I think the time taken from us getting the brief to internal presentation would have been about two-and-a-half weeks.
DW That was for 14 ideas?
SM Yes.
DW Was there much retouching involved?

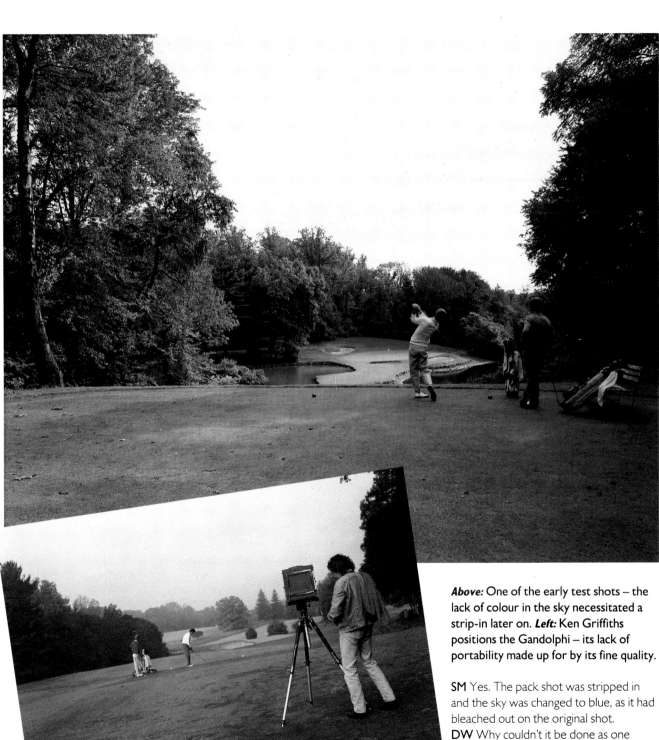

Above: One of the early test shots – the lack of colour in the sky necessitated a strip-in later on. **Left:** Ken Griffiths positions the Gandolphi – its lack of portability made up for by its fine quality.

SM Yes. The pack shot was stripped in and the sky was changed to blue, as it had bleached out on the original shot.
DW Why couldn't it be done as one shot?
SM Depth-of-field problems. If the bottle was in focus the golfers wouldn't be, so retouching was the obvious answer.

77

GORDON'S GIN

DW Is there a target market?

SM Yes, 25- to 55-year-olds at the top end of the market. But in a broad sense the 40- to 50-year-old drinkers are going to drink gin and tonic, or gin and orange, and they're not going to change. The target is new drinkers, people in their early 20s to mid-30s; people who are prepared to try something different, a new mixer. So it should be stylish, sophisticated, premium brand, etc., but it still needs to feel fresh.

DW What's the media spread?

SM It's 48-sheet and 64-sheet posters, and all the good magazines.

DW How did you choose the photographer?

SM I'd never worked with Ken Griffiths before, but I had met him and I thought he was easy to get on with, amenable, and you can talk about problems with him, which is important.

DW You were doing a still-life on location, whereas most still-lifes are done in the studio. Is that the reason he was chosen – because he had that sort of shot in his book?

SM Not particularly. The background shot has always been done separately and then either the same photographer or another has done the pack shot. We had the option of shooting the pack in London if we had a weather problem. But I was confident that someone with Ken Griffiths' reputation was not going to have any difficulty doing a pack shot wherever it was. I think it looks more natural outside. The trouble with studio lighting is you have so much control that the shot can be over-clarified. It was better to take advantage of the light that was out there, and the natural props that were available. The little plinth the drink is sitting on was actually part of a stone balustrade on the course.

DW It was actually there, not just a prop?

SM It was from the clubhouse on the course. It was all in the same environment, which makes for a better picture. Also, you've got everything in your mind, you're seeing it all together. If you're doing the pack shot separately and you fly back to England to develop your film, two weeks later in the studio you've lost the feel of it. Doing it all at one time also helps tremendously as far as the deadline is concerned. It was relatively easy to do, because we were doing the two things within a day of each other I could see that everything fitted.

I think you get a fresher more natural picture by actually having less choice on the lighting. I was very worried that it would look stripped in.

DW As this hasn't actually run yet, do you know if it's measurably successful?

SM It's the sort of thing where you won't get one ad to double sales, but what it should do is increase people's awareness of the brand. The connotation is that if the customer buys some gin, and it's Gordon's, he feels he's made the right decision.

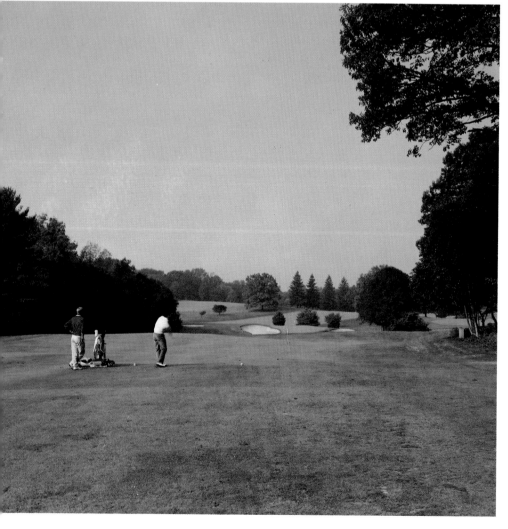

The manicured beauty of American golf courses determined the choice of location for the shoot.

DW How many people were involved with you on the set?

SM There was myself, Ken Griffiths and his assistant, and Jan Davis who did the research and the styling.

DW Did you use professional models?

SM No, we used the golf course professionals, as it seemed a little indulgent to fly two models over from England. Jan had been in touch with the management at Sleepy Hollow and had been given a tour of the course by one of the people who actually appears in the shot. They were very helpful. They were able to advise us on the factual details of the tee, things a golfer would spot, and they knew all the players, so we didn't ruffle the feathers of anyone who was actually trying to play while we were shooting. So, it was easier to ask them than to go through the agonies of casting.

DW How long were you in the States?

SM About eight days in all.

DW How long on the location?

SM We spent one day looking at the locations and making our choice, then we were actually shooting for four days.

Interview with the Photographer

DICK WARD First of all, what was your brief?

KEN GRIFFITHS In this case the client was pretty specific about what they wanted. The layout was the agency's decision. They specified the size of the bottle, and the position of it.

DW What are the logistics on this kind of thing? Do you transport all your own gear or did you hire in at the location?

KG It varies. In this case we used all our own equipment, even down to the two power packs. Because we didn't really know what sort of shot we were going to end up doing, we took it all with us.

DW How did you find the location?

KG We had a location-finder, Jan Davis. She also produced the shot. She went off

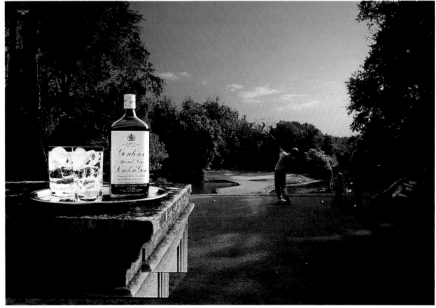

and came back with half-a-dozen pictures of golf courses in the States. We chose the States because their golf courses tend to be better-kept than the ones here.

DW What was your timing on the whole thing?

KG We had a meeting about a month before we went, and we were there for

Top: The first test shot featured the product on a table; later on it was placed on a stone plinth, which suited the overall perspective a little better. ***Above:*** The finished shot, prior to cropping and stripping in the sky and action background.

79

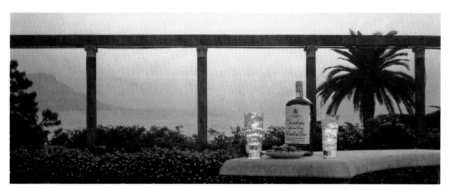

'N'ice

five days to get it – that was all of it. The final shot actually consists of three exposures. The idea was that it should look like the number 1 hole. We made it look like the teeing-off point, though it wasn't the actual tee. We chose a pretty location first, and then made it look like the number 1 hole.

DW How do you control your lighting on a location?

KG We just chose a certain time of day, and did the background shot first. Then for the pack shot we waited until we had a similar light. On the one we used the light was coming over my left shoulder at sunrise. I then had to do the background in the same kind of light so that it looked as though it had been shot at the same time. I tried to do the bottle and the background in one shot, but the depth of field was too much to hold and every-thing was a bit soft all the way through, so I ended up doing it as two shots.

DW So you had no artificial light at all?

KG No, just reflectors, and they are placed depending on where the light is coming from. Normally it would be just to light the bottle or the label. Again, you don't want to overlight it to make it too

crisp. We did take lights with us in case, but we didn't need them, we only used the reflectors to bounce back natural light into the shot.

DW Does this follow a similar format to the other Gordon's ads?

KG I tended to make the background softer, otherwise it would have looked too much like illustration. It's a slightly misty day anyway, so it looks a bit soft.

DW Was a misty day part of the brief?

KG No, not exactly. We wanted dawn or evening light, but the mist happened to be the weather at the time.

DW What would you do if you had bad weather? How would you have coped?

KG Well, you can get away with putting plastic covers over the bottle for the pack shot. In fact we didn't have good weather for the bottle. We had to wait around for two days until the light was good enough. The contingency plan was to reshoot it in England.

DW As a studio shot?

KG Yes. I would have used the building and shot the bottle in the studio. That would have been a last resort as I prefer to shoot on location, because then there is a more accurate light; in a studio you

can often get it too perfect.

DW Are you known for doing still-lifes on location?

KG The client usually asks me which way I would like to do it, and I like to try the location first. If it doesn't work I try it in the studio. Retouching these days is so advanced that it wouldn't be difficult to match up the shots. But it does get rather tedious and not too much fun.

DW How do you test if you're on location?

KG In the States it's easy, because we just went to New York and had the test exposures processed.

DW Do you do that as you're going along?

KG No. We did the first two days' shoot – the backgrounds, and the first two bottle shots. One worked and one didn't, so we went back and reshot once we'd seen the results. It wasn't until we saw it on the lightbox that we realized that it wasn't as sharp as it should have been. I think it was a problem with the lens. In fact I sent the lens off to be tested when I got back.

DW What models did you use?

KG We used the local course professional, and another golfer.

DW So they're not going to get paid?

KG Oh yes, they got paid quite well. But that's not the point. It is better to use someone who knows golf, the best golfer you can find, as long as he looks presentable and fits the bill.

DW How many assistants do you have?

KG On this shot I only had one.

DW Did you hire him in New York or did you take him with you?

KG No. I took him with me.

DW What camera do you use?

KG A Gandolphi

DW Any particular reason?

KG I've always used them. If I shoot 5 × 4 I still use the same sort of camera. I've always used it since college, and it works well on location. The camera is made of

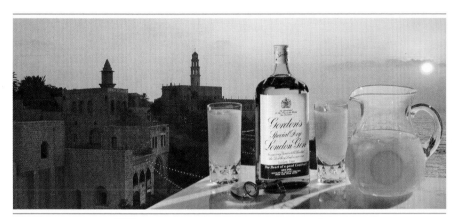

wood. If it's raining it is not affected, or if you are in some strange place and you drop it, you can glue it together, or stick it back, so it's very robust and easy to carry.

DW You work on plate?

KG Yes, 10 × 8.

DW What lens were you using?

KG On this we used a 210 Super AGA Schneider. It has a reputation for being a bit of an awkward lens actually. It is a big lens, and I don't think it's the best, but it is the only one they make of that focal length, which I needed because of the depth-of-field.

DW And what film were you using?

Opposite: 'N'ice, by Nadav Kander;
Above: Over Jaffa, by Ken Griffiths;
Below: And Ginger, by Kevin Summers – previous ads from the campaign.

Over Jaffa

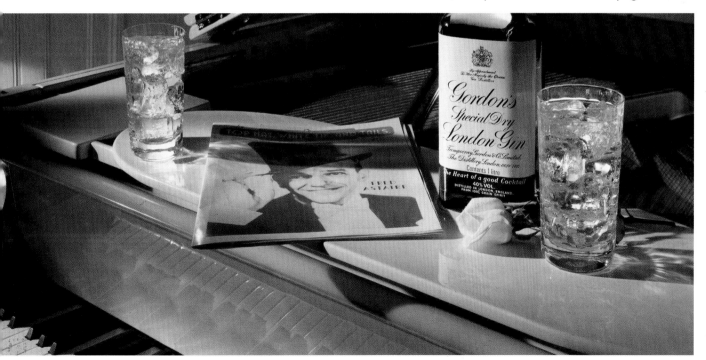

And Ginger

KG Kodak 6122, 5 × 4.

DW Was your brief to get a realistic shot?

KG No, but that is the reason they asked me to do it. They might have gone to someone else to do a totally different shot in a studio.

DW What about aperture and speed?

KG On the location shot it would have varied from one second to about one-fifteenth of a second. We had to have the guy moving, swinging his club. It varied from about a quarter of a second for the main shot to a fifteenth.

DW Did you use any filters?

KG On the main shot I used a grad (a filter which gives the effect of a coloured sky across the top of the image) to brighten up the sky, which was looking pretty misty, and I would have used an 81d (a light-balancing filter designed to decrease the colour temperature slightly for a warmer, redder tone) all the way through.

DW Are all technical decisions left to you?

KG Yes.

DW Was the art director on the set with you?

KG Yes, he says what he wants and I try to get it. He didn't want it too warm so I used an 81d rather than an 81ef. If it had been a brighter morning with more yellows I might have used an 81c. But it was a fairly grey misty morning, and of course each film varies, although we test it as much as we can before we shoot by exposing films from the batch to be used under different conditions and then assessing the processed results. It's a little bit hit and miss because labs also have different colour casts going through, and some labs run the colour a little colder than others. I think with this 210 Super AGA lens the colour wasn't as good as the second shot, for which I used a 165 Super AGA. We did two different locations for the one ad. We were

thinking we might run two different shots, and the results were certainly better on the 165 than on the 210. But when you put it all together the 210 version is the one that looked more unusual.

DW How many people do you have on the set?

KG It varies. Sometimes there are two assistants. If it is a car shot things need to be moved about, but often I only need one assistant. If I'd needed someone else I would have found him there, someone who knew the area.

DW What about the models, wardrobe and make-up?

KG We did our own make-up. We bought some clothes we wanted to use for the colour, and the models ended up with those – one of the perks of the job really! I don't play golf, so I didn't want them!

DW Were they classic golf clothes?

KG No, they were just golfing clothes. But we wanted to have certain colours – a yellow sweater and maroon trousers for one of them and blue and grey for the caddy. Then we reversed the roles for the second shot just for a bit of variation, and to keep them happy as well.

DW Is the final location genuine?

KG We made up the fairway and the tee, in the best looking spot, and added in the plinth afterwards, although that was a part of a building that was on the course.

DW When you were doing the still-life, how far away were you from the subject?

KG Probably about three feet (one metre).

DW Did you use any extension rings?

KG No, because with a plate camera the bellows extend.

DW Who does the retouching?

KG The agency use Studio 10.

DW Retouching seems to be widely used these days.

KG It's an artform I never really made good use of in the early days. If you're clever it can get you out of an awful lot of

A touch of Lime, also by Kevin Summers – another well-thought-out shot that reinforces the style and quality of the Gordon's campaign.

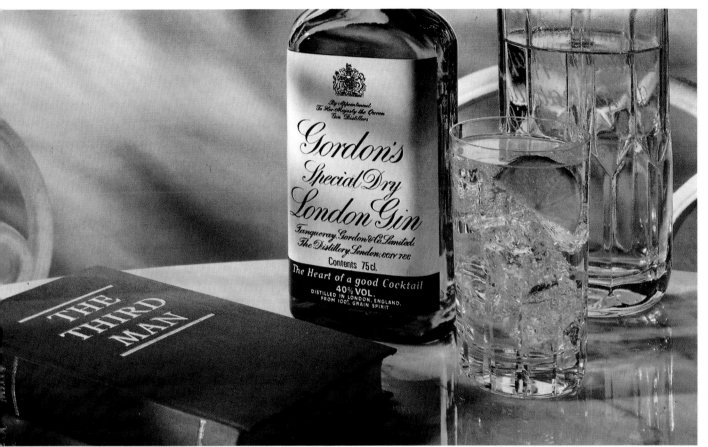

uch of Lime

trouble, as long as you have the basic material. For example, it always pays to shoot the location without anything in the foreground in case something goes wrong. Then it is possible to shoot the pack shot later and drop it in, but you can't if the pack shot is already in there. So I always cover myself with at least a background with nothing in it. However, in this case it didn't matter a great deal because we already intended to strip things in later on anyway.

CAMERA	GANDOLPHI
FILM	KODAK 6122 5 × 4
LENS	210 SUPER ANGULON SCHNEIDER
FILTERS	GRAD, 81d
PARTICULAR TECHNIQUES	RETOUCHING

COMPOSITE

There are many reasons for making an ad with two main images. One of the prime reasons is to elaborate on one picture, to show more detail in the second image, and thereby tell a story or set a mood. This method is often used for technical subjects, where the customer needs precise information on a particular product. For example, the main shot of a machine could be embellished by another shot, such as a close-up of a specific part of the same machine, which explains how it functions. Cut-away drawings can sometimes be used in the same fashion.

The photographer's problem with a brief of this nature is to tie in the composite image. Sometimes a stock shot may be used in conjunction with the main product shot, for example, to lead into the product in a humorous way. A film still in black-and-white of a well-known comedian, with an appropriate copy line to reinforce a joke, could lead to a modern shot, in colour, of the product. This kind of graphic solution can be attention-grabbing, but is also cost-effective: the only real expense is the contemporary shot because the cost of the archive would still be minimal.

Where two new images are created to be used together, the abilities of the most experienced photographer are tested, because the problem is to duplicate the light on the location shot in the studio, so that the impression given is that one shot has been used.

The problem of selecting a photographer from the art director's point of view is to find someone who is a perfectionist, someone who will not be happy until the close-up shot is an exact duplication of the lighting on the location. To produce work of this calibre the photographer also needs a production team to solve the problems of location finding, and prop buying.

JUST ADD WATER.

A superb example of Nadav Kander's sportswear photography, for Speedo Swimwear.

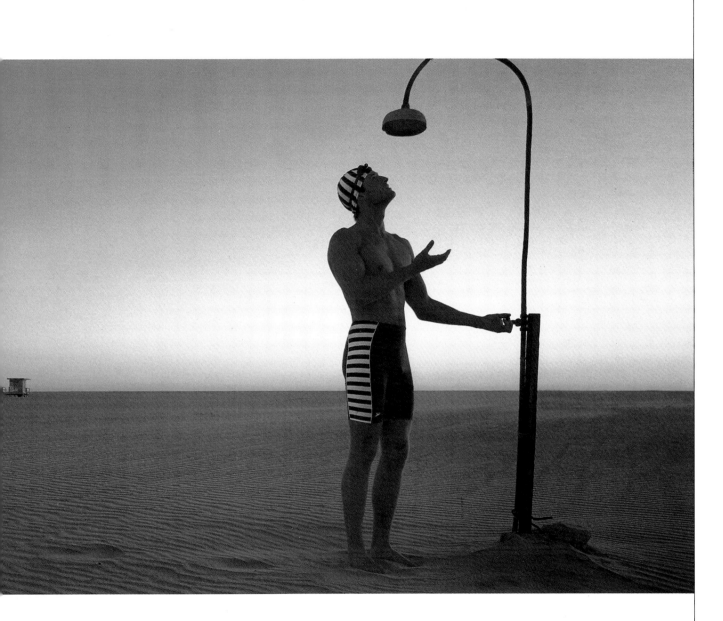

CUT TO CUT THROUGH WATER. SPEEDO®

SEIKO

THE CLIENT	SEIKO [Hattori U.K. Ltd.]
THE BRIEF	TO SELL A SPORTS WATCH SUGGESTING ITS TECHNICAL SOPHISTICATION, USING A CLOSE-UP SHOT
THE AGENCY	BURKITT WEINREICH BRYANT CLIENTS & CO LTD.
ART DIRECTOR	ROBIN SMITH
COPYWRITER	ROBIN WEEKS
PHOTOGRAPHER	NADAV KANDER
MODEL	BRIAN SOLANO/ MODELS ONE
PRODUCTION	FIONA BOURNE
ASSISTANT	ALLAN MCPHAIL
STYLIST	GILLIE DEAN
LOCATION FINDER	PATRICK ELLIS

The purpose and function of a wristwatch hasn't really changed since its invention, so manufacturers must appeal to the customer in a far more imaginative way than simply by selling a timepiece. All watches tell a story about the wearers, and how they perceive themselves, and there is a multitude of reasons someone might buy a watch. So a campaign to sell watches, especially at the quality end of the market, must say a lot more about the watch than its ability to keep perfect time.

For this product the agency had already used extreme close-ups of the watch, with some marked success, and inspired many imitators. They felt it was time to take the campaign a step further, and create more interest by adding a story line and a location shot.

The location shot was comparatively straightforward, although it was a challenge to show what looked like a winner crossing the line on his hands. Once the logistical problems were solved, the photographer managed to complete the shot in an afternoon; although not finishing until late evening, when there was, finally, no more light. The whole image was put together in less than a week.

Interview with the Art Director and the Copywriter

DICK WARD First of all, what was your brief on the campaign?

ROBIN WEEKS The brief was to stress the technical sophistication of the watch, but also show its good looks, and to remind consumers of Seiko's pre-eminent position as the number one brand in sports watches, as they are the official timekeepers to British Athletics. Although Seiko are known as technical leaders, we also wanted to stress the kudos of owning an object like this, as well as the detail and quality of design.

DW Why did you think of showing a close-up of the watch?

ROBIN SMITH Last year the agency initiated a consumer press campaign which set the style. The big watch became almost a trade mark. A watch filling a page looked very impressive, so this year we had to develop that idea – keeping the look, but adding a story.

RW It's surprising how the huge close-up of the watch sells. Some of our competitors followed the lead that Seiko took last year. Although last year's campaign was very simple, there weren't many campaigns about featuring big watches, so it really worked.

RS Although there was no number or address given on the ads, people were tearing the ads out and saying 'I want a watch like that'.

RW The first ad in this series got a similar response. There was no phone number or address, but by 11 o'clock the next morning Seiko had received 40 phone calls asking 'Where is the watch available'?

RS The problem was that the ads were still rather basic – a pretty picture with a large watch. So there wasn't enough of a concept for the overall campaign. Our brief was to try to use the large watch, but also put a story to it, to give it content and intrigue or interest. This wasn't easy,

because if you've got a large watch dominating the ad, there isn't a lot of space for anything else. So we came up with the idea of a composite ad, with a small photograph of a scene including the kind of person who might wear the watch.

RW As watches are so prevalent in magazines, especially just before Christmas, we had to show more than just a shot of a watch. So we thought it was really crucial to actually give an idea and a look to the ads that would make them different, and give them a story.

RS Obviously the running of the marathon on one's hands is the 'running' of it on the hands of one's watch, taking the split times that you need when you run a marathon. One of the watches in the range is self-generating, whereby movement of the wrist powers the battery. It's the first quartz watch of its kind and houses the world's smallest generator.

DW How is it different to a self-winding watch?

RW It's the kinetic movement of your wrist that powers the battery, and that's a world first. The chronograph also has the slimmest quartz movement in the world, which is a strong selling point. There are eight watches being launched this year, two or three of which are technologically ahead of the competition, with the other five being style leaders. Our job was to find a campaign that could marry those two elements. We felt we wanted to do a story based entirely on technology, but we couldn't spread that over the whole range. So the compromise was to find a formula whereby we could put technology in and marry that to a particular lifestyle, as exemplified by marathon runners.

DW Has the campaign been successful?
RS Yes, so far, and it hasn't run for long.

The combination of live-action and studio close-up shots demonstrates the versatility of the photographer.

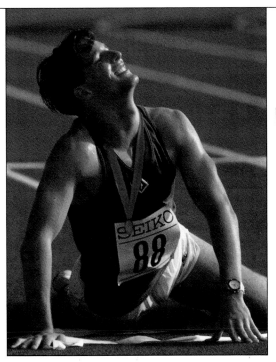

RUN A MARATHON
ON YOUR HANDS?

Hands that have timed the world's best.
Hands that can log your split times, race times, somebody
else's time at the same time; up to six hours
on the stopwatch; to one fifth of a second on the tartan;
pressure-tested to 150m below sea level. From the official
timer of British Athletics, the Seiko Sport-Tech.
After 26 miles it'll look a sight more elegant than you will.

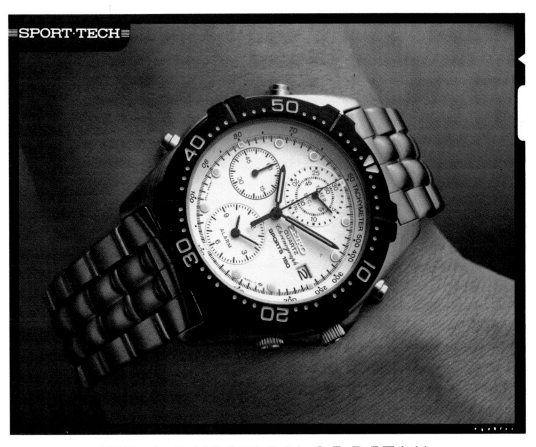

IT'S A QUESTION OF DETAIL

SEIKO

SEIKO

Right and opposite: The Art Director's first rough visuals showing both landscape and portrait versions of the ad. The client was particularly concerned that the athlete should look like a winner. **Below:** The athlete's pose was modified, and a medal was added, to clearly show that he had won the race.

DW How do you get your brief?
RS It starts with the client's approach to the agency; with how he thinks he wants it presented. Then the brief passes to planning, and they decide what sort of strategy we should adopt. When they've decided how it should be handled, they write a creative brief which goes to the client for approval. By the time it reaches us we have a defined area in which to work, but one which is still loose enough to provide creative opportunities.
RW We came up with three completely different campaigns, but one was impractical because of cost, and the account men thought the other one didn't

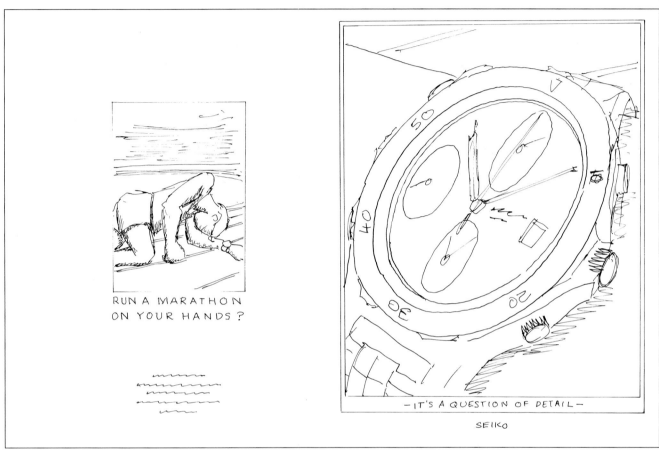

RUN A MARATHON
ON YOUR HANDS ?

— IT'S A QUESTION OF DETAIL —

SEIKO

talk about the watch enough.

DW As you wanted to create a mood, what sort of market are you aiming for in terms of age, etc?

RS Primarily an active sort of person, who's successful and competitive.

DW What's the media spread?

RW Sunday supplements, and some exposure in sports and running magazines for the sports watch.

DW How long did you take to come up with this idea?

RW We had a month to mull over the problem, and a few weeks to knock it into shape. The people from Seiko UK had to go to various meetings in Japan to have the overall strategy approved by the head office, who say 'Yes' or 'No' over the advertising here. That's why we had to get it done quite quickly. Since then, it's

been a case of solving problems as we went along. The client was worried that in this particular ad it was important that the model didn't look like a loser. 'Run a marathon on your hands' is a good line, but the client was worried that he'd come across as if he's lost the race. That's why it was a tough shoot. We had to convince the client that we could create the shot, show glamour and yet at the same time show someone who was totally exhausted. We didn't actually see that as a problem, but the client did, initially.

RS We proposed other concepts as well.

RW For the marathon man we tried out all sorts of things. We had the victory clench, and we tried him on a road instead of on a running track, but eventually we came back to the original layout, and convinced the client we could

make him a winner. The medallion round his neck, which is actually quite discreet, confirms that he's won the race.

RW It also doesn't detract from the shot and the client's happy the guy is acknowledged as a winner.

DW How did you decide which shot to do first?

RS The point is that the runner is a small picture on the finished ad, and the big shot has to imply that it's an enlargement from that shot. So if we'd shot the watch first, and then taken the shot of the guy running on the track second, the two shots would have never married. So we did the small shot first, in order to see where the precise position would be – against his wrist, or on his running shorts. Then we reconstructed that in the studio, including the exact lighting, to achieve a

89

correlation between the two shots.

DW Is the idea of the campaign to sell a new product or reinforce Seiko's name?

RS Both. It's as much a corporate campaign as to demonstrate that Seiko continually put out revolutionary or innovative products.

DW Is a watch like this sold as a functional object or as a cosmetic one?

RS It is designed as a functional object but has to be an attractive accessory, so it's probably sold on its cosmetic appeal.

RW They're very much a personal statement about the person who's wearing them. They are, in effect, a piece of clothing, but a very important piece. They're not like a jacket or a shirt, which you change every day.

RS When you're selling quality watches, the customer not only wants status and prestige, but also needs to know that their watch is a leader, functionally and technically.

DW Were there any particular difficulties with these shots?

RW The reason you don't actually see that many large watches on hands is that hands look so ugly when they are enlarged. The watch looks great, of course, but the hairs and the veins on the hand, together with any imperfections in the skin, look absolutely dreadful. For many years Seiko actually refused to do enlarged watches, because they believed it was impossible to find a good-looking wrist to carry the watch. So one of the main problems was finding the right wrist. Very few people have decent wrists when they're enlarged to that degree.

DW I was going to ask you, how you chose the model.

RS A lot of it was finding someone who was willing to shave their hair off. But the most important thing is that the pores must be very small, because when the image is enlarged they can look like craters. So we had to find a young skin, and good bones to take the width of the

strap as it doesn't look right on a small wrist on which you only see the face.

RW The strap is an important part of the watch's fashion appeal, so we had anticipated some trouble in finding a model whose wrist looked just right.

DW So you have to use the same model to do the running shot and the close up?

RW Not necessarily, but we were fortunate in this case, apart from an old scar that we hid with the watch. The model was right for both shots.

RS Even though you would think it's going to look strange when you look at a man's hand and arm without any hair on it, the fact of the matter is that when you look at a wrist you don't see the hair, so you don't make that kind of judgement. It's strange how photography can play tricks like that.

DW So you did have quite a problem finding the model?

RW Only as far as the wrist was concerned. But we were lucky with Ben, as he has the kind of looks that are very much in fashion today – straight out of *Chariots of Fire*.

RW We wanted someone who looked basically beautiful. We cheated a little, in the sense that this guy is not like the average marathon runner, who is generally thin and muscley. In terms of build he's more like a 400-metre man, but in the cause of aesthetics we thought it was justified.

DW So how did you choose the photographer?

RW Nadav has a good sense of the aesthetic; a feel for beauty, and that's very important for a watch.

RS He has an eye for detail and a reputation as a perfectionist. His work is beautifully lit, and beautifully crafted. He is a perfectionist in every sense.

DW Did you have any problems on the location shot – like insurance, for example, in case of bad weather?

RS It didn't really matter for the

marathon man. If it had been raining it would simply have been a different shot.

RW We spent all day and all evening, and had five minutes of sun, but we got the frames from that. They were the best. It still looked quite good in the grey, but we were lucky to get the sunny shots.

DW You extended the shadows too?

RS The original shot was beautiful, but I knew that as soon as it was printed it would go flat. So we used a little re-touching to darken shadows and brighten highlights. Because of the way the lens reduces perspective the shadow under the man did not look real – he looked like he had no legs – so we extended the shadow to give more depth.

DW How long will it run for?

RW The main burst is September to Christmas, because that is the most important watch-buying time. You advertise in the summer to keep the trade happy, but you're actually looking to sell at Christmas.

Interview with the Photographer

DICK WARD What was your brief on the Seiko job?

NADAV KANDER To make the close-up picture, which was the larger, look exactly as if it were a zoomed-in shot of the smaller picture. So the light had to be the same for both, which meant that natural light had to be recreated in the studio. The other point was that the guy had to look like a winner, even though he had collapsed over the line.

DW Couldn't you just enlarge from the first shot?

NK It would have been impossible to do that, as you'd just get an incredibly grainy and bland picture of a watch.

DW As the model was down on his hands, and you had to make him look like a winner, what was your solution?

NK The client suggested having a medal around his neck, and according to the

PRODUCTION SHEET

NADAV KANDER
PHOTOGRAPHY

17 BRITANNIA ROW, LONDON N1 8QH TEL 01 226 9217 TELEX 23374

DATE 4th July 1988

CLIENT/PRODUCT Seiko JOB N

AGENCY Burkitt Weinreich Bryant TEL

LOCATION Crystal Palace Sports Centre, Ledrington Road, SE19 TE

CONTACT Brian Stoddart T

HOTEL

CREW/PERSONNEL	NAME
Photographer	Nadav Kander
Art Director	Robin Smith
Copy Writer	Robin Weeks
Client	John Peel
	Charles Carr
Traffic	
Production	Allan McPhail
1st Assistant	
2nd Assistant	Patrick Ellis(Page 840 7000-439 81
Location Co-ord.	Gillie Dean
Stylist	
Modelmaker	
Set Builder	
Catering	
Hairdresser	
Make Up Artist	
Runner	
Location Van	
Vehicle Transport	Brian Solano (Models One)
Model	
Model	

NADAV KANDER
PHOTOGRAPHY

17 BRITANNIA ROW, LONDON N1 8QH TEL 01 226 9217 TELEX 23374

DIRECTIONS TO LOCATION - CRYSTAL PALACE SPORTS CENTRE

Crystal Palace Sports Centre
Ledrington Road
Norwood
SE19

Tel: 778 0131

After crossing Vauxhall Bridge, drive past the oval and then into
Harleyford Street. Carry on straight, across Kennington Park Road
and into Camberwell New Road.

Bare right at Camberwell Green and drive along Denmark Hill which
leads into Herne Hill.

At the bottom of Herne Hill go straight across into Norwood Road
and then take the first left into Croxted Road.

Carry straight on along South Croxted Road and
Park, then right, into Coll
turn right,

MEDIA PLAN

BURKITT WEINREICH BRYANT CLIENTS & COMPANY LIMITED

CLIENT HATTORI(UK)LTD PRODUCT SEIKO WATCHES PERIOD OCTOBER'88 - JANUARY '89

PLAN NUMBER 2 Booked

DATE 14.10.88	SEP	OCT	NOV	DEC	JAN	No.of Ins Booked	Total Cost £
Harpers & Queen			Nov(V)	Dec(L)		2	8,000
Woman's Journal		Oct(L)		Dec(L)		2	7,400
Cosmopolitan		Oct(P)				1	8,200
Cosmo Man			Nov(T)			1	8,000
M & S Magazine		Christmas (P)				1	11,000
Penthouse		Oct(AS)	Nov(T)	Dec(CS)		3	5,000
What Car		Oct(AD)	Nov(CD)			2	15,247
Car			Nov(P)	Dec(AD)		2	12,137
Golf Monthly		Oct(P)		Dec(V)	Jan(P)	3	5,670
Management Today		Oct(AD)	Nov(AD)	Dec(P)		3	23,100
Business			Nov(P)	Dec(AD)		2	8,400
Country Living			Nov(V)	Dec(P)		2	7,000
GQ			Nov(T)			1	3,130
World			Nov(V)	Dec(P)		2	4,680
What Hi-Fi				Dec(CD)		1	4,024
Homes & Gardens				Dec(L)		1	5,600
Official Olympic Journal (Pub. July '88)						1	3,124
Geographical			Nov(V)	Dec(P)		2	1,300
Supercar Classics				Dec(P)		1	1,150
Marie Claire				Dec(L)		1	3,500
					Total £		145,662
					GRAND TOTAL £		501,756

research, in the London marathon you actually get a medal as you cross the line. But I also had the finishing tape on him, and his facial expression shows that he hasn't lost. He shows some pain and exhaustion, but also happiness.

DW Who handled the research and production?

NK It was all done within our studio, with Fiona doing the groundwork, but with me overseeing it. She set everything up, she found the stylist, got the location finder and I approved them. First, the agency director wanted it a bit like *Chariots of Fire*, with old 20s-style shots. They were going to be plain blue and white, which can't be bought, so we were going to have them made. However, this would have made it impossible for me to do it to schedule, so they eventually changed their minds and made it modern.

DW What exactly did the stylist do?

NK She bought a lot of running gear for us to choose from, and she found the medal to hire. She also made sure the number was in the right place; should it be up high on the chest or lower? It's very important to get these things right. The trouble was, when he put on all this brand-new gear he looked so fresh we had to have him exercising and running about before the shoot to make it look as if he had just run a marathon.

DW Did she do the make-up as well?

NK Yes. She used gel on his hair and some flesh tones on his face and arms.

DW Why flesh tones on his arms?

NK To make them more appealing, a little sun tanned, and as if he'd been exercising.

From the top: The production sheet shows the shoot is run with the precision of a military operation; Instructions on how to reach the location; The media plan shows the precise sales targeting for the ad; The crew wait for a little sunshine.

DW Did you find the location for the outdoor shot?

NK We thought of the running track at Battersea first of all, as the track is such a good colour, but the art director wanted more atmosphere. Crystal Palace is the best one for stands and it's the one where international meetings are held.

DW So you didn't have to do a recce?

NK We had a location-finder check out five different locations. This confirmed that Crystal Palace was the biggest and had more presence than the others. As

we needed some atmosphere, it had to be the place. I thought it could have been very nice with a whole race meeting; stands packed, people in the background, people running behind him.

DW The budget wouldn't run to that.

NK No, it was timing.

Below left: The Art Director positions the model and product. *Below:* Nadav Kander demonstrates the pose he wants. *Bottom left:* Capturing the tape breaking.

DW What was the timing on the shoot?

NK We produced it and shot it in a week. The actual shoot was a day on location, a day in the studio and a day in between.

DW What would have happened if you'd had really bad weather the day when you were out there? Would you have had the confidence to get a shot without even half an hour's sunshine?

NK Before I went I thought that even if it was raining it wouldn't matter with a shot of the marathon. If people look at that ad and think it's a reportage picture, then I'm happy. I did not set out to make an aesthetically beautiful picture, I wanted to make a realistic picture of a marathon, so if it was raining I might have got an even more realistic picture! As it happens, we did choose pictures which were side-lit.

DW Did they give you a rough to follow?

NK Yes. Although I didn't follow it exactly, I matched its design.

DW Did you use an assistant lying down in the position for the final photograph, to test the location shot?

NK I couldn't use a polaroid because I was using such a long lens. I knew before I went there how I was going to do it – at a certain height and very, very tight in – all sweat and guts! I wanted it to look like a 'grab' shot (like a press photograph), to look like the guy has run off the track and he's shattered. I knew I wanted the lines

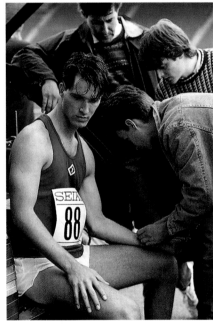

going at an angle and nothing else in the picture, but Alan did lay down on the track so that I could get my distance.

DW On the technical side, what camera did you use on the location?

NK A Nikon with a 600mm IFED lens.

DW What was the reason for using a 600mm lens on the location?

NK I was about 120 feet from the subject, so there were two reasons for using that lens. First of all, because we didn't have a race meeting I wanted only him in the frame. Secondly, that lens is made for sport photographers and that's what it's marketed for. It gives it a reportage – sporty look to the shot. And what happens with this lens is that you get a small depth-of-field, so his head and the face and watch are in focus, his feet are out of focus and the track is totally blurred. There are two ways of doing it. If I'd done it at a race meeting, I probably would have used a wide-angle with the whole track and loads of people. But to make a reportage you've got to use that long lens to get that 'from the hip' feeling.

DW Any filters on that?

NK I used a 5 red and an 85c warm-up. The red makes it look more realistic, but the red alone will produce a golden look.

DW Is that for flesh tones?

NK No, just for the feeling. The light was very cold and flat so I needed to add contrast. I added more red to the red of the track – to warm it up, to make it look hotter, more appealing and more gutsy.

DW You didn't have any lights on the location shot?

NK No.

DW What was your aperture and speed on the final shot?

NK The speed would have been about a 30th and the aperture would have been quite open, so that I got that lack of depth of field, probably f.8 to f.11.

DW What camera on the studio shot?

NK We used a 5/4 Linhof.

DW Did you use your assistants to test the studio shoot?

NK Yes, many times. I did two or three tests, about five or six frames for each one, which took about nine hours in all.

DW Once you had tested and set up the right aperture, did you touch it again or just concentrate on the image in the viewfinder?

NK Well, there's no viewfinder on a 5/4, but I do have to adjust sometimes, because at certain angles a watch glass acts like a mirror and will pick up much more reflection than expected, so I do bracket it slightly – in other words, take a number of frames at different settings to ensure I end up with the correct exposure somewhere amongst them.

DW What lights did you use in the studio and how did you arrange them?

NK I think the most important thing when doing a still life is to recreate natural light, so that it doesn't look like a set-up in a studio. Probably about 90% of still-lifes I'm asked to do are like that. In the 1970s

Opposite right: A long lens was used to foreshorten the background. *Below:* All action shots require numerous exposures before a satisfactory image is achieved.

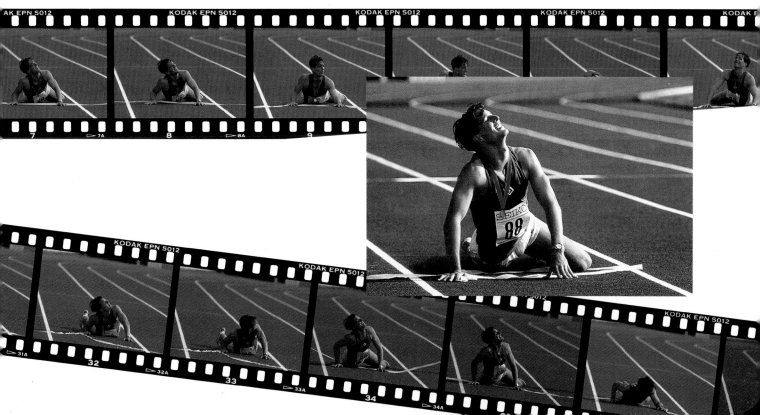

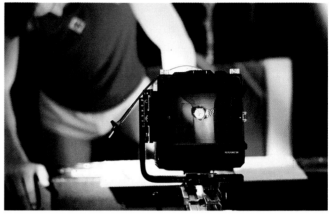

it would have been a different story. A still-life would have been a table top, or in the case of Seiko possibly a scene with the watch, a headband and maybe a race number, as if it was shot in a changing room of a gym, or something like that. If you look at the still-lifes I do, all of them could either be outside, or in a cellar of a vineyard, or in a packing house of a fish-monger. I always try to think of how the light would be, and try to recreate in the studio the beautiful light that you get outdoors, or the kind of light you might get through a small window high up in a large room – that north light through a large sash window. In this case I had to think of exactly how it was lit on the location shot. There was a stand to the left which was filling in a bit, and I had a big sky to the right. I had to achieve the feeling of natural light from a large, overcast sky to the right, so I had a large soft screen on my right which created the same effect as an overcast day when the sun is likely to break through at any time.

DW How do you make up this light?

NK I've had a big screen made. It looks like a trampoline, with strobe lights behind it. If I just used plain strobe lights it would look too harsh and obviously like a studio shot. So when the watch is in position I want to be able to look left and imagine that's an overcast sky. At the same time it was getting quite black

Top left: A 'swimming pool' light recreates exterior lighting. *Top right:* The Linhof facilitates precise results. *Above:* The model holds an awkward pose.

behind me so I didn't let any light hit the part of the screen immediately over my right shoulder.

DW So you masked that area off?

NK I graduated it rather than masked it (i.e. progressively blocked out the light across that area of the screen), but

nothing too harsh because I was duplicating the outdoor shot. If I was outside with the direct sun I could have masked off, but on an overcast day you wouldn't mask off, you would just graduate the light off so that everything is happening softly.

DW So you had more light at one end of your screen than at the other?

NK Yes. I was duplicating what was outside. The light was mainly a soft light. And then, where the sun was supposd to be I placed a directional light, using a snoot which makes it even more directional, coming through the screen to make it look as if it was coming through the clouds. That way I made quite a hard light down his arm, and then I filtered it so that the studio lights were the same balance as the location shot.

DW What's a snoot?

NK Just a roll of card, slightly narrower at one end so that it's cone-shaped. It fits over a light to make it more directional.

DW What filter did you use?

NK It was warmer, but not as warm as the other shot, probably an 81 b.

DW What aperture did you end up with on the studio shot?

NK I would have been at 32.

DW How did you fade the light off?

NK Well, these lights have barn doors on them, so one would have been wide open, and the other partially closed. Then

I had the round directional light, which was the main light, giving a hard line just as if the sun was above – as it was outside. The main thing on this kind of shot is, in addition to the technical side, thinking about how to obtain the outside light in the studio. It's very difficult to copy light. You see light on a tranny and if you want to duplicate that in a studio, it's difficult.

DW Did you have a make-up artist?

NK We did the make-up ourselves, just rubbing in a little cream flesh tone.

DW What about the background?

NK The background had a print of the location shot, at an angle that wouldn't reflect from the screen, about 30 inches (105 cm) behind the model, just to give the colour of the track in the background.

DW Did that come out in the final shot?

NK I think it did, just a hint of the colour. The main thing behind him is his leg. He had his leg up, and you find that if you light it exactly as it was on location, when he puts his leg up it's lit the same way.

DW At what height was his hand?

NK Table height, which makes it easy for him and me.

DW What tripod did you use?

NK A cambo, which provides the sort of flexibility you need for studio work, as well as the sturdiness required to support medium and large format cameras without causing vibration.

DW Do you remember the power on these lights?

NK It would have been 5000, 5000, and 4000, probably 14000 joules altogether.

DW How much time did you have to set up in the studio?

NK I nearly always do still-lifes in two days. I try never to do it in one day. I like to do a set-up day when I test everything, then the shoot day when the art director comes in. But in this case we had to do one day on location, and one day in the studio. Fortunately, it worked.

DW The art director mentioned that wrists look ugly in close-up. How did you manage to solve that problem?

NK We had to shave his wrists, and it didn't look bad. It doesn't look natural, but you wouldn't notice it as the watch is so dominant, and it's what the Japanese want. Even if I don't like something, or don't think it looks right, I'm not going to shout about it or stamp my feet. A good ad is always made with a fair amount of compromise on all sides. I think that is a very sound policy.

Below: Blue marks used for focussing. *Centre:* A precision close-up. *Below left:* Screened strobes and snooted directional light simulate an overcast day and sun through the clouds.

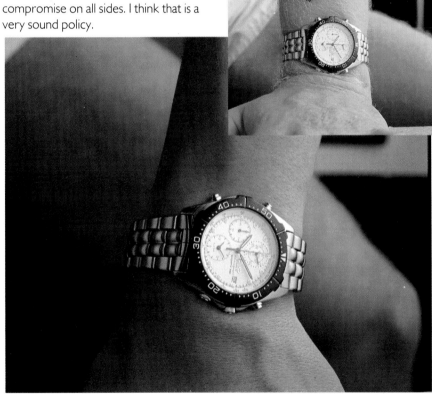

CAMERA	ON LOCATION, NIKON; IN STUDIO, 5/4 LINHOF
FILM FILTER	ON LOCATION, 5 RED; 85c; IN STUDIO 81 b
LENS	ON LOCATION, 600mm IFED;
F STOP	ON LOCATION, f8 f11; IN STUDIO, f32
LIGHTS	IN STUDIO, STROBE LIGHTS
SPEED	ON LOCATION, 1/30;
TRIPOD	CAMBO

The creation of an arresting landscape photograph involves a combination of several factors. Obviously the photographer has to be in the right place at the right time; hopefully the weather conditions will be kind, although this isn't necessarily essential to a brilliant photograph, and there usually has to be something impressive to photograph. This last factor can be inhibiting for the amateur photographer when, for example, he is faced with a stunning view from the top of a mountain, doesn't know where to point the camera first, and when the prints come back from processing they never ever capture how the scene looked in his mind's eye. The amateur, more often that not, will be using a 35mm camera with a standard 50 mm lens and when this combination is used to photograph a vast landscape the details that appear so dominating in the visual image very seldom have the same impressive quality when transferred to a print.

The same is true when trying to capture a seascape, especially when the sea is rough. When a standard camera is held approximately six foot above the surface of the water a force nine gale in the North Sea can look like a boating lake in a park. One of the secrets to avoid this is to keep the camera closer to the surface of the water, but most amateurs would be loath to risk their equipment in this way. For a professional, however, this is all part of the risk of the job, although the insurance premiums to cover this can be somewhat excessive.

The most impressive thing about the series of photographs over the following pages is that the photographer has produced a great result from very little to work with. This also proves that it is not always necessary to be in the most exotic locations in the world to achieve first class results.

This exciting action-packed image was shot by photographer Duncan Sim in New Zealand, and commissioned by P.P.G.H/JWT for Van Neille Tobacco. Duncan used a 35mm Nikon and strapped himself onto a following yacht.

THE CLIENT	EASTBOURNE TOURIST AUTHORITY
THE BRIEF	TO REVAMP THE IMAGE OF EASTBOURNE AS A LOVELY PLACE TO VISIT
THE AGENCY	HJSW
ART DIRECTOR	PETER DENTON
COPYWRITER	OLIVER WINGATE
PHOTOGRAPHER	DUNCAN SIM
ASSISTANT	MALCOLM

Eastbourne is a pretty, but average English seaside town. Today Eastbourne faces stiff competition from other similar resorts. Moreover, the number of domestic holidaymakers in the UK has been consistently falling in recent years, as the delights of package tour holidays and cheap short breaks have lured them to the Mediterranean and across the Channel. So, the Eastbourne Tourist Authority employed a London agency

EASTBOURNE

and a top photographer to promote the most attractive aspects of the town. The sheer quality of the resulting images justify the client's choice. Indeed, the campaign has been very successful, attracting write-ups in the press and winning awards from the travel industry.

Interview with the Art Director

DICK WARD What was your brief?
PETER DENTON To revamp the image of Eastbourne as a place to visit. It had an old-fashioned reputation as a place that people go to when they retire. So the client wanted us to bring the age-group down, by saying that Eastbourne is actually a more surprising place than you think. It has good restaurants, good night-life and it's an attractive place as well, surrounded by beautiful countryside. We also highlighted its family appeal, as there are lots of things to do that would entertain kids – the Red Arrows go there once a year, for example. The rocks called the Seven Sisters are famous, so we couldn't leave them out. And there's a windsurfer in that shot too, to make it obvious there are watersport facilities as well.
DW How did you choose the photographer?
PD I had a good idea of the look I wanted, which wasn't in the postcard style. I looked at quite a few books, but Duncan Sim's seemed to have that edge of vitality. He happens to have been brought up in Eastbourne so he knows the area, which helped because we had

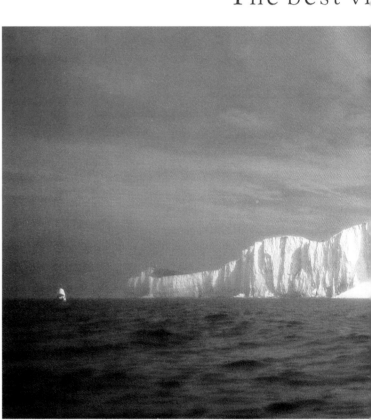

The best vi

f Eastbourne. By a long chalk.

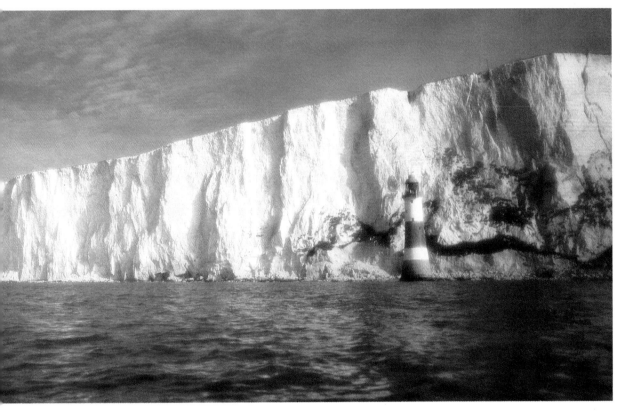

EASTBOURNE

to go and do a recce for a day.
DW How many roughs or ideas did you come up with?
PD There were about 10 ideas that weren't used, so there must have been about 14 in all – the budget didn't allow us to use more than four pictures, supported by a single headline for each.
DW Is there a target area?
PD Yes, London, with the intention of bringing the age group down to 25-45.

DW As you are selling a whole town, who exactly is the client?
PD The client is the Eastbourne Tourist Authority – a group who work with the council and are also answerable to the local hoteliers.
DW What about the logistics, like hiring boats and so on?
PD We had a lot of help from local businessmen, who were in the yacht club. They let us have the use of their boats.

The finished ad employed a stunning shot created from essentially very little subject matter.

We set off in a boat at four in the morning to try to catch the sunrise. It was a two-hour trip along the coastline to get there; then we were waiting around for most of the morning until we got the shot of the cliffs. We struck lucky on the way back because we managed to get the pier

Left: It was essential to get up early in the morning to make use of all the hours of available light. *Below:* Two of Peter Denton's marker visuals for the ad. *Opposite top:* Duncan Sim captured the shot of the pier by keeping the camera almost at water-level. The two jets were cleverly retouched in by Carlton T&S. *Opposite bottom:* Two of the art director's early roughs, drawn before the location was decided upon.

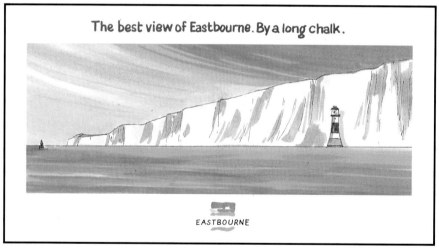

The best view of Eastbourne. By a long chalk.

EASTBOURNE

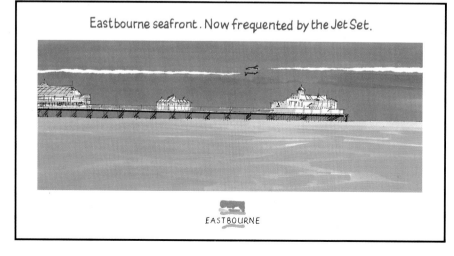

Eastbourne seafront. Now frequented by the Jet Set.

EASTBOURNE

around midday and found the lighting conditions we had been hoping for. However, there was nearly a mishap there as the boat's anchor got fouled on something, so Duncan put on a wet-suit and dived down to free it!

DW What about your timing on the job, from the time you got your brief?

PD The gestation period was about three months I suppose, but we were actually waiting for the weather as well.

DW Were there insurance problems?

PD No, we just kept our fingers crossed. We went for a week and were lucky.

DW When was it shot?

PD In summer.

DW What was the timing from the shoot to when it appeared in the media?

PD It was actually quite a long time, as the Red Arrows had to be retouched.

DW Retouched on the transparency?

PD Yes.

DW What was the media spread?

...ourne seafront. Now frequented by the Jet Set.

EASTBOURNE

PD Basically tube cards [subway ads].

DW How long did it run for?

PD For approximately a month.

DW Has it been measurably successful?

PD With it being an 'overall image' campaign, it is very difficult to say. It's been noticed within the industry and won a Gold Award for Travel Advertising, and the Chairman's Award – a top award in the travel business. It also made a Creative Circle award for best poster photography.

DW How many other people were involved when you were doing the shoot?

PD There was a stylist and the assistant.

DW When did you do the second shot – of the couple dancing at night?

PD Again very early, about half-five – something like that. The tourist authority were keen to get across the message that the town has some interesting night life, and a picture of a couple dancing in the dark seemed to be a way of doing this.

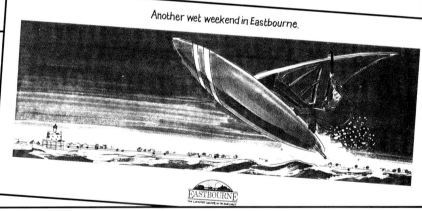

Another wet weekend in Eastbourne.

EASTBOURNE

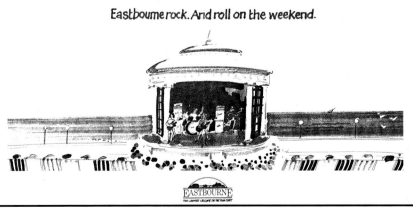

Eastbourne rock. And roll on the weekend.

EASTBOURNE

EASTBOURNE

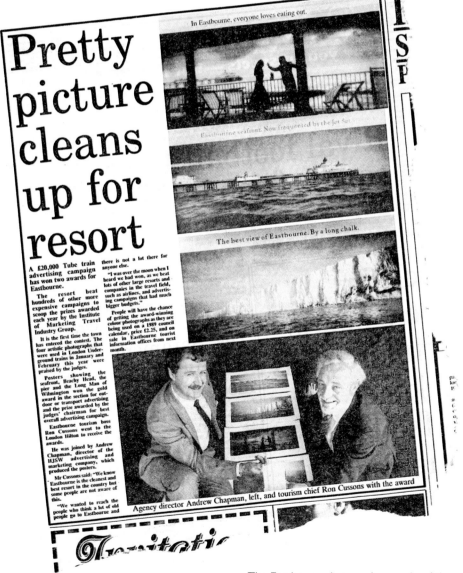

Pretty picture cleans up for resort

A £20,000 Tube train advertising campaign has won two awards for Eastbourne.

The resort beat hundreds of other more expensive campaigns to scoop the prizes awarded each year by the Institute of Marketing Travel Industry Group.

It is the first time the town has entered the contest. The four artistic photographs that were used in London Underground trains in January and February this year were praised by the judges.

Posters showing the seafront, Beachy Head, the pier and the Long Man of Wilmington won the gold award in the section for outdoor or transport advertising and the prize awarded by the judges' chairman for best overall advertising campaign.

Eastbourne tourism boss Ron Cussons went to the London Hilton to receive the awards.

He was joined by Andrew Chapman, director of the HJSW advertising and marketing company, which produced the posters.

Mr Cussons said: "We know Eastbourne is the cleanest and best resort in the country but some people are not aware of this.

"We wanted to reach the people who think a lot of old people go to Eastbourne and

there is not a lot there for anyone else.

"I was over the moon when I heard we had won, as we beat lots of other large resorts and companies in the travel field, such as airlines, and advertising campaigns that had much bigger budgets."

People will have the chance of getting the award-winning colour photographs as they are being used on a 1989 council calendar, price £2.25, and on sale in Eastbourne tourist information offices from next month.

In Eastbourne, everyone loves eating out.

Eastbourne seafront. Now frequented by the jet set.

The best view of Eastbourne. By a long chalk.

Agency director Andrew Chapman, left, and tourism chief Ron Cussons with the award

The Eastbourne logo and a sample of the enthusiastic press response to the campaign.

DW When you first got the brief, did you immediately think in terms of using really good photography, or did you think of various other things you could do?

PD We had an open brief, but what I had in the back of my mind was the old railway posters for various places around the coast. My idea was to recreate them in a photographic way. They never said very much at all, they just showed you a lovely image of wherever they were selling.

DW Like 'Come to Skegness. It's bracing?'

PD Yes, and that really was the idea, a modern version of the railway poster. It's never really been described as that, but that's what we had in our minds when we did it. We just wanted to put a little twist

Eastbourne, everyone loves eating out.

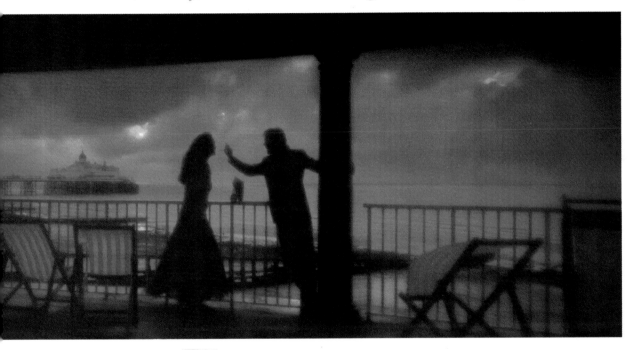

EASTBOURNE

in each of the photographs so that they were not just a picture of the cliffs – that's why we had a little windsurfer in there, not just a picture of the pier, and added the two jets going over the top. Also the idea of shooting the pier at midday is not the usual thing to do. Conventionally, the picture would be taken in early-morning or late-afternoon light, for softer tones and longer shadows. But we wanted to achieve a high-key effect and the relatively harsh light helped this. It also made the sea colour more interesting.
DW The pier is quite a traditional part of the English seaside.
PD Yes, although during the shot from the boat an inflatable castle appeared from nowhere, but I thought 'it doesn't

matter, it's all part of it' so we left it in.
DW What about the town itself?
PD It's actually a very elegant town compared with many others, so it did warrant that quality of photography. That's why I wanted someone like Duncan Sim to shoot it, because he could give an almost romantic feel to it.
DW Well his style is almost abstract.
PD The photography and the logo in combination make a very 'art'-orientated ad, which was very nice to do – a piece of advertising for what amounts to an unusual client – a seaside resort.

Interview with the Photographer

DICK WARD What was your brief?

A full gale was blowing during this dawn shot – something the photographer was able to disguise.

DUNCAN SIM The agency sent me some rough layouts and asked if I was interested. The brief was basically to show an English seaside resort in a beautiful way.
DW Would you be able to get a good result from virtually any area?
DS Yes, given the time.
DW What was the whole time on the shoot? Generally speaking how much time do you think you need to research and find the locations?
DS Well this was a special case because I grew up there, so I knew the place

103

extremely well. I've run along those cliffs before, I knew they were there. But it's like all advertising or landscape photography – you're solving problems all the time. The problem is always there and sometimes it takes longer to solve than at other times. A professional photographer is trying to create order out of disorder, harmony out of disharmony.

DW Were there any problems with weather?

DS We had one or two problems, but in general we were lucky.

DW How would you cover yourself for that sort of thing?

DW You can't really, you just have to use what you're given and wait as long as you possibly can. I've been pretty lucky so far.

DW So if necessary you would have to get a shot in cloudy or bad conditions?

DS I think for Eastbourne it would not have been possible. We would have had to wait, because they were stipulating blue sky.

DW During what time of year was it actually shot?

DS During summer. The trouble with the pier shot was that there were a lot of people in the sea, and it was difficult to persuade them not to be in the picture.

DW Did you do it early in the morning?

DS At about midday on our way back from the cliff. The beach was quite crowded.

DW How long did the shoot take.

DS It was about ten days.

DW When you get a brief like this, do you do your own research as a first step?

DS Well it all depends on the situation. I like to do my own research because I find out more that way, and there aren't many good location-finders – the good ones are normally very busy. But I think it's best to do it myself because I am being hired for my opinion. If I drive to a place and look at it, I know what's a good view. Sometimes, when I've had a tight

schedule, I might ask someone, a local, where a good spot is. But usually what someone thinks is a good view isn't good for the lens.

Duncan Sim ready for action for the cliff shot – the camera also has to be very robust for this kind of work.

DW Do you use an Ordnance Survey [large-scale] map?

DS Yes I do. It's all right for a country like England, because the maps are accurate and usually make sense. But when you get to somewhere that looks great on the map, it doesn't necessarily work out on the ground.

DW The shot of the cliffs is obviously from a boat. Did you do the pier from a boat or from the beach?

DS It's from a boat. As we had a low budget, we borrowed a boat from the local yacht club in return for a shot of their premises!

DW What about the night-time shot of the couple dancing?

DS That was done at 5.30 in the morning! The two models came down early from London, and it was freezing cold with a Force 9 gale blowing – but I still managed to get the shot.

DW As you've done this kind of thing before, did you or the agency handle all the logistics?

DS I like to organize the timing and transport and so on myself.

DW Did you arrange the helicopter on the aerial shot?

DS Yes, but we were a bit unfortunate – we had to go up twice in one day because of the weather.

DW Did you find this more difficult than shooting in more exotic locations?

DS Yes, but this was interesting.

DW What camera did you use?

DS I was going to shoot on plate, but after looking at the locations I realised the camera needed to be hand-held and thought 'no way' – plate cameras are so bulky, they really need to be used on a tripod, so I sent to London for a technarama set. I'd never used it before. I did things with it that I wouldn't do now. It's a Linhof 6/17 roll film camera – a large format (617cm), almost a 3:1 ratio, so its especially suited to a wide and narrow depth tube/subway advertising format.

However, the unusual 617cm format presents tricky composition problems when hand-held, which would not arise if it was possible to use a tripod.

DW Did the agency supply a rough?

DS Yes, I was supplied with roughs, but they changed. I think the only rough we stuck to was the one for the pier. The other two changed because we found better locations. The rough that showed the cliff with the lighthouse was never going to work because the windsurfer filled almost all the frame, which meant the cliff and the lighthouse could not be included. This meant that the windsurfer could have been virtually anywhere and I didn't feel that this showed Eastbourne off to it's best advantage. If there's a stunning landscape, you may as well use it.

DW When you've actually found your location and set up, how long does it take you to get the shot?

DS The problem with the 6/17 is that it was not as easy to use as I thought! I was very lucky to get away with it, treating it the way I did. I was hand-holding most of it and that's not something I would do

now. The shot of the cliffs took most of a morning, as it was a two-hour trip along the coast, and we were lucky to get the shot of the pier on the way back.

DW How do you protect the camera when you're so close to seawater?

DS Because it was very calm it wasn't really a problem. I have been on a shoot in Force 10 storms where the cameras have actually disintegrated.

DW How do you manage those shoots?

DS Grit your teeth and hang on, but there's no way of protecting the camera. Although you can get a weather case they aren't very effective in really extreme conditions.

DW You must have a high insurance bill.

DS Yes, it is quite high.

DW How much gear do you need to transport?

DS It depends on the job. For something like this, not too much – basically I need cameras, filters, and film. There's no lighting or anything else.

Weather conditions allowed the pier to be shot on the return from the cliffs.

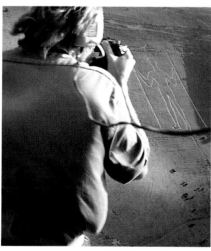

Top: A helicopter was hired to recce locations for the shot of the old man. **Left:** Duncan Sim was strapped in with a harness that enabled him to swing outside the helicopter. **Above:** The harness in use above the old man – the photographer has a good head for heights.

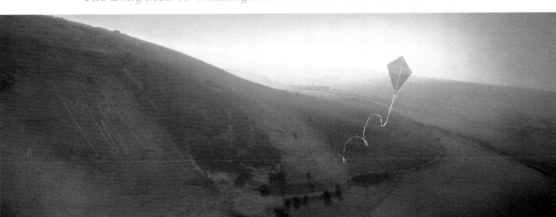

The Long Man of Wilmington. On a short walk from Eastbourne.

EASTBOURNE

DW Do you have an assistant?

DS Yes. At the moment it is Malcolm.

DW What lens did you use?

DS A Schneider 90 super angular. It's the best lens in the world. All lenses are compromises between the number of coatings, number of elements, and focal length. This one works really well, in fact it's almost too good.

DW What do you mean?

DS Well it almost shows too much detail, I had to soften it back heavily with filters. But I would rather have too much sharpness than not enough, as you can always lose it, but never put it back.

DW What film did you use?

DS This was all shot on Fuji 50 ASA – a fine-grain roll film that provides rich colours, especially blues, which were important to these shots.

DW Did you use any artificial light?

DS No, it's all daylight.

DW Do you keep technical notes?

DS No, never.

DW Can you give me a rough approximation of aperture and speed?

DS Something like 1/30 at f.11.

DW What about filters?

DS I use polarized filters and soft filters.

The finished ad of the old man. The kite was retouched by Carlton T&S.

The polarizer eliminates unwanted reflections from surfaces such as water and it also tends to brighten some colours and generally improve colour saturation. Soft focus filters slightly diffuse high-lights creating a softer, more fluid image.

DW Are creative decisions left to you?

DS The art director was there and we got on very well, so the creative decisions were mutually agreed, but I tended to make the technical decisions.

DW How did you get a reputation for doing landscapes?

DS I worked with John Carridge for three years, and travelled a lot with him. When I went freelance I just wouldn't do anything else. I had people offering me still-lifes, but I turned them down. It was really tough, because landscapes involve a lot of money. You've got to build up a reputation.

DW So all you have is an assistant, even when you do the long-distance locations?

DS Sometimes a production manager.

DW Not on this?

DS No, the budget wouldn't run to it.

DW You have achieved a fantastic quality in these shots, with a beautiful blue in the sky. If someone just went along with an ordinary camera they wouldn't get that?

DS I doubt it, although we were lucky.

DW Also, it's in focus in the foreground and in the distance – is that the lens?

DS Yes, it's a very wide lens. A Schneider 90 is equivalent to 20mm. Obviously that is going to give you good depth-of-field.

DW The pier will be placed in the middle distance and background so you've got to have something in the foreground. Is that why you got really low in the water?

DS Yes, shooting as low as possible tends to give much more movement to the sea. I was just leaning out of the boat, hand-holding the camera.

CAMERA	LINHOF 6/17
LENS	SCHNEIDER 90 SUPER ANGULAR
FILM	FUJI 50 ASA
LIGHT	DAYLIGHT
APERTURE AND SPEED	F.11 1/30
FILTERS	POLARIZED AND SOFT

FASHION

One of the most important things for a fashion photographer, apart from having a technical knowledge of photography, is to achieve a rapport with the models. If the photographer cannot make the models feel at ease, the shoot will be a disaster.

In addition, because weather conditions are not necessarily reliable, and fashion photography frequently takes place out of doors, the photographer must have the confidence to adapt and make decisions rapidly as the light and weather change.

Fashion photography differs from many kinds of photography in other respects too. Often there is no time to make corrections if the whole thing goes disastrously wrong, because the models may have to be elsewhere and the clothes back in the storeroom.

Another difficulty this type of photography presents is that the photographer constantly has to direct and shoot at the same time. It is unlikely that the models will be required to take up a still pose, and this is where the right model can make an enormous difference. A good model will learn the preferences and methods of the photographer. He or she must learn how to relax in front of the camera almost immediately shooting starts. This in itself can be difficult if, for example, swimwear is being modelled in a climate that isn't exactly hot. So the models must be every bit as professional as the photographer and art director.

The photographer of the campaign on the following pages was trained in Fleet Street, London, where quick reactions are essential to a successful career and ideal for fashion photography.

108

T h e

c a s u a l

g l a n c e

RIGHT: *Spot cotton jacket*

£69.00. Plain cotton straight

skirt £35.00. Spot print

blouse £43.00.

LEFT: *Linen look double*

breasted jacket £79.00. Spot

print soft pleat skirt £49.00.

Wrap front sweater £39.00.

COUNTRY CASUALS

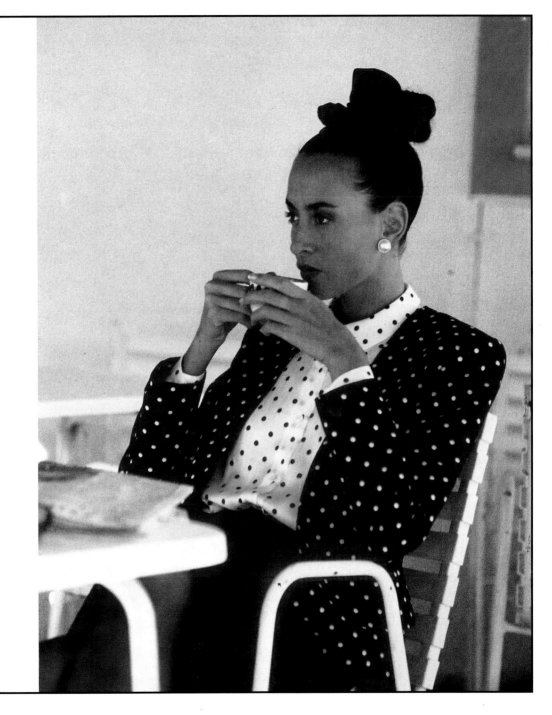

**Excellent examples of accomplished
fashion work by Chris Craymer.**

MISS SELFRIDGE

THE CLIENT	MISS SELFRIDGE FOR J C PENNEY STORES
ART DIRECTOR	THERESA FRY
ASSISTANT	HAILEY
PHOTOGRAPHER	CHRIS CRAYMER
PA	SARAH WRIGHT
ASSISTANT	BEN HARRIS
MODELS	JULIA JASON/MODELS ONE MICHELLE GEDDES, LORRAINE ASHTON
HAIR & MAKE-UP	JULIAN LEBAS CAROL BROWN

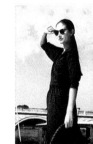

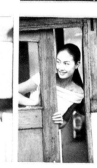

Julia found the role of cabin girl was much to her liking.

love
Miss Selfridge

The contrast between an elaborate still-life and a fashion shoot couldn't be demonstrated more clearly than in this example for Miss Selfridge, aimed as a retail campaign for JC Penney Stores in the USA.

The problem for the art director in this case was to make the right choice of garments for the American market. The clothes she chose would not be on sale in the United States for about seven months, so her decisions were crucial to the success or otherwise of the campaign.

In this campaign, as in most retail advertising, the art director in the store itself organized the shoot and decided on which photographer to use and what clothes to feature. The agencys' role was reduced to selecting the media in which to expose the ads.

Interview with the Art Director

DICK WARD This isn't the same as a normal advertising campaign because you are really the client *and* the art director. So who briefs you and how do you actually decide what to do?

THERESA FRY It's usually up to me to decide how I want to project the stock. In this particular instance I know we're going to do double-page spreads, and so the format is organized around that shape. As I know what the layouts and style are going to be, it really just comes down to the stock itself and selecting the appropriate way of presenting it.

DW Do you make the decision on what stock is to be marketed?

TF Not for JC Penney, because it's a small collection. When our buyers select what should be going into the range they have a meeting with JC Penney who then decide what to buy. We photograph the range they choose.

DW Do you do roughs for the photographer, give him any ideas or just let him get on with it?

TF The photographer is always briefed in advance. In this case it is to get across, through the photographs, that the people who wear Miss Selfridge clothes are lively, happy people having fun.

DW What's your timing normally? In this particular case how long before the shoot did you brief the photographer?

TF Sometimes it's days, but on occasions

Julia spent some time that morning practising her Indian rope trick.

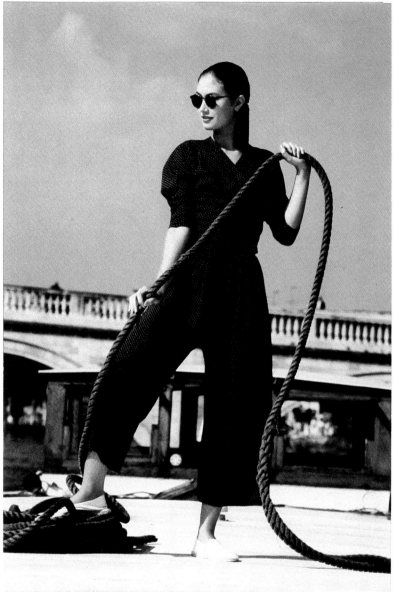

The Miss Selfridge (London) Collection is available now at a large JCPenney store near you **JCPenney**

One of the finished ads, as it will appear in fashion magazines throughout the U.S.

DW So you follow through from campaign to campaign?

TF The theme follows through, so the photographer already has that idea in his mind. He knows at the end of the day what it will look like in essence. It's so much better to brief people well in advance and then leave them to it. There is nothing worse on the day than to have the client jumping up and down wanting to change things.

DW Is there a target for this range?

TF Exactly the same as the target market over here really, which is fashion-conscious young women.

DW Any particular age?

TF No. They could be 16, they could be 36. It depends more on their attitude to dressing than on their age-group.

DW Do you have any marketing profile, like A's B's C's, etc?

TF Yes, we do, but that has been discredited in fashion to a great extent.

DW Why is that?

TF Generally, not a lot of people think there is any validity in that kind of profile as far as clothes for women go. It all depends on an individual's dress sense, and a woman from virtually any level in society can have good dress sense.

DW What's the media coverage in the States?

TF It goes to _Just 17_ and _Mademoiselle_. I know they are extremely expensive, but I don't have anything to do with that.

DW Do you choose the photographer just by looking at portfolios?

TF Yes I do. I look at a lot of portfolios, and sometimes one grabs my eye. I don't know how, it's just instinct. They're not necessarily the best, it may just be that they capture a certain mood. A portfolio doesn't necessarily even have to be presented well, as long as it has something to say. However, the

it could be hours. It varies, although we usually have a lot longer with JC Penney than with other jobs. With Miss Selfridge itself I might not see the stock until two or three days before the shoot, so I can't mark out what I want to do in more than general terms. This time we had a lot of prior warning and it was easier to arrange because we're basing the JC Penney range on bestsellers from over here.

DW Do you just say to the photographer you want pictures of some girls?

TF No, no, no! He'll know the mood. We usually use photographers we've worked with in the past. We have our own style that goes with a particular campaign – it's not a straightforward ad, it's part of a little storyboard that's all written in scrapbook style – so, for example, we would have a small picture of the models with a short sentence underneath. i.e. 'Sarah and Jane go for tea'.

111

portfolios have got to be fairly consistent so that you get the idea that the photographers know what they're doing. I also like to see a combination of colour and black and white to see how they work in both.

DW Where did you see this particular photographer's book?

TF He started to work for *Just 17* and I liked the mood of his work, he seemed to be capable of capturing happiness and liveliness very well, which is what we want to put across, so I got his book in.

DW Through his agent?

TF No. I much prefer to deal direct.

DW How long will this campaign run?

TF I believe it appears for just one month.

DW Are you constantly supplying material to go over every month?

TF No, it's intermittent, because it's a very costly business in the States. If you're inserting in any national publication I believe it's something like 75,000 dollars. So they don't advertise in the same way we do in the UK.

DW Are all your garments exported to the States and not made under licence?

TF They are exported from all around the world. They only originate from here in that we get all the collections together.

DW Do you take out any insurance when you're shooting?

TF No, but we're obviously covered on the normal liability insurance.

DW Has the campaign been measurably successful so far?

TF It's very difficult to assess, because I'm not directly involved. The whole thing is planned out with the PR campaign linking up with it, so it's part of a total package. I am seeing *Just 17* because they'll be doing an editorial feature, but that's my only contact with the press.

DW How do you select models?

TF It's a combination of ourselves and the photographer. The selection is very, very important, but at the end of the day the photographer has the final word. It's no

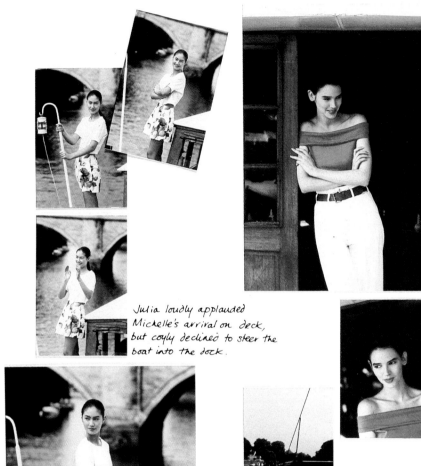

Julia loudly applauded Michelle's arrival on deck, but coyly declined to steer the boat into the dock.

love
Miss Selfridge

good having a beautiful model, and a photographer who is not keen on photographing her. And the model must be right for the clothes and fit in with the Miss Selfridge Image – young but not babyish, trendy and fresh-faced and someone who moves easily.

DW As you're working about seven months in advance, does this mean that US fashion is behind European fashion?

TF It does in some instances, but not with

everything. Some trends begin in the US and then come over to Europe.

DW Do you think they are more conservative in the US?

TF They are in some ways. For example, classic lines are more enduring in the US and less subject to the influence of new fashions, but it does depend on where you go. If you look at *Just 17* or *Mademoiselle*, for instance, there is very little difference between them and some

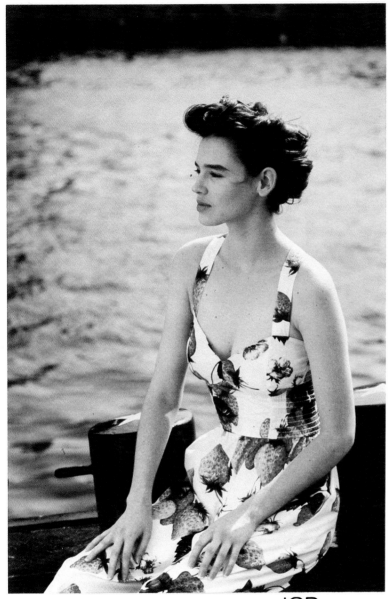

Michelle posed prettily for the crews of the passing yachts.

The Miss Selfridge (London) Collection is available now at a large JCPenney store near you

JCPenney

Another finished ad sustains the fresh and happy theme of the series.

It's starting to change here, but we still haven't got Sunday trading, which they have in New York.

Interview with the Photographer

DICK WARD First of all, on a job like this, what is your brief?

CHRIS CRAYMER I have worked with Theresa Fry a few times, so by now we have what you might call a relationship. With a Miss Selfridge campaign I no longer really need to have much of a brief. However, JC Penney is younger in appeal than Miss Selfridge, so the brief was to make the image accessible to the girl next door; it's not supposed to be so high fashion that it is unattainable. The whole look is designed to make a young girl feel she could look like this. The hair is done in such a way that it appears that the girl could do it herself. The make-up is also done in a similar fashion. The brief was to get a real-life situation on a stills picture. It's not portraying fantasy, it's not trying to say 'this is what the most beautiful girl in the world can look like'.

DW What's your history as a photographer?

CC I used to be on Fleet Street working for the tabloids.

DW Did you do portraits?

CC Yes I did. Sometimes they had to be done so quickly you just shot what you could. All these situations stood me in good stead, because they taught me that you've got to make an instant decision to really go for something and make the best of it, which is an important aspect of fashion photography.

DW What made you leave Fleet Street?

CC I felt that photographically I wasn't progressing, although I did enjoy the way of life. So I decided to change direction – surprisingly, quite an easy transition.

English magazines. *Mademoiselle* is very much geared to high fashion, but certainly their fashion pages are as strong as anything that comes out in the U.K. On the other hand, American *Elle* is different, more sexy than the English *Elle*. They are less conservative than they were a few years ago – like Australia, where they are catching up fast. The only change really is seasonal, and the American seasons tend to be different from ours. There is New

York weather and Los Angeles weather, with all the extremes in between from west to east and north to south.

DW Do you think there is more competition in the UK?

TF It's run very differently. If you go into a store in the US it's like a sea of nobody, except at Christmas time.

DW Why is that?

TF They have such long shopping hours, so they are not as concentrated as here.

113

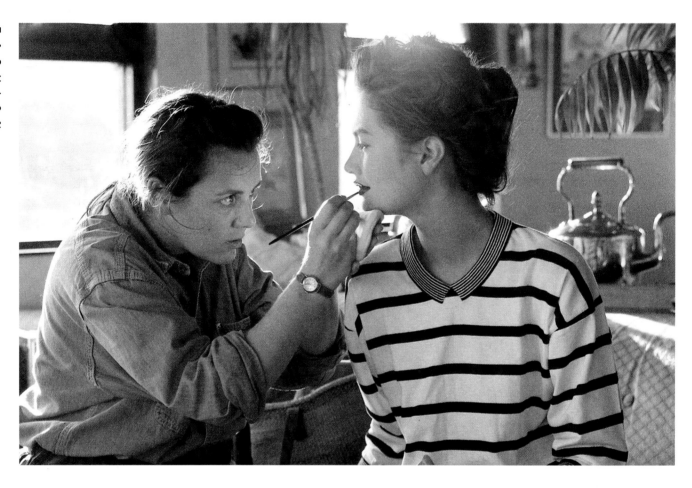

DW Did you have an agent?

CC I had an agent in Milan, which was one of the things that really helped me get established over here. Because Paris and Milan are centres of fashion I managed to get work, and came back with some pictures, which helped later with work in this country.

DW How did you make that first transition? How did you get your first job in Milan and Paris?

CC They have a different attitude to photographers. I got work for one magazine on the strength of one test.

DW Which you just did on spec?

CC I put the whole thing together as if it was a real job, with a make-up artist and hairdresser. Then I showed my portfolio to an art director in Milan, who said he

Above: A good make-up artist is essential on a fashion shoot of this kind. **Right:** To maintain the high standard of make up and hair, constant vigilance is required.

liked only one picture! I was really offended! But he asked if he could take it out of the portfolio to show the fashion editor, and I was booked to do a set of pictures for an Italian magazine in Richmond Park! That was a real break, and from then on I started working for that magazine. That is the kind of break you need if you're trying to get into international photography. Suddenly you're on a different level, and the whole thing begins to snowball, because then you start working for British magazines at a higher level, and you can go back

The assistant keeps a constant check on changing lighting conditions.

abroad with better pictures to show and the whole thing starts again. I think that to some extent I was quite lucky because success came quite quickly.

DW How long have you been doing fashion work?

CC About three or four years.

DW Do you start out with a plan on a shoot like this?

CC I get my assistant to bring along just about every kind of film we possess, and I often don't know what I'm going to do until the girl walks out. But I got used to making quick decisions when I was working in Fleet Street.

DW How long did you have from the time you were given the brief?

CC We normally have two to three weeks in between being commissioned and actually doing the job.

DW Do you choose the models?

CC I like to have a great deal of influence over who is picked. They have to be girls that I feel will be good in the framework we are given. On occasions a client will say 'we're having this girl', but usually they will listen to what I have to say and come up with a shortlist of people and pick from them. I would be very reluctant to do a shoot with someone I hadn't seen or met, or had some prior knowledge of.

DW Do you have regular favourites?

CC Yes. If I've had a successful shoot with a girl, maybe for a magazine, then I'll remember her for an advertising job. There are certainly girls who I would use again and again. I have used Julia Jason for a previous Miss Selfridge campaign and I've done a trip with her to Thailand. I'm using her on this job, and she's getting better and better. She knows what I like and she's becoming more and more confident. She's a very good model.

DW Do you choose the hair and make-up people as well?

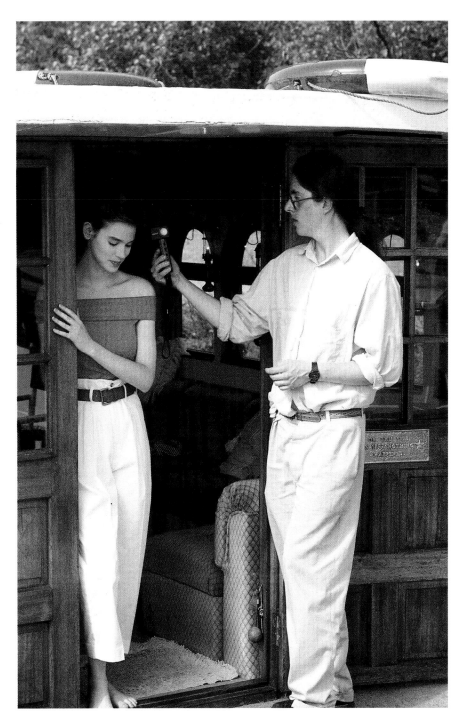

CC Yes, I like to have that influence too. The hair and make-up for a fashion shoot are a very important part of how the overall image is going to come across. For example, a make-up artist who did heavy theatrical make-up would be totally wrong for the image we were trying to get across of a fresh young girl who was

115

fun-loving and slightly sporty. I use Carol Brown because she's an excellent make-up artist. She is able to get that look across and make it seem as though anybody could do it. That is the real art, to make it look attainable.

DW You didn't choose the location or see it before you actually went there?

CC Well Sarah Wright, my PA, took polaroids of the location, as I have been incredibly busy this summer. I haven't always had time to look at locations.

DW So the client didn't choose the location?

CC They suggested it, and we went and photographed it. They had decided they wanted a boat because the theme of the clothes was nautical (water and so forth), and it had to be near London, so it was a fairly narrow brief in that respect. A river-boat, complete with brass railings, seemed an excellent setting. But Sarah is a very important part of my set-up because she is gradually beginning to see with my eye, so she can often do the location and casting for me.

DW If you're doing a shot in your studio, obviously you control your own lighting. So what sort of limitations are there on a shoot like this? If you had weather problems, for example, how would you handle it – say if you had a really dull day?

CC It really depends on the client. Some clients will come to you and say 'We want a sunny day with blue sky', and if that is really what they want, and the weather lets you down, you have to cancel it and do it another day. Miss Selfridge is different. If it's a bad day, then you make a feature of it being a bad day. They have a very open approach. As long as the photographs are in the right mood they are happy. What they don't want is a static fashion shot; they want something that looks like real life. For them weather doesn't really matter.

DW How long do you take to set up before you start shooting?

CC The hair and make-up will normally take one-and-a-half to two hours, and during that time I like to wander around on my own and get the feel of the place. Sometimes I take a camera and look through it. Sometimes I just have a rectangle to look through, I tend to attract strange looks from passers-by! I work out certain possibilities, so that if I put the girl on the bridge, for example, and it doesn't work, I will have already worked out a couple of options. It's difficult to be really specific about it, but I do find that just an hour of wandering about looking at angles and where the sun is going to be, enables me to keep the flow going on the shoot. There might be only four to six shots to do in the day, and often they can be worked out in that hour.

Miss Selfridge tend to want more pictures than that, and the situation can arise where, having taken one shot, I've got to take the shot of the next model while the first is changing, and so on, which is really very difficult. Thankfully it normally works, but you do tend to live on your nerves a bit. It's not a situation where you have time to test things out,

Above: A fill-in reflector is used to compensate for excessive back lighting. **Opposite:** The photographer will be shooting constantly to capture that elusive 'magic' moment.

and I rely all the time on spontaneity. Sometimes a person may come by with a dog or something like that, and I might include it. The whole idea is to keep the thing alive.

DW So the models are very important?

CC Models are all-important! Fortunately, as I've become more successful I get better girls coming to see me. When you're starting off you get girls that are not really top-drawer, which often means you have to work harder with them. It can actually get easier the higher up you go.

DW What are the logistics of it? Does Miss Selfridge just arrange for everyone and the clothes to be at the location?

CC Normally on a location shoot we travel in a location van, which is a bus that can carry eight or nine people. It is equipped with a generator and a make-up mirror. The models can change and have their hair and make-up done in the

back of the van, and the photographic equipment can be stored in there as well. On this occasion, as the location was so close to London and the girls could change on the boat, we all made our own way there, but that is unusual.

DW What camera were you using?

CC I use Canons. It just so happened that during my latter days in Fleet Street we all went over to Canons.

DW What lens were you using?

CC I've used a 85mm. f1.2 lens. I like the focal length because it suits what I call fashion portraits, and also because it is so fast, even in very low-light situations. It suits my photography to be able to use natural rather than artificial light. It also helps throw the background down using a wider-opening lens. I also use a 300mm telephoto lens, always on a tripod. I wasn't doing that on this particular shoot, but that is often the lens that I would use in a street situation. It helps to pull the model out of the background, so that you are looking at him or her rather than the overall scene. But I think that a certain amount of technical knowledge is

needed to do fashion shoots. You must also have visual know-how to pose a model quickly and positively. There are some photographers who are brilliant at still-life, and I have great admiration for them. But if they try to impose that vigourous control on a fashion shot, it usually doesn't work, because it looks like the girl has been standing there a bit too long, or she looks awkward.

DW What film were you using?

CC On that shoot I was using EES 35mm colour film, which is 400 ASA. It is a film that technically is not really right – it's grainy, and high contrast. But in this image I wasn't aiming to show exactly what the garment looks like. Instead, I was trying to create a mood, and the grainy film helps to get that across.

DW Do you keep technical notes?

CC I think my assistants do. I am used to working in a black-and-white darkroom, and I do feel now that I know what is going to work, and what isn't. It really comes down to experience. I have done shoots where I've photographed three people over a 15th of a second. We've

sweated a bit, but it has worked.

DW So you're changing the aperture and speed all the time?

CC Sometimes I will photograph an outfit and I'll change the lens for the same outfit to try slow shots as the model's moving.

DW So you get a bit of blurr?

CC I tend to cover myself to start with, and make sure I get half a roll done. Then I try to see what happens if we really open up. I try out a range of alternatives – it's a case of trying to move on from the basic picture.

DW So you don't know the aperture and speed you were working at?

CC No, but we tend to work either wide open or one stop down.

DW Did you have any filters?

CC No.

DW Do you ever use them?

CC Occasionally. The filters I use most are warm-up filters – 81a, 81b, 81c.

DW Would you use them on a cold grey day if you wanted to warm it up?

CC Yes. But I'm not really into those filters that make red skies, or sepia-toned filters, or pictures with a sky that looks like it has been airbrushed. It's alright for some things but I just don't think it's right professionally.

DW How long do you reckon it takes you to get the girl really relaxed?

CC It does vary. With Julie, for example, we've worked together so often in the past, there's no problem. Some girls just love it in front of the camera. Within a minute they're enjoying themselves. Other models will get through the whole day and it really hasn't worked.

CAMERA	CANON
FILM	EES 35mm, 400 ASA
FILTERS	NONE
LENS	85mm f1.2
LIGHTS	NATURAL

BEAUTY

The organisation for a location shot can often resemble a military operation. With a limited time schedule and budget, the location must be chosen carefully and the logistics arranged to run smoothly. This task generally falls to the photographer's personal assistant. To produce a series of shots for a campaign inevitably takes a long time. The creative team must first decide the overall design and then select the photographer. The photographer will normally have the final say on the selection of models, although it may have to be a joint decision with the art director.

Most photographers prefer to work with models they know, and in locations they are familiar with. The responsibilities of the photographer also include making sure that everyone is happy at the chosen site, and preventing personality clashes. They can even extend to making sure that everyone has their own room, so that after the hectic round of shooting, surrounded by virtual strangers for hour after hour, some privacy is guaranteed. All kinds of problems can occur in this situation, and improvisations must be made by everyone involved in the shoot.

Below: A superb example of photographer John Bishop's location work, shot for British 'Elle' in the Bahamas. ***Opposite:*** A charming studio shot that typifies John's ability to capture freshness and spontaneity.

BERGASOL

THE CLIENT	BERGASOL
THE BRIEF	TO DEVELOP AN ESTABLISHED CAMPAIGN AND TO LINK FOUR SKIN TYPES WITH FOUR CATEGORIES OF THE PRODUCT
THE AGENCY	SLAYMAKER COWLEY WHITE
ART DIRECTOR	STEVE DONOGHUE
COPYWRITER	JOHN PEAKE
PHOTOGRAPHER	JOHN BISHOP
ASSISTANT	CHRIS BRACEWELL
P/A AGENT	CARA PRESSMAN
MODELS	JOANNA RHODES AND LISA STONE/Models One HELEN JAMES/The Edge RACHEL DAVIS/Synchro
HAIR AND MAKE UP	WENDY SADD/Joy Goodman
LOCATION	BARBADOS

The whole concept of suntanning is unique to the western world and is a very recent phenomenon. In the 1920s and 1930s, and earlier, a suntanned face demonstrated that a person had to work in the open and was therefore one of the labouring classes. A suntan was something to be avoided. It is really only since the Second World War that the availability of mass travel has enabled thousands of people to holiday in warmer climes, and to return with the visible evidence of their good fortune proclaimed on their bronzed faces. The quest for a suntan, whatever the original skin colour, is now something to be prized. Consequently the competition between companies to provide a flexible suntanning product is very severe.

Products of this nature, although cosmetic, could also be described as pharmaceutical. The responsibilities of the manufacturers therefore extend to making sure the product is safe. But they also have to ensure that the product can do what they claim it does. This was the reasoning behind the use of four girls with different colouring – to prove the product can produce a tan on any complextion.

Interview with the Art Director and the Copy Writer

DICK WARD What was your brief?
STEVE DONOGHUE The brief was to develop the 'brownies' campaign, to clearly identify four skin types and link them visually to the appropriate Bergasol product. I did this by taking the number graphic from the packs and using it as a design element on the girls' swimsuits. Another part of the brief was to relax the style of the photography from stylized studio to natural location.
JOHN PEAKE We also wanted to establish that hair colour is a shorthand way of determining skin type. It means you don't have to change between suntan lotion factors – you stick to the same one.
DW How many roughs or ideas did you come up with?
SD We probably started off with about a dozen ideas, then six were presented to the client. This was after our own internal meetings to see which ads best met the brief.
JP We had a lot of ideas but we were governed by budget.
DW What's the target market?
SD It's universal.
DW But aspirational.
SD Yes, with a female bias; women who normally buy for their men. We want the brand to retain its up-market image to help support its premium price.
DW What's the timing on it.
JP About two weeks from start to presentation.
DW How did you choose the photographer – from his reputation or his agent?
SD I looked through about half-a-dozen portfolios and John's stood out as being fresh, with a reportage, editorial feel. I thought he would be right for it. A lot of

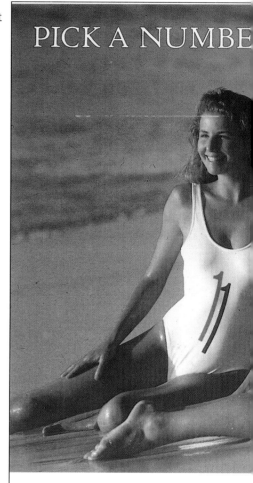

PICK A NUMBE

fashion photographers tend to make their pictures too moody, but John's book looked very natural and that was how we wanted the girls to look. I shortlisted three portfolios, and although it had a lot to do with budget, John's experience and background was really the selling point. He's been everywhere, done everything, and on location that is the kind of man you want to fix things.
DW Are you trying then to reinforce the brand image?
JP Reinforcing, and trying to make the 'brownies' theme harder and stronger than it was.

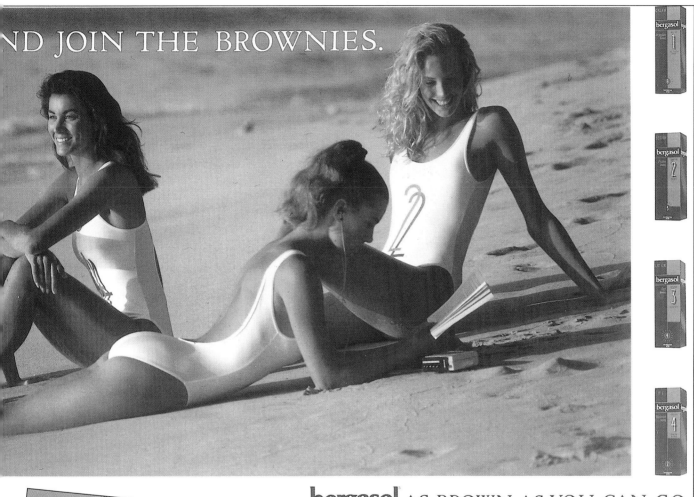

ND JOIN THE BROWNIES.

bergasol AS BROWN AS YOU CAN GO.

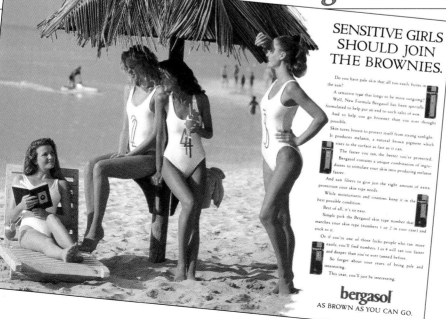

SENSITIVE GIRLS SHOULD JOIN THE BROWNIES.

Do you have pale skin that all too easily burns in the sun?

A sensitive type that longs to be more outgoing?

Well, New Formula Bergasol has been specially formulated to help put an end to such tales of woe.

And to help you go browner than you ever thought possible.

Skin turns brown to protect itself from strong sunlight.

It produces melanin, a natural brown pigment which rises to the surface as fast as it can.

The faster you tan, the better you're protected.

Bergasol contains a unique combination of ingredients to stimulate your skin into producing melanin faster.

And sun filters to give just the right amount of extra protection your skin type needs.

While moisturisers and vitamins keep it in the best possible condition.

Best of all, it's so easy.

Simply pick the Bergasol skin type number that matches your skin type (numbers 1 or 2 in your case) and stick to it.

Or if you're one of those lucky people who tan more easily, you'll find numbers 3 or 4 will tan you faster and deeper than you've ever tanned before.

So forget about your years of being pale and interesting.

This year, you'll just be interesting.

bergasol
AS BROWN AS YOU CAN GO.

Above: The largest format ad clearly captures the theme of different shades of brown. **Left:** Cutting out the right side of the ad helps place the copy and adds impact.

DW How long will it run for?
SD From early spring to late summer.
DW You had a problem with using the word 'brownies', as that's the name used by the junior branch of the Girl Guides. How did you get over that problem?
JP It took care of itself. We kept the brownies concept in the headline but played it down in the copy.

DW Do you have any insurance problems on a location shoot like this?

SD We had personal cover because we work for the agency, but group cover was organized by John and Cara. Cara is very good with the budgeting. In fact this job was governed by what we could afford, so that dictated the location choice. John really wanted to go much further afield to get the guarantee of good weather, but given that you have to transport ten people you are limited in where you can go and what kind of hotel you stay at.

DW Do you have any particular problems working on location?

SD Yes. Working on location is unpredictable, you're in the lap of the gods. You can't do anything about the weather. All you can do is shorten the odds against things going wrong by choosing a good photographer and location.

JP Although John almost got it wrong this time didn't he?

SD Well, there was nothing even he could do about the clouds. Some days they seemed to wait until we were ready to shoot, and then covered the sun for the rest of the afternoon. On this kind of shoot you only have two occasions during the day to work – early morning and late afternoon. The midday sunlight is far too hard and hot, so you only need a couple of bad days and you find yourself running out of time.

DW How closely do you expect the photographer to follow the rough you have come up with?

SD You have to be flexible. What you draw in a London office is not what you find on a Barbados beach. But if you've chosen the right photographer his experience will be of great help; as opposed to editorial photography, where you can be more opportunist in lighting – these pictures were governed by the quality of light on the girls' suntans.

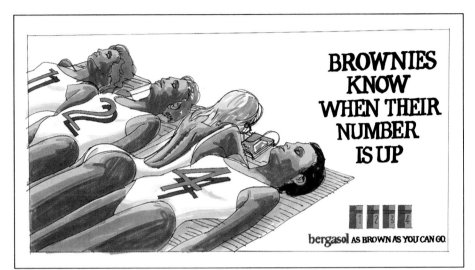

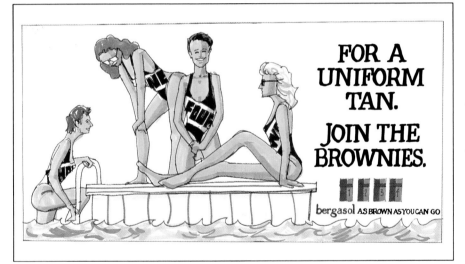

Left and above: Steve Donoghue's accomplished roughs set the style for the photographer but are not necessarily slavishly followed.

JP What has to be retained is the advertising idea.

SD The idea of the 'brownies' has been measured as a success. It has great recall among people, so that is why we wanted to continue with it.

DW How did you select the models?

SD I left it very much to John's experience. He gave me a recommendation for each category of hair colour. We did get to see the models before we went, but it was John's final decision – it was his experience that we were buying. We expected him to recommend the girls that he knew would be good for the job. They weren't really required as high-fashion models, they had to be girls who could look almost like the girl next door.

JP More approachable – that's how we wanted the whole campaign to feel.

DW Going back to the logistics of the shoot, does it all come out of the same budget?

SD Yes, it's all part of the photographer's job to make sure it comes in on budget.

DW Do you ever mention beauty or fashion in the copy?

SD No, it's all part of the story, the way it is made, and the effect on the skin is your proof of how it works. Even though we show it visually we don't get too technical. Often women will buy this product for the family or for their men.

Interview with the Photographer

DICK WARD First of all, what was your brief?

JOHN BISHOP My original brief was from the art buyer, Tony Dell, at the agency. They wanted to do four girls on location in November, and first of all they suggested going to Eilat in Israel. Then I had a meeting with Steve Donoghue and he showed me the sort of pictures that he wanted – girls lying on the beach, girls at a beach bar, and girls with a boat – and I didn't feel that Eilat was a very good place to go, as it's fairly built up and the beaches are quite rocky. The sea and the weather are very good, but it doesn't have white beaches, beach bars or palm trees. So we then thought about where else to go, and we came up with various places, various ideas. I had been to the Seychelles and Mauritius, and I thought either would be ideal, and then the Caribbean was talked about. There are really good places there, like Harbour Island, but we ended up going to Barbados because of the budget. It was

123

A splendid tropical sunset taken after the day's shooting is over – the stuff that dreams are made of!

fine, although some of the beaches are not as good as those on some of the less populated islands. It would have been better to go to the Seychelles. The problem was that it was a short shoot – five or six days – and the Seychelles was too far away.

DW What was the timing on the whole shoot?

JB We actually went for seven days, to shoot three ads.

DW How many girls were there?

JB Four.

DW Did you organize the location and the logistics?

JB Everything.

DW When you quote for a job like this, do you include all of that?

JB Yes, that's all part of the job.

DW Do you have to have insurance cover?

JB I have a public liability of a million pounds for anything that happens to someone while working with me, and we take out specific travel insurance as well, to cover anybody being sick or having anything stolen.

DW How do you begin to approach this? You obviously have a good idea of what you are looking for when you get to the location.

JB Well it depends. On this job it was fairly specific. The girls had to be suntanned, so I allowed two to three days for the girls to get suntanned.

DW That's quick!

JB Yes, but the girls generally do have a bit of colour, because they travel all the time. The fact that they were already a little bit suntanned helped in the casting, and they all spent some time on a sunbed before we went away. We left on a Thursday, got there Thursday night, and they spent Friday and Saturday getting

suntanned. We started shooting on Sunday evening.

DW While the girls were getting suntanned did you spend the time looking for locations?

JB Yes, the girls were on the beach while Steve, John and I were driving around looking for likely places. I have been to the Seychelles and Mauritius and Australia several times and I have been to a lot of beaches – Jamaica, Antigua, Barbados, the Grenadines and the Dominican Republic – in fact, to most of the Caribbean islands, so I know what I am looking for.

DW Is it very important to have a rapport with the models?

JB Yes, very important. You have to have a relaxed, responsive relationship with the model if you are to achieve the picture you want.

DW How long does that take?

JB I have worked with all the girls before. We do a lot of fashion and magazine work, so I try to use girls I know. This was a special brief; I had to use one girl with red hair, one with brown hair, one with blonde hair and one with black hair, and then they had to be not too fashion-orientated. They had to be normal-

looking, attractive girls, a bit sporty, and healthy. Having said that, they have all been in *Elle, Cosmopolitan, Marie-Claire,* and they have all worked abroad, in New York, Milan, and Paris. I try not to take a girl away on a trip if I don't know her, because I have in the past and it can be rather difficult. It's easier to take girls you have worked with in the studio or possibly on a smaller shoot before.

DW What sort of problems could you run into?

JB I think the main problem is weather, which you can't really have any control over. It's possible to increase the odds in your favour by going somewhere that should be good, but it is difficult. We arrived on the Thursday and there were clouds everywhere, and everyone we spoke to said it hadn't stopped raining for a week! Luckily, from the day we arrived to the day we left, apart from some clouds and a little rain, we had a lot of sunshine. It is a big problem and you can only go with the law of averages.

DW Do you ever take a back-up model?

JB No, because if something serious happens we would fly someone else out. This is the advantage of using someone

124

you know. You hear stories of girls lying out in the sun without using suntan cream and getting themselves burnt, so you take girls who are intelligent enough to look after themselves. We try to go to a place that is comfortable to stay in, to minimize potential problems. I always make sure everyone has their own room on the trip, so that people don't have to share rooms, which can create a problem. I try to fly British Airways or another major airline, but no charter flights as they can cause problems. They tend to be less spacious and comfortable than scheduled flights, which on a long distance can be important. Also, the food is usually awful and flights times are often delayed. Although, in fact there was a delay on the way back – 12 hours! I try to make sure that there is enough money in the budget for us to eat out in good restaurants to keep people happy.

I endeavour to make sure that things go as smoothly as possible, so that people do actually have a good time, and that during their free time they can enjoy it or get some peace and quiet, and then feel like worrying again when it's time to work.

DW Do you ever take out weather insurance?

JB No, I never have weather insurance, as it is always so expensive, often half the price of the whole job!

DW How do you test?

JB We take a lot of polaroids to make sure everything is OK. For example, a polaroid shot can reveal inadequate depth-of-field or vignetting. But normally I prefer to go to places where there are labs. Then I can shoot, and have them developed the next day. Miami is a good location for that reason. The South of France is another good place, with a great lab in Nice, which is very reassuring. But in Barbados the facilities don't really exist – we would have to send the film back to the UK or to the States, which would be risky. So we test all the film in bulk,

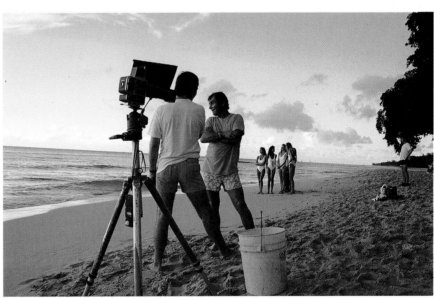

before we go out. With Kodak I buy 3000–4000 rolls of film, and keep them in stock so that we always have the same quality of colour.

DW How many exposures do you reckon to take during the course of a job of this nature?

JB It depends. We shot for three ads, and we did five or six variations on each, so I shot about 100 rolls of film.

Top: One of the models enthusiastically endorses the product. ***Above:*** Making the decision on whether the light has finally gone for the day.

BERGASOL

DW How closely did you follow the rough?

JB We followed the layout quite closely, because the agency had already sold the idea to the client. There was also a copy line which we had to fit in, which only made sense if the girls were doing certain things. But we did also shoot a lot of pictures without following the layout, as back-up. It's fairly easy to have a layout to work to, as it gives you something that everybody has accepted, the client included. But sometimes it's difficult when it doesn't work. What an art director might draw in London doesn't always work out when you're in the Caribbean.

DW When you're working with a group of pretty girls, it must attract attention. How do you deal with crowds of people who come to watch?

JB You tend to get that kind of thing in some countries. I have shot in New Guinea, for example, and we had a lot of excited local people around. I have shot in Thailand, India and Indonesia, and it is sometimes a bit difficult, but generally speaking, in the Caribbean, Barbados and America people have seen it all before Even so, we did have a few problems in Barbados with young people who would hang around in the background and wouldn't move.

DW Any aggression?

JB A little, but not much – we gave them money.

DW Any other logistical problems?

JB One problem that can occur is getting cameras and equipment into some of these places. In this case we had to send money equivalent to the value of the equipment in advance to the customs, which they hold on to. You can also buy something called a carnet which, in theory covers you: you arrive somewhere, and if you are lucky you can go through the green channel (nothing to declare), but they might stop you, then you could have a problem. So in this case

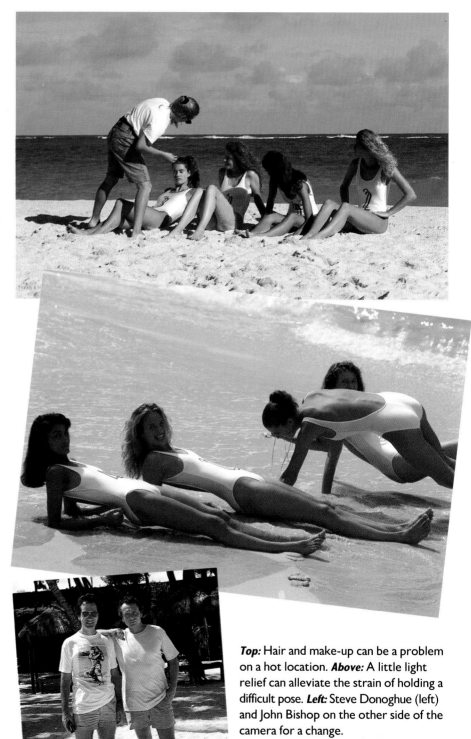

Top: Hair and make-up can be a problem on a hot location. **Above:** A little light relief can alleviate the strain of holding a difficult pose. **Left:** Steve Donoghue (left) and John Bishop on the other side of the camera for a change.

The girls take the chance to sample local wares between takes. **Right:** It is difficult, but essential, to keep sand off hair and body during the shoot.

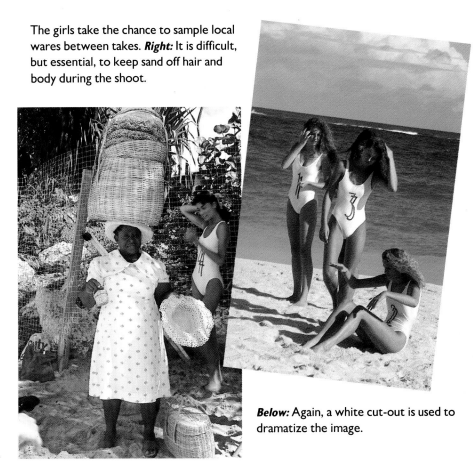

Below: Again, a white cut-out is used to dramatize the image.

we opted to send the money to Barbados, and then, hopefully, get it back a month after returning home.

DW Do you specialize in this kind of work?

JB Pretty much – mainly fashion and beauty.

DW What camera do you use?

JB I used a Hasselblad on this particular shoot, although I do use various different cameras.

DW And the lens and film?

JB I varied between a 150 and 350mm lens, and used Ektachrome Epp.

DW Do you use any lights on a location like this?

JB On this one we used just daylight and reflectors, but on other trips I would take lights.

DW Can you remember the aperture and speed?

JB I was shooting at 250th, at about f5.6 to f.8.

DW Did you use any filters?

JB No.

DW How many people did you have on the set?

JB Ten of us went to Barbados. There were four models, myself and my assistant, then there was the hair and make-up person, the art director, the copywriter from the agency and finally, the client.

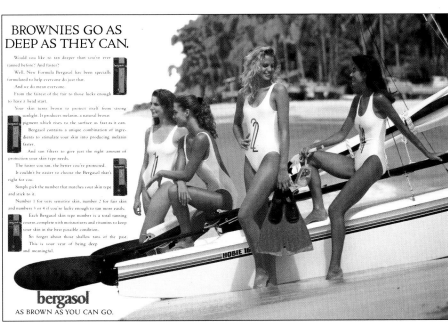

CAMERA	HASSELBLAD
FILM	EKTACHROME Epp.
LENS	150 and 350mm
LIGHTS	REFLECTORS

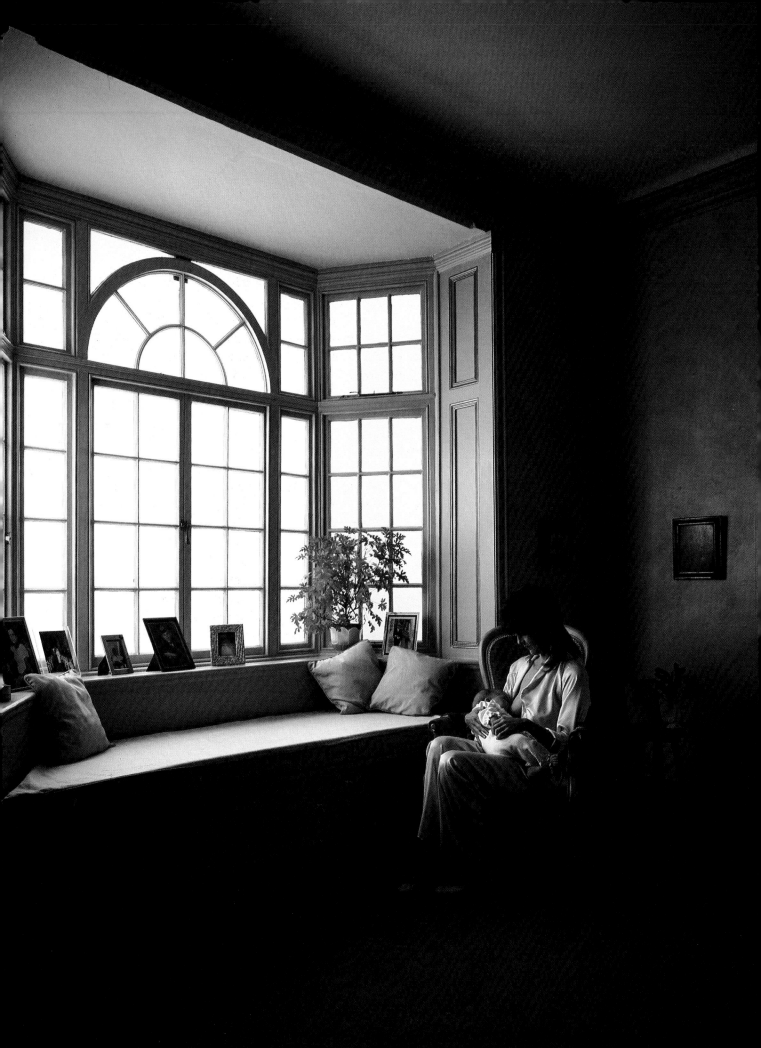

BABIES AND CHILDREN

The first step in photographing babies or children is to find the right child. Casting sessions are essential to find the child who suits the particular requirements of the ad. The ideal is to find a lively and good-looking set of twins. Then the photographer has a back-up should one baby be so recalcitrant as to make any photography out of the question.

The difficulty of a job like this is how to achieve a perfect shot with a model who, for obvious reasons in the case of small babies, cannot be directed. The solution is to allow a generous amount of time for the sessions and work the babies for as little time as possible, the maximum being around 20 minutes. It is also important that you have a hand model who is experienced in holding babies.

Other problems involve keeping the child's attention or making sure he or she is looking in the right direction. It is a good idea to place the baby's mother in the child's sight to make him or her feel secure and to keep the child looking in one direction. The photographer may find himself having to talk constantly to the baby or get his or her attention with a toy or rattle. The photographer will also need assistants to stand by armed with boxes of tissues to wipe the dribble off the baby's face, and a wardrobe mistress to change the baby's clothes when necessary!

There are no particular insurance or legal requirements in using small children for a job of this nature, because when they don't want to be photographed they soon let everyone know! So there is no problem in terms of 'overworking' the child, or any suggestion that the baby can be caused distress as a result of this kind of work.

One of photographer Steve Cavalier's delightful studies of a mother and baby that has helped to give him a reputation for excellence in this highly-specialised field of photography.

COW & GATE LTD

THE CLIENT	COW & GATE LTD
THE BRIEF	TO SELL A NO-SUGAR BABY RUSK
THE AGENCY	ABBOTT MEADE VICKERS/SMS LTD
ART DIRECTOR	ANDY ARGHYROU
COPYWRITER	LYNDA RICHARDSON
PHOTOGRAPHER	STEVE CAVALIER
ASSISTANTS	ANDREW JENKINSON/ GEOFF ELEY
MODEL	SUE TAYLOR/Freddies
BABIES	JAKE AND JESSE BURGOYNE
WARDROBE	KATE ABRAHAMS

There is a vast range of baby foods available today, with intense competition among the various manufacturers to promote these products. The market remains fairly static in terms of the numbers of babies who continue to be born and grow up, but it is also always changing, because there is a constant stream of inexperienced mothers who need good products and accurate information.

As every day brings different experiences and challenges for a new mother, so a manufacturer like Cow & Gate is highly aware not only of its responsibility to maintain the highest standards, but also of its duty to inform and educate. In these health-conscious times, an effective and strong selling point is the absence of sugar in a babies' food, because sugar is now becoming anathema as far as feeding children is concerned.

The other interesting aspect of this campaign is that it transcends all the conventional marketing profiles like A's B's and C's (social groups based on income levels), because it is aimed simply at new mothers, although it does assume a certain awareness and desire to be informed among consumers generally. In this particular case, the photographer made several test shots using his assistant to get the right exposure and speed.

Once this was found and set, the camera wasn't adjusted again, leaving the photographer time to concentrate on the image in the viewfinder. Obviously a great many exposures are made on a job of this nature and are then whittled down by the art director to a shortlist of maybe three or four, or in this case just two, both of which are superb examples of the art of child photography.

Interview with the Art Director and Copy Writer

DICK WARD First of all, what was your brief on the campaign?

ANDY ARGHYROU The original brief was 'Liga rusks are lower in sugar than their nearest competitor'.

LYNDA RICHARDSON The problem was that, although that was true, it only sounded credible if we could name the competition – which happens to be the most famous rusk around. For legal reasons we couldn't, and we thought the brief sounded like a bit of a cheat.

DW As Cow & Gate have more than one product, is this ad going to be part of a series?

AA Yes. Cow & Gate produce a number of baby-care products – baby meals, milks and juices as well as rusks.

DW Will this ad be in a common format?

AA It's going to be a one-off but with a similar look and style to the rest of the campaign.

DW Do you get a brief from the account executive or at a client meeting?

LR First it comes from the client; the client briefs the account handler. It then goes to the planners and is thought about, and rewritten if necessary. When it's finally agreed upon, it's then rewritten for internal use. In this particular case we felt the original brief didn't work, so we discussed it with the account planners and changed it, because at the end of the day we have to write an ad that works.

Can a fe be

Surprising though it may be, some ordinary rusks contain as much as 31% sugar.

Which means that every time your baby eats one of these rusks, they're eating 5.3 grams of sugar.

That's the equivalent of two ordinary sugar lumps.

Is that really such a lot?

Maybe not for an adult. But it becomes proportionately more when you consider the tiny size of a baby.

The real problem is, that most babies take an instant liking to the taste of sugar.

Even at this early age, they can develop a sweet tooth. (Despite the fact they haven't got any teeth.)

And this sugar habit can become the habit of a lifetime.

Cow & Gate Liga rusks contain 64% less sugar than the leading rusk.

Our Cow & Gate Liga rusks contain just 11% sugar. Which is just enough to make our rusks taste good.

They come in three tempting flavours. Orange. Banana. And Original. Then there's our gluten free rusk.

We've also thought carefully about the best shape for a rusk.

We've made ours oblong, because it seems that's easier for a baby to hold than a round rusk.

So when do you start feeding Liga rusks?

Your baby is the best person to answer that one.

Because there are no hard

DW So what was the brief you finally agreed on?

LR 'You can be sure you have the low-sugar rusk when you choose Liga.' It

v ordinary rusks really o high in sugar?

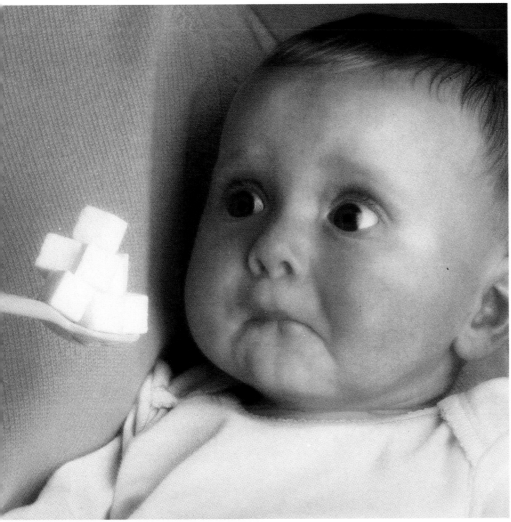

and fast rules about the exact timing.

From around 3 months (don't worry if it's a few weeks later) your baby will become dissatisfied with the usual milk feeds.

They'll probably start to cry more, and want feeding more frequently.

This is the ideal time to introduce Cow & Gate Liga rusks.

These can be mashed in breastmilk or babymilk.

This doesn't just satisfy their appetite. But gets them used to the idea of solids.

Then later on, you can give the rusks whole, to encourage the teething process.

As you'd expect from any baby rusk they're completely free

For more information write to:
Cow & Gate Ltd., Trowbridge, Wilts. BA14 8YX.

from added preservatives, artificial flavouring or colouring.

And they contain essential vitamins and iron.

Which makes them a tasty and nutritious alternative to sweet biscuits at any age.

Then when your baby grows up, hopefully they'll never have to give up sugar.

Because they never had too much of it in the first place.

Cow & Gate

We want what's best for your baby.

may sound a bit dull, but it's true and it's believable. Above all, it's simple.

DW Is that all you get to go on?

LR You get background information too.

AA That was their given advertising strategy.

DW What's the actual target market for this product?

The finished ad, which deservedly won several awards, partly because it takes extreme patience and skill to obtain such an expression from a baby.

131

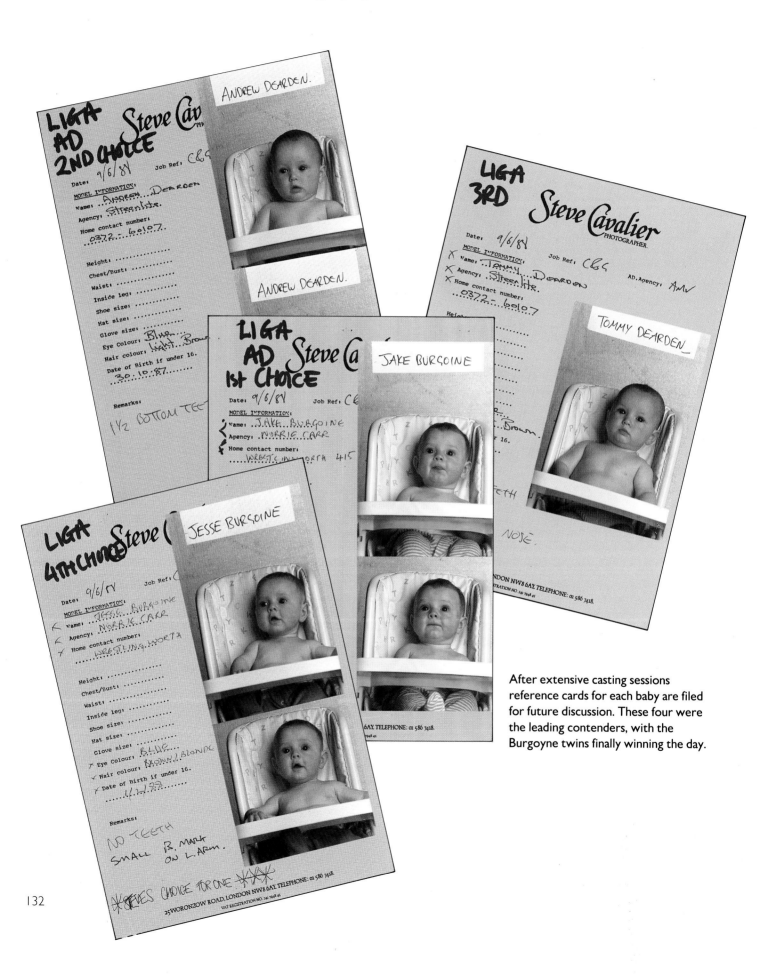

After extensive casting sessions reference cards for each baby are filed for future discussion. These four were the leading contenders, with the Burgoyne twins finally winning the day.

LR It's obviously mothers. But every time you write an ad for mothers you want to reach the first-time mothers, the idea being that if you can reach them first time around then you'll get them second time as well.

DW There's no sort of A's, B's, C's in marketing this product then?

LR Normally with a product you are given a marketing demographic. In this case I think the desire to look after your baby is exactly the same whatever segment of society you're in.

DW What was your timing on the whole job and then specifically on this one?

AA Well, this was part of a campaign, but I think it took us about a week to ten days to come up with it.

DW What, on the whole campaign or just on this one ad?

LR Just this one ad. You wouldn't expect to do an ad like that in hours or just a couple of days.

DW What's the media – is it magazines or hoarding billboards?

AA It's specialist women's press-magazines like *Mother and Baby, Parents*, sometimes *Good Housekeeping*, but usually the mother's specialist press.

DW How do you arrive at a decision when casting the baby? How many babies did you look at, and what were you looking for?

AA It's got to look good, be photogenic, and have the right reactions.

LR The thing with babies is that you can't have a bank of babies, because babies change day by day. So we usually see about 15 or 20 different babies, and that's sometimes not enough.

DW You're really just looking for a good baby?

AA It's looks and performance really. Steve writes details on them for me, just so that I know if they have no teeth, a small birthmark on the left arm, and things like that.

LR Or wouldn't stop crying!

AA Yes, and colour of eyes and age, obviously. And then he marks a choice on the contact sheet, and I just go through them all. I either agree or disagree with him, but we eventually come to some kind of decision, as he can remember how the baby performed. I may say I like such and such baby and he might say that one was quite good or bad. Whoever we decide to go with, we always have a back-up. In this case we had a set of twins, which is ideal.

DW What is the real purpose behind this campaign – is it a new product or an old product?

LR There's no such thing as an old product if you're a new mother. If you've

never had a baby then you probably only knew Cow & Gate by name. You would be completely unaware of sugar content in rusks. You would have no idea about stage 1 and stage 2 baby foods. So to all intents and purposes it's as if we're dealing with an uneducated audience.

DW How long will it run for?

AA I should think at least a year. But it could keep going, as next year there will be a whole batch of new mothers. So we could run it to them and it would be new. They've got longevity, if you like, but we still tend to do one a year.

DW How did you make your decision on choice of photographer?

AA Well, I've always worked with him

The art director's first visual roughs, which convey the concept of the ad to the photographer.

What are you feeding your baby when you feed them ordinary rusks?

Can there really be this much sugar in a few ordinary rusks?

Can ordinary rusks really be so high in sugar?

Some of the alternative headlines, which didn't quite make it.

(Steve), he's good with children and has two of his own. I can rely on him, he's like my right arm actually. He's particularly good at seeing when they're going to misbehave, and moving one out and the other one in.

LR It's actually quite a specialist type of photography, because you can have the best photographers in the world and ask them to take a picture of a baby, and if it cries for five hours they'll end up crying themselves.

DW So did his reputation lead you to choose him in the first place?

AA I used to use him on other jobs before we started doing the Cow & Gate campaign.

LR He was an award-winning photographer prior to this.

AA And I just feel I have a special relationship with him. Because he is so good he can just turn his hand to anything, although it seems that because I worked with him on Cow & Gate, he's ended up doing lots and lots of babies, so he's

getting a bit labelled.

DW Apart from the obvious ones, what other problems do you have with babies? Are there any insurance or legal requirements for example.

AA Not really. We work them for a very short time, as you saw, because you can't get any more out of them. And there's the old story of never work with animals or children.

LR If you decided you wanted to take a picture of something like a camera in a desert, you could do it, but a baby has to be in a very controlled environment. There's nothing that you can ever do that might jeopardize that baby's well-being or health, and quite rightly.

AA Basically, you can put them in a studio, and if the weather's nice you can put them outside. But you can't push them and you can't ever jeopardize them, and neither would you wish to. I suppose you can play tricks, and you can take a studio shot and strip things in if you really wanted to.

LR You can never push them. You have to wait until they do something. It's impossible to direct them, really.

AA You can have a rough idea of what you want, and hope that you're going to get it, then just keep doing it until you do get it. If the baby continues to play up, then you can't force it. You just have to have another baby, which is why we cover ourselves by having at least one other baby to hand.

DW Are you particularly known for doing babies now?

AA Probably. I've been doing it for six years now, so it's a label I have to live with.

DW Have you got any children yourself?

AA No I haven't. Actually that's the funny thing, I'm a bachelor, but I do know a lot about babies, possibly more than most mothers! That's the interesting thing about this kind of account – it's very educational, I know when babies should be fed, what they should have and what they shouldn't. I'm very aware of it.

LR I haven't got any children either, and I've learnt an awful lot from it. It really is a great education.

AA It's impossible to art direct or write for an account of this nature without actually knowing what you're talking about. There is a certain responsibility attached to it.

LR Because mothers are terribly unsure, and need to be given all the correct facts, whoever is writing about it has to learn it. Then the client double-checks it, just in case there are any mistakes. Also, there are incredibly avid mothers who really want to have as much information as they can get.

DW Does the client feel that they have a social responsibility?

AA Very much so. That's why 'we want what's best for your baby' is their line.

They are terribly concerned about it, and quite rightly. They are very aware they are dealing with young lives.

Interview with the Photographer

DICK WARD What was your brief on the Cow & Gate job?

STEVE CAVALIER We wanted to tell a simple story really, about there being no sugar included in the rusks. So conversely we're showing someone giving a baby a heap of sugar to get that point across. It's an attention-getter, as nobody would dream of doing that in reality.

DW Was there any particular market area you're aiming for?

SC Not really. It's going in magazines like *Living, Mother & Baby, Family Circle,* so that's what dictates the market.

DW What was the timing on the whole shoot?

SC We shot 12 rolls of film over a two-day period.

DW What was your timing from your first brief in the agency?

SC This one came through very rapidly. I talked to Andy a couple of weeks before the shoot. On the day what I'm after is to try to get the child's reaction.

DW Who dictates the wardrobe – is that Andy's decision or yours?

SC It's basically Andy's. But in saying that, its all a joint decision between myself and the stylist.

DW Did Andy supply you with a rough?

Visuals of the complete ad made up after the shoot and shown to the client for final approval.

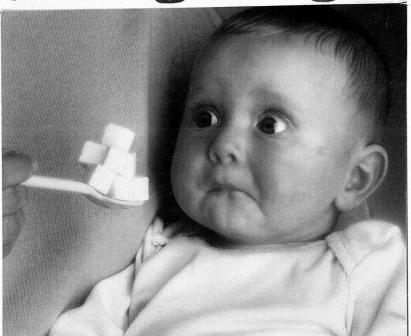

135

COW & GATE LTD

B A B I E S A N D C H I L D R E N

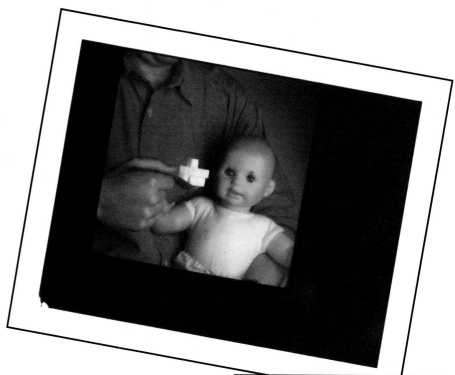

SC Yes, a basic layout to show what was wanted.

DW Is there any particular way you plan when you're shooting children?

SC I think it just comes down to experience of working with children. I have two very young children myself, so I do get a slight feel for how they react. I can see how much time I've got with them, and whether or not they get bored. So we try not to expect more than two hours' worth from a child. It is always best to have an alternative child so you can swap them over while one has a feed and rest.

DW By the time you set up, how many hours can you work with a baby in a day?

SC If I can, I'll try and work them in the morning, but often the dictates are such that you can't. It just means that it's harder if you have to work in the afternoon, as mornings are generally better for little children.

So I normally pre-light it and pre-test the day before, using one of my luckless assistants, then swap them over when it comes to the day. That way the lighting and colour tests are taken care of, so there is just the worry of the reaction of the child.

DW So the main problem is keeping them happy?

SC Depending on the shot. If you want some special expression you've got to be very patient and hang on in there until you get it. But we always work on the basis that if the kid's not happy then it's not worth pursuing it. We take them out of camera, have a rest and a break ourselves, and let them have a feed or a sleep.

DW So is there any particular method or tricks you use as far as children go?

SC Not really, it's just a matter of being technically spot-on before we start, so that you don't put a wonderful child on that's doing all the expressions in the world and you're not ready for it.

DW On to the technical side of things. What camera do you use, or were you using on that shot?

SC Just a motorized Hasselblad.

DW Film?

SC Ektachrome 100.

DW What aperture and speed did you end up with?

SC Because of the depth-of-field needed – as we had to get the spoon with the sugar lumps and the child all in focus – we had one close-up ring on a 150mm Sonar lens. We were close-in with a lot of magnification, so we needed a small f. stop. We were finally shooting at 22.

DW How were the lights worked out?

SC We basically used two. One was a strobe lamp, which is called a swimming pool; it consists of four, four-foot flash tubes inside one big casing. And then I used just one other head, lighting the background to lift it with a bit of colour.

DW You put an actual blocking-off light with a black screen on the lefthand side. Why did you arrive at that decision?

SC We were burning out too brightly on that side, so it gives a nice direction to the light, and highlights in the child's eyes. The

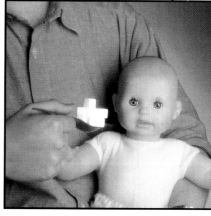

Top: Using a doll to make a polaroid test.
Above: A test on film to establish exposure and composition.

black piece is actually bigger than the light source itself, so it lets no light spill round on the far edge of the child. It just gives the light a tighter quality – directed light rather than just flooding light.

DW So you highlighted the left side of the baby's face rather than the back of the head or the whole head?

SC Yes. You don't necessarily want to spill light on the outside of the arm and

136

the body and the extremes of the head. It's better that the light concentrates on the centre so that you get a nicer feel.

DW What's the purpose of the white panel?

SC That could have been any colour, because it all gets lost in the end.

DW Was that just to keep the light away from the background?

SC Yes, because I wanted that degree of control with the head alone, and there would have been a light spill coming through. Although it would have been minimal, it still would have been contributory.

DW The white bit and the black were actually closed weren't they?

SC Yes, containing it all, the blacks doing all the work.

DW It was a white bit of board?

SC Yes.

DW There's no actual technical name or number(s) for the strength of light from the strobe?

SC Yes. I can go down and look it up in the book. We write everything down that we do.

DW Now, was there any reason why you were up on a ladder and the model was on a raised table?

SC Only really for ease of working, to get a lamp in comfortably. It's a lot easier to work with a raised subject if I'm raised up as well. It just gives more flexibility. If you suddenly decide you want to drop your lamp, you can. If you want to go up, you can raise it. If the model's on the ground you're limited to certain heights.

DW You can only go up, you can't come down?

SC On a cambo tripod, if you're at a certain height and the art director wants to drop a little, you're stuck. So it means you have to get a different type of tripod, or swing your camera underneath. Also, you get a better highlight in the eyes, because you can get a long spread of light. There is a curvature to the eye, so you've

One of the stars of the show having a break between takes with a helper.

got that nice big light source giving you a really nice highlight that follows the curvature right from the top to bottom. This is better than the light cutting-off halfway up. That's what would happen if you had the light lower down. A light like that on a child's eye can make it look rather disturbing.

DW This back strobe light on the background – was that squared or didn't it really matter?

SC It was tipped a bit.

DW What was the purpose of that?

SC To echo the curvature of the mother's arm with an area of shadow, although probably we'll crop in so close we won't see it at the end of the day.

DW You mean on the mother's right shoulder and right arm?

SC No, left behind the baby's head. The baby was sitting on her left, so the area behind the head would have curved.

DW So you would have created a dark tone on the background to frame the composition?

137

SC Yes. It gives a little bit of lift behind the child's head and the mother's shoulder. It doesn't burn out very brightly, it just gives a slight graduation to the background, which is always nicer than a flat tone.

DW Did you use any particular filters on the shoot?

SC Yes. I had a slightly soft filter, an 81a, which is like a pale brown. This gives it a softer and warmer feel, and helps the skin tone.

DW Did you push the film at all?

SC We ended up pushing the film a quarter of a stop.

DW What was the reason for that?

SC It has a slight cleaning effect. It gives it a touch more contrast and warmth. We could have shot it at a little higher exposure, but it's sometimes nicer to under-expose just a tiny bit and push it a quarter of a stop, to give the shot a slightly different quality.

DW So you're using processing as another tool of the trade?

SC Yes. It just gives me that extra flexibility and allows me to produce the result I want. It has the effect of pulling more magenta in to make it all slightly warmer, but at the same time helps to pull out the white on the sugar lumps a little bit.

DW Did you have the beige on the background to complement the skin tones?

SC Yes. It helps to knit the whole thing together, especially as we decided on a peachy-coloured sweater for the mum, which just ties in quite nicely with the browns and beige.

DW Does the art director just say he wants a nice photograph of a baby, or does he qualify his brief by saying he

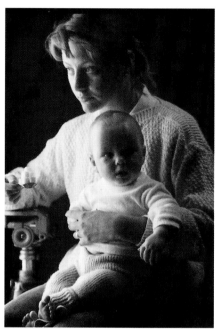
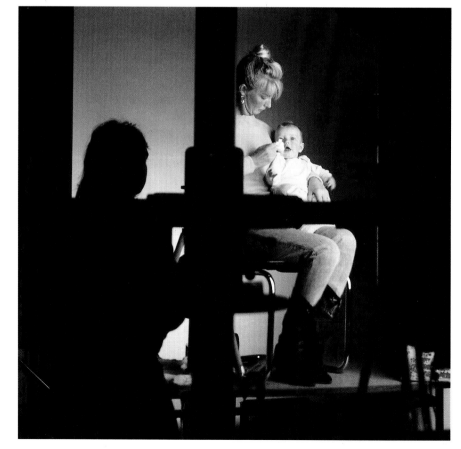

Top left: No make-up can be used, but a hairbrush can be effective. *Top right:* There's a constant battle to attract the baby's attention. *Right:* The work can be just as arduous for the hand model.

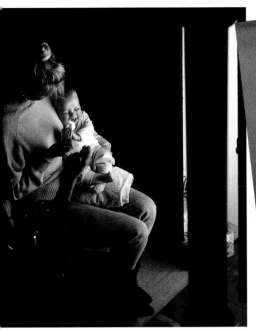

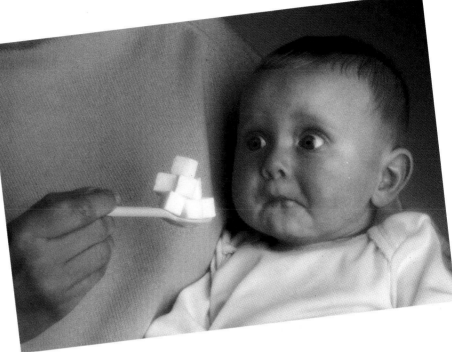

wants it moody or dramatic, or were all these decisions left to you?

SC There's always a discussion about it, but primarily it's left to me. We have worked together on Cow & Gate for quite a time.

DW Have you had a lot of experience with babies?

SC I've been doing the Cow & Gate campaigns for about six years now, and I believe they've all done exceptionally well.

DW Are there any particular legal or insurance requirements that you have to fulfill when you're using young children?

SC It's a good question. There are obvious things you have to have, like public liability insurance, which covers you for negligence, but there's no specific clause referring to children. With kids below school age you can do pretty much what you like, with the mother's consent. It's only when they're of school age that you are answerable to the local authority or the educational authorities. There's a law that children of school age can only do a certain amount of hours in a day, but with babies, it's impossible to work them too hard because they just let you know they're fed up – in no uncertain terms!

DW How do you select your hand model?

SC By making sure that she's worked with babies before, and knows how to handle them. As long as she doesn't come in and go 'Ugh!' when they throw up! I have a nucleus of six or seven that I use regularly who can handle children.

Top left: Occasionally the baby will let everyone know he has had enough. ***Top right:*** The final shot is technically perfect and has captured an expression beyond the hopes of the art director and client. ***Right:*** To illuminate the set, Steve employed a strobe lamp – a swimming pool, which consists of four 4 foot flash tubes in a big casing – and another head to give the background a bit of colour. Blocking off the light with a blank screen gave a nice tight direction to the light and produced highlights in the child's eyes.

CAMERA	MOTORIZED HASSELBLAD
FILM	EKTACHROME 100
FILTERS	81a
LENS	150mm SONAR
F STOP	22
LIGHTS	STROBE LAMP (SWIMMING POOL); HEAD LAMP

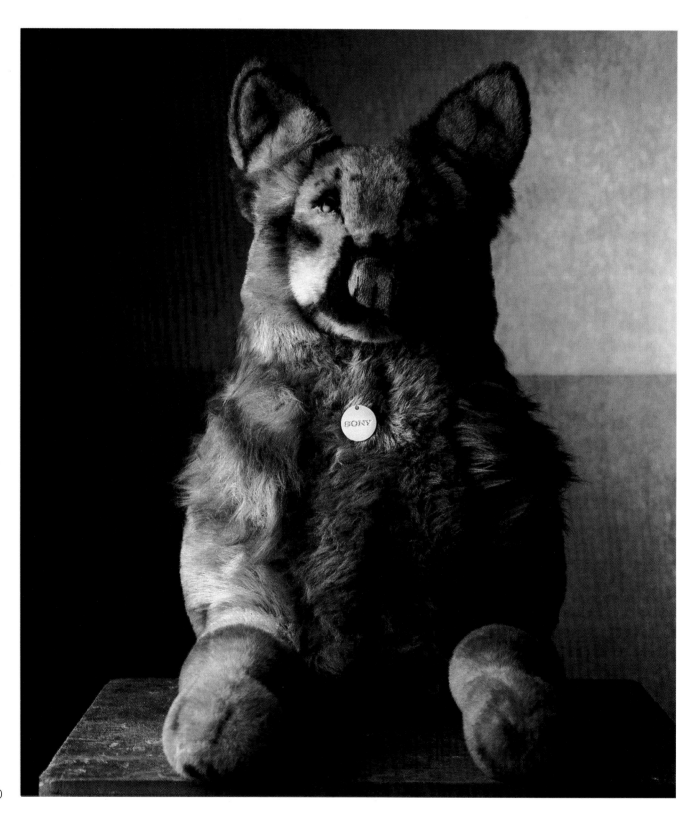

Photographing animals professionally can be a highly risky business because there can often be problems in getting the right result. The photographer must allow plenty of time and materials to get the right shot as the animal cannot be directed, and sometimes arriving at the right shot often depends on luck as well as the photographer's skill.

The animal usually has to be supplied by a specialized model agency and comes complete with its own handlers. Photographers prefer to deal with reputable handlers who can be trusted to produce the kind of animal they are looking for because, if an animal goes to a casting there is a fee involved, whether the animal is used or not. If a particular animal is used regularly it is usually because it looks good and has a good temperament. It doesn't matter if the dog, cat or chimpanzee is the best-looking animal of its kind in the world if it constantly tries to eat the camera! In this campaign 'Bandit' is a seasoned performer, having appeared professionally several times before.

Using animals to advertise a product can also be risky, because the animal may be such a successful attention-getter that nobody remembers the product it is associated with!

Photographer Mike Parsons' shot of a stuffed dog was used as test for lighting and exposure on the Sony shoot. Such animals tend to prove more predictable than their live counterparts!

THE CLIENT	SONY UK
THE BRIEF	TO SELL A SEPARATE HI-FI SYSTEM THAT IS AS GOOD AS THE BEST BRITISH MAKES
THE AGENCY	BMP DAVIDSON PIERCE
ART DIRECTOR	ASHLEY JOUHAR
COPYWRITER	SHAUN BATEMAN
PHOTOGRAPHER	MIKE PARSONS
ASSISTANT	BARRIE JENNINGS
AGENT	SUZIE JOEL
MODEL	BANDIT/ANIMALS GALORE
BADGE MADE BY	IDM
PROPS BUYER	VICTORIA KEBLE-WILLIAMS
BACKGROUND ARTIST	DICK OKE

It is not generally known, but the best-quality Hi-Fi equipment is made in England. In fact, the top end of the Hi-Fi market is dominated by a handful of small English electronics companies that sell to the kind of people who listen to the sound system as much as the sound. This ad is designed to appear in specialist publications aimed at this elite. They regard Japanese equipment manufactured by Sony as slightly inferior 'toys' for the mass market. But Sony are determined to break down what can only be described as a jingoistic prejudice, because they are convinced that their equipment is equal to the best Hi-Fi that can be found anywhere in the world.

Sony therefore wanted an ad that suggested England 'at a glance', so that by implication their product would be associated with the best Hi-Fi. The use of a bulldog to immediately suggest all that is British is a clever one for an ad with a comparatively small budget. The creative team know they are trying to communicate to an informed audience. So using the dog as an immediate attention-grabber, and backing it up by sound technical copy should make for a highly successful ad.

Interview with the Art Director and Copywriter

DICK WARD What was your brief for this ad?

ASHLEY JOUHAR It's a double-page spread going in the Hi-Fi specialist press. Apparently, Sony have been producing these separate Hi-Fi systems for some time, although among the Hi-Fi buffs Sony aren't perceived as a brilliant separate's manufacturer, even though they are good. That is because the British Hi-Fi enthusiast thinks that British is best.

SB The very top end of the Hi-Fi market is dominated by some very small English companies that make the kind of equipment Hi-Fi enthusiasts are really interested in.

AJ This is only when you buy them as separates – unlike the stack systems that Sony are well ahead in.

SB The cost of the equipment at the top end of the market is more than the average Hi-Fi purchaser would be prepared to pay. It is not uncommon to pay £3000 for an amplifier. So the business is worth quite a lot of money. But consumers do tend to think that British is best, so a manufacturer like Sony still finds it difficult to break into that market, despite the fact that they have a great name.

AJ The proposition is that although Sony's range may not be British, it sounds British. They can make that claim because all the top engineers in Japan who build the equipment for them send the production models over to top British audio engineers, who work as consultants for all the top Japanese companies in England. These British engineers take the models apart, play them and send them back with comments on what they think about them, including what the British people are looking for. Then they are redesigned according to the guidelines supplied by these top audio engineers. That is why

Your ears tell you it's British, your eyes tell you it's not. Which do you trust?

A dilemma facing any discerning hi-fi buff when hearing our ES, separates for the first time.

 This unnerving experience should be blamed on the team of top British audio engineers and consultants who helped us develop our ES range.

For Sony to use the best hi-fi specialists in the World (the British), to satisfy the most demanding hi-fi enthusiasts in the World (the British), is cheating you might say.

Maybe. But there's definitely no cheating on what goes into our equipment.

Both the CD player and the amplifier featured for example, have Gibraltar chassis. (Rock solid bases that keep vibration and magnetic interference to an absolute minimum.)

Both have 18-bit linear converters with eight-times oversampling. (To save you looking through reams of competitive specifications, that's the best there is.) In fact, we've gone to extraordinary lengths to keep sound signals pure.

The CD player is copper shielded, its loading tray acoustically sealed. The tape deck is divided

they can say it sounds British, because at the end of the day the final work is done by all those British engineers who have ripped them apart and initiated the basic design and improvements.

DW So in the copy are you actually

three compartments (all shielded). with equal
t distributed on each foot to reduce
ion. The tuner

Hi-Fi 'Tuner of
ear' Award 1989) has AM circuitry specifically
ned for the UK's medium and long wave bands.
Lastly. the loudspeakers have titanium tweeters
nprove treble and a reflex design for more
ate bass.

**OR ONE SMALL DETAIL
THINK OUR
ATES WERE BRITISH.**

All these measures would be pointless. though.
u skimped on cable. We don't.

Our phono leads have gold plated connectors
nprove the flow. and we spot weld them onto
cable (instead of using 'sound tarnishing'
ering like some people).

Both phono and speaker cables are made
near crystal. oxygen free copper. They offer a
of resistance so

gible that unless

accidently trip over them. you'll forget
re even there.

To hear some pure. unadulterated sound.
a listen to Sony ES separates at one
the dealers overleaf. And remember.
r origins may be Japanese, but their pedigree
essentially British. SONY ES

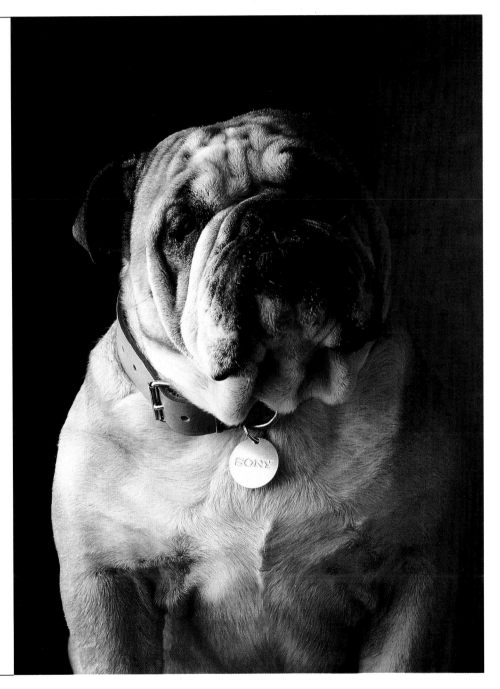

saying that it's ripped apart by British designers?
SB It doesn't go into that much detail, but it does say that British design engineers are quite heavily involved.
DW Who actually gives you the brief?

AJ We are briefed by the account handler, rather than directly by the client.
DW How many roughs or ideas did you come up with?
AJ About three or four.
DW What was your timing? How long

Technical ads are not usually known for their visual appeal, but 'Bandit' proved an immediate eye-catcher and lent considerable impact to the ad.

did you get to come up with those ideas?

SB We had about two weeks.

DW So you had to write the copy in that time?

SB Just the concept, and once that was approved we would get a copy brief, but much later on. This is peculiar to Sony. Because they believe they know the most important factors about their equipment, they always like to make sure these are written into the copy.

DW We have already talked about the target market – it's aimed at top-range Hi-Fi buffs. Is there any demographic profile?

AJ People who can afford to change their equipment every year, as some of these enthusiasts do, and who would think nothing of paying thousands for an amplifier. It usually means men aged 25 to 45 with a reasonable amount of disposable income.

DW How did you choose the photographer?

AJ Partly from his reputation. I was going to use Mike on another job, as I had seen his book, which is very good. Although he hasn't any animals in his book, he wanted to do some portraiture, and I was sure he could handle it.

DW Did you first see his book through his agent?

AJ I got it from his agent via our art buying department.

DW Is it too early to say how successful this ad has been?

AJ We don't really know at this stage.

DW How long will it run for?

AJ About three months. This ad is replacing one that ran previously, saying basically the same thing. But the last one was a black-and-white single-page ad, and it was felt that it wasn't doing the job.

DW When you do a shoot involving animals, do you need to take any special precautions?

AJ No. That's the responsibility of the animal agency and the handlers. They

watch over the animal and would soon tell us if we were doing something the animals didn't like. They don't like it too much if you want to paint or colour an animal in any way. In fact, that might be illegal. But we shot Bandit on quite a high table and they never complained – although he did, by jumping off a couple of times. Obviously if it had been a tiger it would have been a bit different!

DW This ad is to reinforce the brand image then?

SB The aim is to sell serious equipment to enthusiasts, while adopting a higher profile than previously.

DW What about the little black-and-white shots on the ad?

AJ They were just stock shots from the client.

DW Did all the other ideas you came up with involve animals?

AJ No. All the visuals we thought of were trying to tie in Britain with Japan in some way. We even thought of merging the Union Jack with the Japanese flag, or the archetypal Englishman with a typical Japanese so that half his face was Japanese and half English.

SB But Sony don't always like the Japanese identity played up too much because they have several factories in this country, and to all intents and purposes they are British. So pushing the Japanese side of it can be counter-productive. This seemed the ideal way to put the British up front in a positive way.

AJ We came up with the dog because it symbolized Britain, or Britishness. It was convenient too, as we could use the dog tag to get Sony on the main picture.

DW Was the shot you ended up with exactly how you wanted it originally?

AJ No not really, but when animals are involved there is always an element of unpredictability, which can make it so much more interesting. When we were shooting, someone dropped a plate and we all jumped out of our skins. But the

The art director's rough provides a good guideline for the photographer.

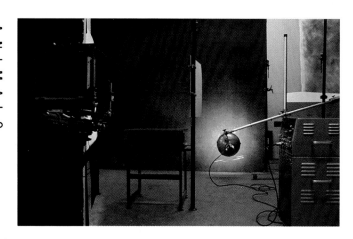 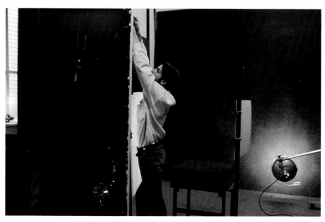

dog just cocked his head. It was such a nice pose we used it.

DW Did the photographer organize the badge-maker and the dog?

AJ No, that's all part of the photographer's brief. But we were at the casting session.

DW Did you have any trouble writing the technical copy?

SB On the copy brief Sony include all the technical points that they think should be in there. In this instance they sent too much, so I edited out what I thought made good copy, which was about a third of the material, and worked it as a basic story around the English design. In the ad we are talking to people who have advanced knowledge of the product, although that's not to say that anybody reading it, whether they know about Hi-Fi or not, wouldn't be amused by it.

Interview with the Photographer

DICK WARD What is your brief from the agency?

MIKE PARSONS We're just sent a layout really. The layout is the brief, so when we got the layout we contacted the art director and talked it through. Basically, he wanted a dog with character, one that epitomized Britishness.

DW What was your timing from brief to finish?

MP About two weeks from the brief, a period which had to include the casting.

DW How long was the shoot?

MP Only one day.

DW Did you have any control over choosing the dog?

MP We found the agency to get the dog from, but then it was decided in conjunction with the art director. He was here during the casting, so that he could see the animal's temperament, which is as important as its looks.

DW How many dogs did you look at?

MP Six, if I remember correctly.

DW All from the same animal agency?

MP Yes. They are mainly bulldog breeders.

DW How did you choose Animals Galore?

MP We needed a bulldog and Animals Galore tend to specialize in them, although they do have other animals. It's also important to choose a reputable animal supplier, because you have to pay for an animal to be brought to a casting session. So it's essential that you choose the right handlers, because then you have more chance of getting the right animal at the first session.

DW So you didn't have a back-up dog if the first dog misbehaved?

MP No, we knew it wouldn't. The casting was not only to look at the physical features of the dog but also at its

Above left and right: Setting up the lights and positioning the matts before the subject is brought onto the set makes for a more efficient and less stressful shoot. *Right:* Using a stuffed dog during tests also helps. *Far right top:* Bandit takes a well-earned break with his immobile co-star. *Far right middle and below and right below:* The handler has to be in constant attendance to make sure the animal is happy and not getting stressed under the lights.

behaviour. The first dog we looked at was really nice, but we knew it couldn't do it on the day as it was huffing and puffing and salivating everywhere. Although they were all great, Bandit is an old campaigner and had been used before. It seemed as if he was used to a photographic environment because he was impeccably behaved. We thought that there was no need to ask them to bring two dogs as he was so relaxed.

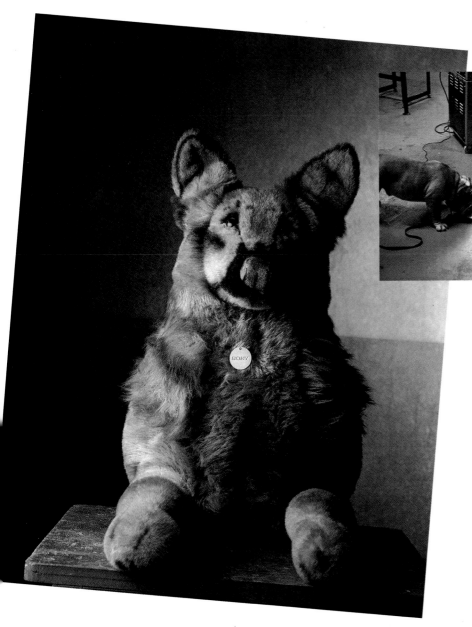

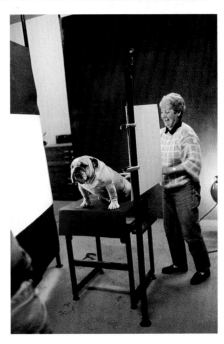

DW Are there any particular laws or insurance problems you have to worry about when you're using animals?

MP Not as far as I know. If the animal was dangerous there would be problems, but Bandit wouldn't hurt a fly, and the animal handlers would take care of that side of it. If we wanted to paint the animal black or white, I am sure they would soon let us know if we couldn't do it.

DW You haven't photographed any animals before – what made you confident you could handle this one?

MP Actually I have. A few years ago I had to do a studio shoot with a load of ducks, and that was a nightmare. I was very naive and I assumed they would be controllable. Obviously they weren't, and were wandering all over the studio. It was a disaster!

DW How did you control that?

MP I couldn't. The handlers were hitting them with sticks to try to make them come towards camera, water was flying everywhere – it was real chaos. But in this case, with a dog, you can expect to have more control. When we got the layout

we could see that what they were after was really a portrait – and the fact that it's an animal is immaterial.

DW Did you approach the job with any feeling of trepidation?

MP No, not really. You have to tell yourself that although it is just a portrait, it is in fact a bit more than a portrait. The old story of 'don't work with children or animals' is always at the back of your

Left and below: **The animal handler and photographer try constantly to persuade Bandit to hold a position – in the event, the final pose was obtained when the dog reacted to the sound of a plate accidentally dropped on the set.**

mind, so we knew we had to shoot more film and that had to be built into the quote. If you were photographing a person you could expect to cover the shot in 20 sheets. If you're doing a dog you might allow 50 sheets, because no matter how well-behaved the dog is, you still can't talk to it or direct it!

DW From the time you got the dog up on the stand, how long did it take you to get the shot?

MP We did some tests on a toy dog first, and as soon as the handlers arrived we got Bandit in quickly and did some more tests straight away. We used about six sheets just for the colour of the dog, as you never know how the colour is going to react.

DW Polaroid tests?

MP Polaroid and film tests. Six sheets at

200 percent rush, which means the lab turns them around in 40 minutes. By this time the dog had been exercised and felt a bit more relaxed, so then we went for the shot with another 20 sheets and got those on 200 percent rush as well. We then broke for lunch and waited for the shots to come back from the lab. I knew I had to see the results before we could let the dog go. When we came back and saw the sheets, one of the shots on one of the first session was good and I thought we'd got it, but we covered it again with another 20 sheets just to make sure. I was pretty sure we had it, but I felt there was no harm in trying to improve on it, and as it turned out, the shot we finally used came from the second session. It's interesting that the shot we used wasn't the expression we originally wanted. We

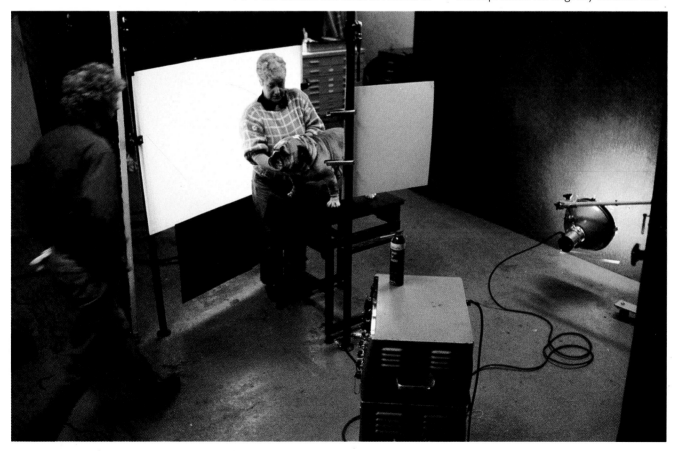

expected quite a stern, square shot, just a classic bull-dog, but this one behaved so well, and the slight cocking of it's head really made it.

The main thing was that before the dog went home we had seen the film. I would have hated to let the dog go home and sit there biting my nails wondering if I'd got it or not.

DW Basically there's no difference between shooting this and any other portrait?

MP Only in the amount of film that has to be used, and at the end of the day it's a dog, and you expect a dog to be trained.

DW I see that you've used a props-buyer on this. Was this really necessary on such a small job?

MP Yes it was. We needed a traditional bulldog collar, and as it turned out the props buyer spent a day finding one. We didn't have the time to do that.

DW And the badge-maker?

MP Well obviously we couldn't make a dog tag, so that had to be allowed for in the budget.

DW What camera do you use?

MP A 10 x 8 Symmar.

DW A Symmar seems to be an extremely popular camera.

MP Yes it is, but the Norma is an unusual one as it's old. They stopped making them about 18 years ago, but it's a lovely camera.

DW What lens did you use?

MP 4/80.

DW And which film?

MP 6117 Kodak 64 ASA Ektachrome.

DW Lights and aperture?

MP A strobe flash with a c/l head, and the aperture was 32⅔rds – probably 45.

DW Did you use any filters?

MP I filtered the back light to warm up the background, and on the lens we warmed it up a bit using an 81, and I also pushed the film to warm it up a bit.

DW Are all technical decisions on the shoot left to you?

MP Yes, Ashley left it totally to us. He might say 'the background needs warming up a bit' or something like that, but he wouldn't tell me to stop down or how to do it.

DW How many people are on the set when you're doing the shot?

MP Myself, and my assistant Barrie Jennings, and Suzie. We also had the art director, of course, and the two dog handlers.

Right: To illuminate the set, Mike employed a strobe flash with a c/l head. The back light was filtered to warm up the background and this effect was accentuated by using an 81 filter on the lens and pushing the film a bit. Mike used a stuffed dog to test the lighting, thereby alleviating some of Bandit, the model, of unneccessary stress before the shoot began in earnest.

CAMERA	10 x 8 SYMMAR NORMA
FILM	6117 KODAK 64 ASA EKTACHROME
FILTERS	81
LENS	4/80
LIGHTS	STROBE FLASH

DATE	20th October 1988		ORDER NO	BMP 567/2x	JOB NO	MP/63	
FILM	Kodak "6117", Batch no: 103			ART DIR	Ashley Johmar		
DATE SHOT	20th October, 1988		CLIENT	SONY	ASSISTANT	Barrie Jennis	
					CAM	Sinar 10x8	LENS
JOB DETAILS	British Bulldog – Sony nameas on col						

POLAROIDS B.W.					COL		
①	B&W	Pol	f45	Back Light 3k (Chead).			
②	B&W	Pol	f45	Back Light 3k¾ x 2.			
③	B&W	Pol	f45	Side Light 3k (Bank (double diffused))			
⑦	B&W	Pol	f45	Side Light 3k , Back Light 3k¾ x 2.			
⑤	B&W	Pol	f45	Side Light 3k , Back Light 3k¾ x 2.			
⑥	Col	Pol	f32⅔	Side Light 3k , Back Light 3k¾ x 2.			
				10 x 8 Black & White Polaroids with var al			
②	B&W	Pol	f45	Side Light 3k , Back Light 3k¾ x 2.			
③	B&W	Pol	f45	Side Light 3k , Back Light 3k¾ x 2.			
⑦	B&W	Pol	f45	Side Light 3k , Back Light 3k¾ x 2.			
				SHOOT. - Colour			
⑩	Chrome	+⅔	f45	Side Light 3k , Back Light 3k¾ x 2.			
⑪	"	+⅔	f45	Side Light 3k , Back Light 3k¾ x 2.			
⑫	"	+⅔	f45	Side Light 3k , Back Light 3k¾ x 2.			
⑬	"	+⅔	f45	Side Light 3k , Back Light 3k¾ x 2.			
⑭	"	+⅔	f45	Side Light 3k , Back Light 3k¾ x 2.			
⑮	"	+⅔	f45	Side Light 3k , Back Light 3k¾ x 2.			
				Kodak Tmax 100 - SHOOT - Black & White.			
⑯	100asa	N	f45	Side Light 3k , Back Light 3k¾ x 2.			
⑰	"	N	f45	Side Light 3k , Back Light 3k¾ x 2.			
⑱	"	N	f45	Side Light 3k , Back Light 3k¾ x 2.			
⑲	"	N	f45	Side Light 3k , Back Light 3k¾ x 2.			

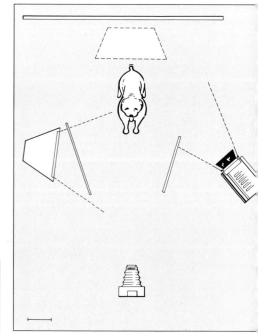

Above left: Mike Parsons keeps Bandit happy with a tit-bit. *Above:* When working with animals it is essential to capture the crucial expression – there may only be one! *Below:* The test shots are checked to make sure the crop is correct. *Left:* The finished shot captures a spontaneous moment that belies all the painstaking work that had gone before.

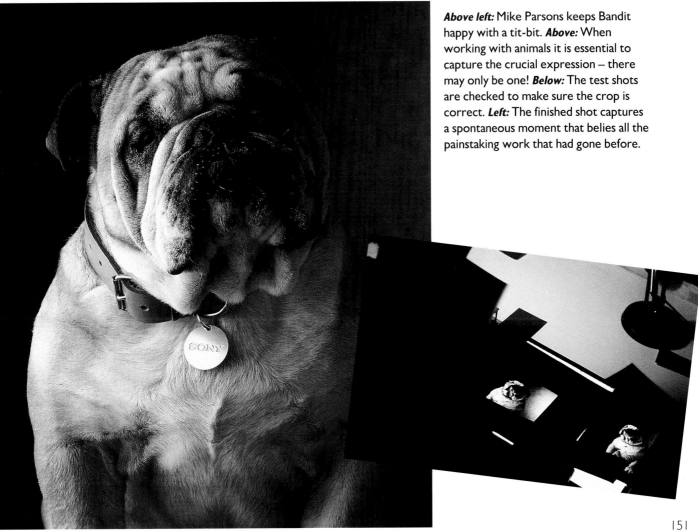

RETOUCHING

In the last twenty years retouching has changed dramatically, from being something that photographers hated to a technical skill that many photographers work closely with and make allowances for, and in many ways can be dependent on. Retouching used to involve simply covering a photograph with paint, using an airbrush, and in that sense wasn't very subtle. Retouching black-and-white photographs in particular meant using black-and-white paint mixed with sepia watercolour to stop the resultant mix from turning blue on the print. An alternative was to use a range of greys in a gouache that already had the sepia element mixed in, and which were designed to blend in with the colours on a half-tone print.

However, photographers complained bitterly when their prints were butchered in this way, so a more delicate style began to develop. On black-and-white prints this involved using dyes to darken tones – blending them in with the surface of the photograph, and a chemical bleach to lighten or reduce dark tones. Also, a scalpel was used to scratch in and strengthen fine highlights, by 'knifing' the surface of the print. This worked satisfactorily on a normal bromide, but with matt or textured papers it didn't work. Consequently, after a while, as the demand grew for invisible retouching even the scalpel was discarded.

The treatment of colour prints and transparencies evolved along similar lines. Paint had to be used to lighten anything that was dark, and photographic dyes were used to strengthen or darken tones. Moreover, there was a period when dye transfers were popular. This print system worked along the same lines as the reproduction of a transparency, in that each colour in the development process was laid on top of the other, with three basic colours and a black forming a full-colour print. Apart from increasing the quality of colour prints, this enabled the retoucher, by the judicious use of chemicals, to reduce, darken or in some cases completely remove one layer of colour at a time. By this process, retouching became completely invisible on the original, and dye transfers reached their zenith.

Art directors loved the resulting, impressive large colour prints, which they could now see clearly, as well as being able to check the retoucher's results by using a before-and-after print. But this system also lost its popularity, because of the high cost involved.

Consequently, it dawned on some people around the early 1970s that if dye transfers could be retouched why couldn't transparencies be treated in a similar manner, as they are produced with the same basic three colours, and black, overlaid on top of each other. As a result, retouching has now evolved to a state where seemingly impossible tasks can be achieved, almost invisibly, on an original transparency, and any number of duplicate transparencies can be produced without any discernable loss of quality.

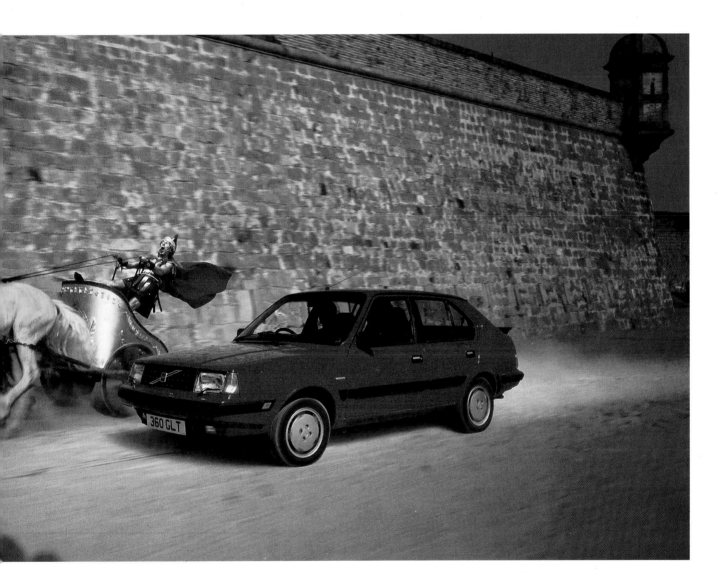

The finished ad of the Volvo racing the
chariot employs all the elements of the
composition isolated in the shots shown
on the following pages.

THE AGENCY ABBOT MEAD VICKERS
THE CLIENT VOLVO CARS
ART DIRECTOR JOHN HOUGHTON
PHOTOGRAPHER KEN GRIFFITHS
RETOUCHERS CHAS SADDINGTON AND DICK BAYNES/ Carlton T and S Labs.

The ad shots for Volvo cars over the following pages are a first class example of the retoucher's art – a comp involving five separate shots. The problem was to create a convincing shot of a chariot racing a moving car, which was obviously impossible in one take. One shot was taken of the car, stationary in the required position; another shot was made of just the moving wheels; and then yet another shot was taken of the chariot. As the charioteer wasn't satisfactrily positioned in that shot, another still shot of the photographer himself was taken, and then added to the final comp. Finally, another shot was used for the dust.

After that, the sky had to be retouched to remove the radio aerials, and the background behind the charioteer had to be drawn, together with the reins, when the new shot was positioned.

Interview with the Retouchers

DICK WARD Do you always work on transparencies these days?
CHAS SADDINGTON Yes, we specialize in transparency retouching and comping.
DW What exactly is comping?
CS Combining more than one transparency, or part of a transparency, with another.
DW When you work on transparency, what limitations are there?
CS There is a great deal that can be done, but we are always governed by what is already there. It is very difficult to

re-draw something, because then you enter the realms of illustration, and that is not what our job is about. We try to make our work an adjunct to the camera, although if we're called upon to draw something in we won't necessarily shy away from it as we can do it in a photographic way.
DW What would you call an impossible task?
CS Something like putting pin-sharp copy onto a transparency.
DICK BAYNES Something else that is difficult, if not impossible, is to put a backlit figure onto a new background, if that figure has originally been shot with fly-away transparent hair. If the figure has been shot on the wrong background, it becomes difficult for us to put it on the new background, because when we strip something together there really has to be a line to work to. Sometimes we've been asked to strip something together and the light has been totally different on the two shots. In that case there really is nothing that can be done to make the final image convincing.
CS That would be difficult for us, and even difficult on a computer.
DB The photographer has to think about what he's asking us to do. We're not really into doing salvage operations. The idea is to be able to work with the photographer to create a final image that is both convincing and professional-looking.
CS And for that we must have the original imagery to start with. If a photographer wants to strip two images together and the lighting doesn't match, we'll tell him that whatever we do, this is not going to look convincing. Now, it may be that he wants a mixed message – a surreal image. In that case it's up to him. We might do it, but we have to make it very clear that it is virtually impossible to convincingly alter lighting.
DB Going back to the backlit soft hair

line, to strip that kind of image onto a dark background is really never going to look convincing. It's impossible to avoid that terrible clash with the foreground and background, and with all the retouching in the world it just won't look right.
DW In a case like that, for it to make sense you would have to lighten the entire front of the figure. Can you do this? Can you change an overall tone or colour of any object?
CS Yes, we can, but it will look laboured in the end. In the days before retouching transparencies, when we were retouching prints and there was an edge to be lost, it might have been possible to get away with it, but that's all we did – to get away with it, to get someone out of trouble. But we couldn't produce the absolutely convincing final image that we can achieve today, and that is what we're trying to achieve.
DB We want to produce images of such quality that nobody can tell if they have been retouched or not.
DW So you work very closely with art directors and photographers?
CS Yes we do, and we find ourselves being involved right from the early stages. When they're figuring out how they are going to do a job, if we can contribute something it can save a lot of money at the end of the exercise.
CS We also get involved with the photographer, when he's actually shooting.
DW Which chemicals do you work with?
CS During the early years of dye transfer retouching we used what was called '3 in 1', which was a bleach that would take everything out. There was the old Ilford manual that everyone referred to, which gave the first basic formula, a very good one, but since those days we've moved onto another dimension.

Now the majority of the work can be done on the camera by duping. The

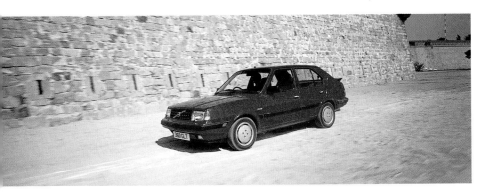

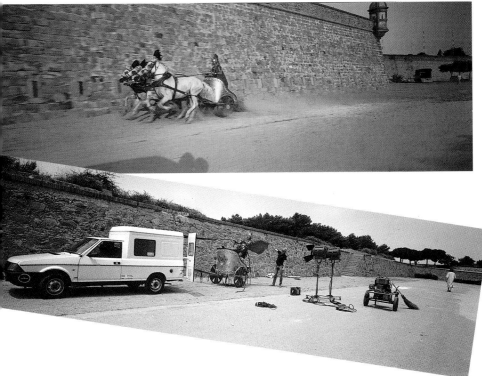

Top: The moving wheels of the car were taken from this shot. *Middle:* This shot provided the main background for the finished ad – although in this instance the charioteer was felt to be too hunched-up and serious. *Bottom:* Ken Griffiths poses as the charioteer and tries to establish the more-lighthearted pose he is looking for.

that's applied by brush, red ochre or something similar, we use Ortho-Chromatic film rubylith, or amberlith. This is an adhesive film, produced in different colours, rather like frisk film, and the different colours are for particular purposes. There are other liths as well, but the most common ones are ruby and amber. A mask is made from this and stuck on the transparency, to reduce or lose an entire colour in a specific area.

This doesn't mean that bleaching has entirely disappeared, and for certain applications it's still better. But the whole idea is to take transparency retouching back to the camera, which is what it's all about. At the end of the day nobody can pick up that transparency and say it's been retouched.

DW How do you feel about that, the fact that nobody apart from people in the business sees your best work?

DB It can annoy you in passing, but the photographers that we work with treat us with respect. They know what we do.

So if you get respect from your peer group that's OK.

CS It would be nice if we could get involved in the awards, but for obvious reasons that's impossible. It certainly would make life easier in terms of finding new business.

DW But your name has come up several times while I've been researching this book. You don't need to look for new business any more – surely it now comes to you?

CS Yes, that's true, but it would have helped in the early days.

DW You mentioned the '3 in 1' chemicals, what exactly are they?

CS They were part of the terminology that dye transfer retouchers used to use, when they had three separate bleaches. Basically, any colour changes are achieved by the use of a reducing agent, which means that the colour can be regenerated. Total bleaching is achieved

retoucher works very closely with the duper. The retoucher will brief the duper and tell him exactly which colour he wants reduced, and by how much in a particular area. This all leads to a far more photographic finish.

DW In other words, an area can be matted-off to take it out entirely or weaken it?

CS Yes. It's almost the same principle as blocking-out on a black-and-white neg, but instead of using a masking system

155

by using an oxidizing agent, and after that the colour can not be re-created. So when they were taking out cyan or magenta or yellow they would refer to them as a numbered bleach rather than by their actual names. There are several types of chemical, but they all fall into those two categories.

DW Is a transparency made up in essentially the same way as a dye transfer?

CS Yes, in as much as the same colour formation is used – cyan, magenta and yellow.

DW For example, if you are changing the colour of a car, would you bleach out all the colour and then replace it?

CS No, if you take out the whole lot, this means that it would have to be completely redrawn. You could also be in danger of making the whole thing look like an airbrush drawing. The more you create work for yourself on transparency retouching, or any kind of retouching really, the more risk of making the job looking laboured. So if you really think about it and find a short cut in the first stage, that tends to make the second stage easier, and so on. For example, we would never take a colour out completely if we were changing a car body colour. Instead, we would take the ruling body of that colour out, to neutralize it back, and then apply colour to create the tone that's wanted.

DW In other words, you would keep all the form in?

CS Yes, that's right, because if you take everything out, it's got to be put back, and no matter how well you do it, that is where you will be caught out.

DB That's what makes the difference between a drawing and a photograph.

DW So, virtually the only limitations are if you're asked to draw something in?

DB Not necessarily. There are instances where we have taken things out and replaced them by drawing them in a

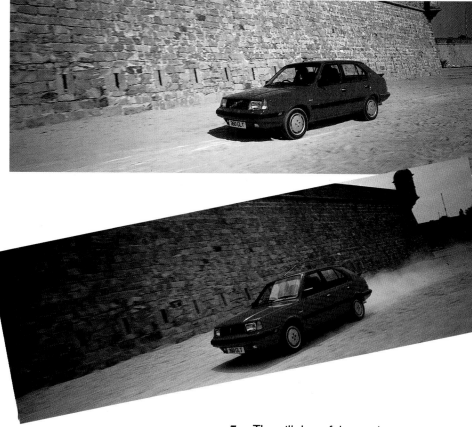

photographic manner. We really pride ourselves on this, if it is approached in the right way.

Initially, photocomposition was almost like cheating, bearing in mind that you are adding to the camera. Then we discovered that people with possibly a fraction of our skills were producing better jobs by comping in. So we realized we had to do the same thing. We were slightly late in this area because we thought we could do better the way we were doing it before. But as we changed over we became more and more involved in the practical applications of retouching, as opposed to being used merely as problem solvers, or to get photographers out of trouble.

Top: The still shot of the car that was used in the final ad. **Above:** The trail of dust was isolated from this shot.

CS When I first started in the business most retouchers were, basically, frustrated illustrators.

DW Yes, and most photographers hated them.

DB Yes, because they thought like illustrators and misrepresented the photographers' work.

CS Now I think we are the photographer's best friend, as we enable the photographer to get out of the studio and get on with the next job. Otherwise he would be forever-trying to get the image right in one go and probably waste a lot of time and go over his budget. Now we do what we can so that he can get on to the next job, and the agency build that in to their cost-calculations.

Aperture: The lens opening controlling the amount of light reaching the film.

Artificial light: Light provided by tungsten bulbs or flashlight – i.e. not daylight.

ASA: American Standards Association – measurement of film's sensitivity to light.

Available light: Any natural light other than that added by a photographer.

Barn doors: Metal flaps which control the spill of light from the centre beam of tungsten lamps.

Bellows: A light-tight box on a camera between the lens and the film. The length of the bellows determines the maximum focal length lens that can be used for a camera and the close-focus limit of a lens.

Bracketing: Technique of taking several pictures of the same subject at slightly different camera settings to ensure the correct exposure.

Colour temperature: The method of defining the colour quality of light on the basis of the colour temperature of a body that would give light of that quality if heated to a certain point on the Absolute or Kelvin scales. Most colour films are designed for sunlight and cloud conditions providing light at approximately 5500K.

Contact sheet: Negative-size photographs of a whole film on a single sheet made by placing the printing paper in direct contact with the negatives and exposing to light.

Daylight film: Colour transparency film balanced for use outdoors or with electronic flash.

Depth-of-field: The amount of a photograph which will appear sharply resolved in front of and behind the point at which the camera lens is focussed.

Extension rings or tubes: Rings or tubes applied to the back of the lens before it meets the camera body in order to assist with focusing on small objects in close-up work.

Field camera: An easily portable, large-format camera, designed to fold into a relatively small unit.

Film speed: The sensitivity of a particular type of film to light. Films are rated for speed using ASA numbers. The lower the number, the slower its speed and the lower its sensitivity to light.

Filters: Made of glass or plastic, filters cover the lens of a camera and alter the colour or quality of light reaching the film. For example, when using a daylight colour film in artificial light, a blue filter will cut back the yellow cast which would otherwise be produced on the film by the light sources.

Focal length: The distance between the centre of a lens and its focus – effectively the distance from lens to film measured in millimetres. Short focal length lenses (e.g. 28mm) provide a wide angle of view while long focal length lenses (e.g. 120mm) provide a narrow angle of view.

Headline: The principal verbal message in an advertisement.

Incident light meters: Hand-held exposure meters measuring the light falling on a subject rather than the light which the subject reflects.

Joules: Units of work or energy, named after J.P. Joule, the 19th century English phycisist. The heat generated or work done by a one ampere current flowing for one second against a resistance of one ohm.

Polaroids: Instant film used by most professional photographers to check visualization, colour values, lighting, contrast and so on, on-the-spot.

Pushing: Giving extra development to a film that has been under-exposed (i.e. rated at a higher ASA setting than recommended by the manufacturer).

Reflected light meters: Hand-held exposure meters measuring the light reflected by a subject.

Rough: An outline plan for the content and format of an advertisement.

Shoot: A (generally) professional photographic session, in a studio or on location.

Shutter speed: The time (generally measured in fractions of a second) a camera shutter remains open and so allows light to act on the film.

Trannies: A transparent positive produced from colour transparency film (also known as colour reversal film).

Tungsten film: Colour transparency film balanced for use in artificial light.

View camera: A type of large-format camera, usually built on a monorail system where the primary camera support is in the form of a rail. Nearly all monorail cameras offer a very large range of interchangeable accessories – larger or smaller backs, different bellows and so on.

Vignetting: Partial obscuring of image edges caused, for example, by irregularity in the bellows.

INDEX

ACKNOWLEDGEMENTS

The author would like to offer special thanks to Derek Aslett for all the location photography.

PHOTOGRAPHERS

Barney Edwards
12 Burlington Lodge Studio
Rigault Rd
London SW6

Christine Hanscomb
The Courtyard
187 Drury Lane
London WC2

James Mortimer
206a Stapleton Hall Rd
Stroud Green
London N4

John Parker
35 Bedfordbury
London WC2

Jon Cox
Burley Hill Trading Estate
Burley Rd
Leeds
W. Yorks LS4 2PU

Ken Griffiths
17 Macklin St
London WC2B 5NH

Nadav Kander
1–7 Brittannia Row
London N1 8QH

Duncan Sim
Flat 4
19 Redcliffe Sq.
London SW10 9JX

Chris Craymer
18 Hewett St
London EC2

John Bishop
126 Shirland Rd
London W9

Steve Cavalier
25 Woronzow Rd
London W8

Mike Parsons
44 Peartree St
London EC1V 3SO

AGENCIES

Ammirati & Puris Inc.
100 Fifth Avenue
New York N.Y. 10011

Colman RSCG & Partners Ltd
35 Bedford St
London WC2 9EN

Collett, Dickenson, Pearce & Ptnrs Ltd
110 Euston Rd
London NW1 2DQ

Brahm Advertising
The Brahm Building
Alma Rd
Headingley
Leeds
West Yorkshire LS6 2AH

Lowe Howard-Spink
Bowater House
114 Knightsbridge
London SW1X 7LT

Burkitt Weinreich Bryant Clients & Co Ltd
200 Tottenham Court Rd
London W1P 9LA

HJSW Ltd
38 St Martins Lane
London WC2 4ER

Slaymaker Cowley White
(now: Delaney Fletcher Slaymaker Delaney & Bozell Ltd)
25 Henrietta St
London WC2R 8PS

Abbot Mead Vickers.SMS Ltd
191 Old Marylebone Rd
London NW1 5DW

BMP DDP Needham Worldwide Ltd
12 Bishop's Bridge Rd
London W2 6AA

Carlton T&S Ltd (Retouchers)
16 St Pancras Way
London NW1

CLIENTS

Waterford Crystal
Josiah Wedgwood & Sons Ltd
Barlaston
Stoke-on-Trent
Staffordshire ST12 9ES

Knorr
CPC (UK) Ltd
Claygate House
Esher
Surrey KT10 9PN

Smallbone
Williams Holdings Plc
Pentagon House
Sir Frank Whittle Rd
Derby
Derbyshire DE2 4XA

Benson & Hedges
Gallaher Tobacco (UK) Ltd
Members Hill
Brooklands Rd
Weybridge
Surrey KT13 0QU

Porsche
Porsche Cars Great Britain Ltd
Bath Road
Calcot
Reading
Berkshire RG3 7SE

Gordon's Gin
Arthur Bell Distillers
Cherrybank
Perth
Tayside PH2 0NG

Seiko
Seiko UK Ltd
Hattori House
Vanwell Rd
Maidenhead
Berkshire SL6 4UW

Eastbourne
Eastbourne Tourist Authority
3 Cornfield Rd
Eastbourne
E. Sussex BN21 4QL

Miss Selfridge
Sears Plc
40 Duke St
London W1A 2HP

Bergasol
Chefaro Proprietaries Ltd
Cambridge Science Park
Milton Road
Cambridge
Cambridgeshire CB4 4FL

Cow & Gate
Cow & Gate Ltd
Trowbridge
Wiltshire BA14 8YX

Sony
Sony (UK) Ltd
Sony House
South St
Staines
Middlesex TW18 4PF

Volvo
Volvo Concessionaires Ltd
Globe Park
Marlow
Bucks SL7 1YQ